IN FITTING MEMORY

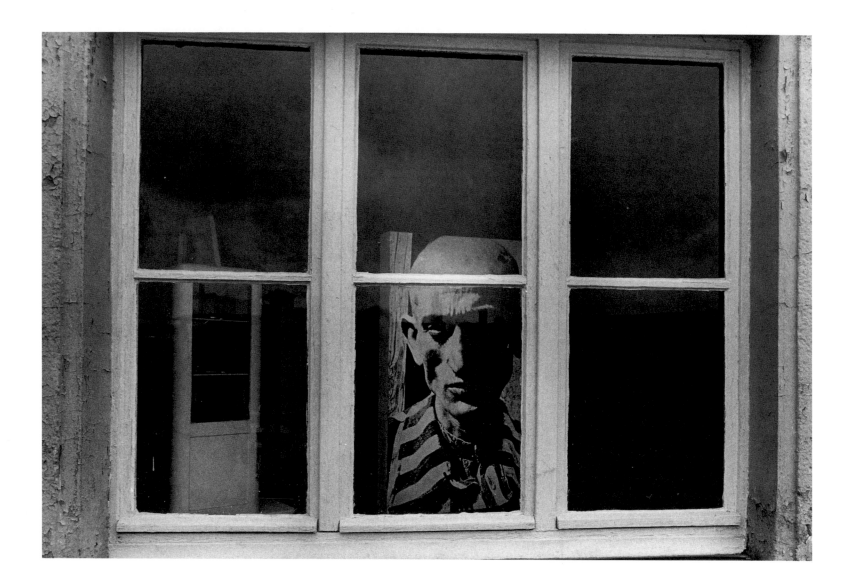

IN FITTING MEMORY

The Art and Politics of Holocaust Memorials

Text by Sybil Milton *Photographs by* Ira Nowinski

PUBLISHED BY

WAYNE STATE UNIVERSITY PRESS DETROIT

IN COOPERATION WITH THE

JUDAH L. MAGNES MUSEUM BERKELEY

Library of Congress Cataloging-in-Publication Data

Milton, Sybil.
 In fitting memory : the art and politics of Holocaust
memorials / Sybil Milton ; photographs by Ira Nowinski.
 p. cm.
 Includes bibliographical references and index.
 ISBN 0-8143-2066-X (alk. paper)
 1. Holocaust memorials. 2. Holocaust, Jewish (1939-
1945)—Influence. I. Title.
D804.3.M56 1991
940.53'18—dc20 91-19603

Frontispiece: Reflected image from inside the exhibition in the
pathology barrack at the Sachsenhausen Memorial. (See pp.
286–87.)

The design motif on the spine and chapter openings is based
on the barbed wire fence in front of the Jewish Memorial
Temple at Dachau. (See pp. 168–69.)

CONTENTS

PREFACE

In Fitting Memory is a critical survey of Holocaust memorials and monuments in Europe, Israel, and the United States. In this volume the Holocaust is defined retroactively as the collective designation for the Nazi mass murder of Jews, Gypsies, and the handicapped and for the related persecution of Soviet prisoners of war (POWs) and other ideological opponents. In this book we have attempted to provide an analysis of the complex interrelationship between authentic historic sites, disparate and ephemeral representations of history, and the changing political and aesthetic balance between commemoration and escapism. Using text and photographs, we have tried to show how since 1945 these memorials and monuments have served not only as secular shrines, but also as temporal institutions reflecting changing public constituencies and distinctive political, social, and cultural contexts.

The transmission of the history of the Holocaust in memorials and monuments involves consideration of institutional and political constraints. Such constraints apply especially to the financing of monuments that might offend governments, patrons, or the communities in which they are located. The Holocaust has thus sometimes been presented in distorted exhibitions or sanitized sites. The cost and labor of maintaining the original sites, changing demands and expectations of diverse public constituencies, and the need to present sophisticated and changing historical research about a tragic past to escapist audiences that have been conditioned by television docudramas pose virtually insoluble problems. The forces that shape and constrain the presentation and transmission of the past to the present and the future also affect memorials in an era of booming international tourism. Memorials and monuments of the Holocaust have become part of the tourist circuit. Of course, no single person is likely to visit all sites, memorials, monuments, and museums about the Holocaust, and, even if such an expensive and time-consuming journey were contemplated, the explosive growth of newly recovered sites and frequently changing museum

1

presentations would make full coverage impossible.

This book started in 1986 as background and comparative research for an exhibition at the Judah L. Magnes Museum in Berkeley of Ira Nowinski's photographs of the George Segal monument *The Holocaust*. Segal's work, installed outdoors in San Francisco's Lincoln Park and indoors as a maquette at the Jewish Museum in New York, raised important questions about the portrayal of history in contemporary public art as well as the comparative impact of representational sculpture.

The title *In Fitting Memory* poses the rhetorical questions: To whose memory and how fitting? It intentionally places Holocaust memorials within their various national and political contexts. The book is based on research and photographic surveys of seven European countries: Austria, the Federal Republic of Germany, the former German Democratic Republic, France, Italy, the Netherlands, and Poland, with comparative data drawn from the Soviet Union, Israel, the United States, Canada, Japan, and South Africa. The design and content of Holocaust memorials reflect national differences in historiography, ideology, and culture as well as a variety of styles and traditions of public art and sculpture. Many memorial sites reflect local events or specific aspects of the Holocaust. Despite the specificity of each site and despite national differences in perspective and emphasis, these memorials collectively preserve for posterity the public memory of Nazi mass murder. They also reflect the development of public art and memorial sculpture on four continents. These monuments, memo-

rials, and museums have also become part of a wider international civic culture in the last 45 years.

We realize that the subject of memorialization is a new field and, while the study of a number of Holocaust memorials presently under construction may modify some of our conclusions about the intersection of historical memory and political identity, we do believe that this book will help those interested in resolving the ambiguities of how to remember the past.

The text, captions, bibliography, and list of memorials were written by Sybil Milton, and the site photographs were taken and developed by Ira Nowinski. Unfortunately, it was not possible to assemble a systematic biographical section on all artists whose works are reproduced in this volume, but relevant biographical data, when available, is integrated into the photograph captions. All captions contain the following information: (a) site; (b) artist's name and title of work; (c) date of design and/or installation, if known; (d) dimensions and materials; and (e) biographical data about the artist, architect, or designer, if available. Titles are given in italics if the works were titled by the artists; unitalicized titles were added by museums, memorials, or the author.

All of the photographs, except for six from Italy, two from the Netherlands, and one from Long Beach, were taken by Ira Nowinski during four photo survey trips between December 1987 and September 1989. Several photographs from Nowinski's portfolio of George Segal's monument *The Holocaust*, completed in 1985 and exhibited in 1986 at the Judah L. Magnes Mu-

seum and the New York Jewish Museum, are included in this volume. The six photographs from Italian memorials were commissioned by ANED (*Associazione Nazionale Ex Deportati Politici nei campi di sterminio nazisti*) and were generously made available to us. The Museum of Deportation in Carpi was photographed by the Paolo Monti Studio, Milan, and San Sabba concentration camp in Trieste by Paola Mattioli, Milan. The two photographs from Amsterdam were made by Ad van Denderen, Amsterdam. The Long Beach Holocaust Memorial Monument was photographed by Jim Strong, Hempstead, New York.

Although we have attempted to verify all information about the history of each memorial and monument, exact data was not always available. Whenever possible, we consulted archival documents and tried to verify information by interviewing artists, government officials, and survivors. Some information may contain errors, since research did not always yield satisfactory answers. We hope that our work will provide assistance to those who will continue to investigate this important subject.

The research and text for this volume were completed before changes in the former Soviet bloc altered the political map of Europe. These changes are, however, still incomplete and it is still too early for any final analysis. Nevertheless, recent developments do show that the administration of memorials in the countries of Eastern Europe and in reunited Germany will at best transform and at worst diminish the status of most Holocaust and anti-Nazi memorials. Thus, the newly installed governments of Central and Eastern Europe have fired the directors of many memorials and cut their professional staffs and budgets. The new regimes have, moreover, insisted that so-called anti-Stalinist exhibits be erected in most memorials alongside those commemorating the Holocaust. Even before official unification, a member of the West German cabinet demanded that in the future the Buchenwald memorial should also commemorate the "German victims" of the Soviet occupation authorities (*Deutschland-Berichte* 26, no. 9 [September 1990]: 27). Further, the memorial in Bernburg commemorating the victims of the so-called euthanasia programs and the one in Brandenburg commemorating political prisoners were closed by the new German authorities on the day they were scheduled to open. These examples could be multiplied throughout Central and Eastern Europe. Growing popular resentment against Jews and Gypsies, hatred of outsiders, as well as the emergence of local fascist groups also bode ill for the future of these memorials.

In this volume we have used the term Federal Republic of Germany (FRG) for West Germany and the term German Democratic Republic (GDR) for East Germany. Only when discussing the Federal Republic of Germany after October 1990, when it included both former West and East Germany, have we used the term "unified Germany." In the same way, we have continued to use "West Berlin" and "East Berlin" prior to October 1990, and "unified Berlin" after that date. For the same reasons—that Germany was divided for most of the period covered by the literature—we have also retained the designation FRG and GDR in the bibliography and in the list of memorials.

ACKNOWLEDGMENTS

This book could not have been written without the help of many institutions and individuals. The authors would like to thank the professional staffs of the following museums, archives, and memorials for their courtesy and generosity: in *Austria*, Dr. Wolfgang Neugebauer, Director of the Documentation Archives of the Austrian Resistance; Hofrat Dr. Peter Fischer, Director, and Hofrat Dr. Kurt Hacker, Director Emeritus, of the Mauthausen Memorial; in the *Federal Republic of Germany*, Ms. Barbara Distel, Director of the Dachau Memorial; Dr. Ludwig Eiber, former Director of the Neuengamme Memorial; Angela Genger, former Director of the Old Synagogue Memorial, Essen, and current Director of the Düsseldorf Memorial; Annegret Ehman of the Wannsee Memorial Project, Berlin; Dr. Roland Klemig, founding Director of the Bildarchiv Preussischer Kulturbesitz, Berlin; Thomas Lutz, Head of the Memorials Department of Aktion Sühnezeichen, Berlin; Heinz Putzrath, Chairman of Ehemalige Verfolgte Sozialdemokraten, Bonn; Ulrike Puvogel, Bundeszentrale für politische Bildung, Bonn; and Dr. Paul Sauer, Director of the Municipal Archives, Stuttgart; in the former *German Democratic Republic*, Dr. Irmgard Seidel, Director, and Dr. Sonja Staar of the Buchenwald Memorial and Museum; Dr. Egon Litschke, former Director of the Ravensbrück Memorial and Museum; and Dr. Johannes Hirthammer, Director, and Dr. Barbara Kühle of the Sachsenhausen Memorial and Museum; in *England*, Ms. Beth Houghton of the Tate Gallery Library, London; in *Israel*, Dr. Yitzhak Mais, Director, and Irit Salmon-Livné, Senior Curator, of the Yad Vashem Museum, Jerusalem; and Miriam Novitch, Kibbutz Lohamei Haghetaot; in *Italy*, Mr. Teo Ducci of ANED, Milan; in the *Netherlands*, Wouter van der Sluis of the Anne Frank Foundation; and Winfried de Vries of the Westerbork Memorial; in *Poland*, Dr. Kazimierz Smolen, Director Emeritus, Dr. Teresa Swiebocka, Deputy Director, and Irena Szymanska, Curator, at the Auschwitz-Birkenau State Museum; Dr. Edward Dziadosz, Director, Maidanek State Museum; and Edmund Benter of the Stutthof Memorial Museum, Sztutowo;

and in the *United States*, Dr. David Altshuler, Director, Museum of Jewish Heritage, New York; Joan Rosenbaum, Director, Jewish Museum, New York; and Susan Morgenstein, Curator, and Dr. Brewster Chamberlin, Director of Archives, United States Holocaust Memorial Museum, Washington.

We would also like to give our particular thanks to many colleagues and friends who helped us on our field trips: in Berlin, Professor Wolfgang Scheffler and Dr. Gerd Schoenberner; in Frankfurt, Dieter Schieffelbein and Melanie Spitta; and in Vienna, Dr. Elisabeth Klamper and Dr. Herbert Steiner. Our special gratitude goes to Teo Ducci, Director of ANED, Milan, who provided us with photographs of the Museum of Deportation in Carpi and the San Sabba concentration camp in Trieste.

Sybil Milton would particularly like to thank Seymour Fromer, Director of the Judah L. Magnes Museum, and Ira Nowinski for their patient support and encouragement of this project; the artists Joszef Szajna, Warsaw, and Wiktor Tolkin, Gdansk, for sharing their memories and works; and Charlotte Hebebrand and Jacek Nowakowski of the United States Holocaust Memorial Museum for their assistance. She would also like to thank Professor Henry Friedlander, husband and colleague, for the advice and support that made this book possible, and for solving various computer problems. She is also indebted to Derek S. Symer for compiling the index.

Ira Nowinski would like to thank Seymour Fromer, Director of the Judah L. Magnes Museum; Dr. David Altshuler, Director, and Deborah Dawson Wolff, Assistant Director for Programs, of the Museum of Jewish Heritage; and George Segal for their insights and encouragement. Invaluable assistance in completing the photographic surveys was provided by Barbara Distel, Director of the Dachau Memorial; Dr. Teresa Swiebocka of the Auschwitz-Birkenau State Museum; and Dr. Yitzhak Mais, Director of the Yad Vashem Museum. Funding for the photographic field trips was provided by the Bernard Osher Foundation, the Jacques and Esther Reutlinger Foundation, the Judah L. Magnes Museum, the Museum of Jewish Heritage, and Wayne State University Press.

Funding for the production of this volume was provided by Natan Celnik, M.D., who together with his wife Ursula was active in the resistance during the Nazi years. We are indebted to Stanley R. Robbin, M.D., founder and chairman of the Holocaust Memorial Committee of Long Island, for assisting us with this grant.

The authors would also like to thank the many correspondents and libraries who supplied them with relevant press clippings and information. We also thank Arthur Evans, Director of Wayne State University Press, for his commitment, perseverance, and belief in our project.

ONE

THE MEMORALIZATION OF THE HOLOCAUST

The Chronological and Political Contexts

Many Americans are familiar with the Holocaust as a European tourist attraction from visiting the Anne Frank house in Amsterdam, the Dachau concentration camp memorial in suburban Munich, or the archeological remains of Auschwitz-Birkenau near Cracow. Holocaust memorials, monuments, museums, and centers have in fact proliferated all over the world in recent decades. In continental Europe they have evolved rapidly from special places with limited audiences to major centers of public education. Most visitors, however, have seldom considered the complex interaction of competing interests reflected in the design of memorials and public sculpture installed at these sites as a reflection of national culture, political ideology, and artistic merit. Moreover, there is virtually no serious analytical literature in any academic discipline that discusses the comparative multinational history and evolution of these monuments and memorials since 1945.

The word *monument* derives from the Latin verb *monere*, meaning simultaneously to remind and to warn. This linkage of liturgical and didactic elements in most memorials is reflected in an ideologically diversified fashion in various changing national historical memories that are concerned as much with the past as with the present and the future.

Although European memorials, de facto secular shrines, reflect different political orientations and artistic styles, they share one common feature regardless of their location. The sheer environmental power of the site relegates most postwar artistic monuments to subsidiary roles. In fact, the preservation of these sites as such, even without additional monuments or public

sculpture, is an act of memorialization. Since there are thousands of former concentration camps dotting the European countryside, the very selection of former camp locations for preservation is often filled with conflict. Thus, the French have built a memorial and museum at Natzweiler-Struthof because it was the only concentration camp built by the Germans on French soil, whereas they have ignored the internment and transit camps built and run by the French at Gurs, Les Milles, and elsewhere since these sites raise uncomfortable questions about French xenophobia and collaboration.

In contrast, at locations where no substantial ruins remain, such as the Warsaw ghetto or the Treblinka killing center, the role of the sculptor and landscape architect is essential to the symbolic representation of mass murder. Thus, the florid and histrionic Warsaw ghetto monument, located in a square surrounded by modern high-rise apartment buildings, differs radically in style from the powerful forest of 17,000 sharp stones—many inscribed with the name of a community destroyed during the Holocaust—designed as a symbolic cemetery at Treblinka in northeastern Poland. Despite their common purpose and governmental patronage, these two Polish memorials reflect qualitatively different aesthetic choices and iconographies. The Warsaw ghetto memorial, built in the late 1940s in situ at the ruins of the former Jewish quarter, merged neoclassical and Soviet realistic styles (photos 105–7), whereas the Treblinka monument was con-

structed in the mid-1960s, when chronological distance from the events probably allowed more latitude for innovative architectural and landscape design (photos 57–62). It was also the response of a new generation translated into more abstract architectonic solutions.

Since Holocaust monuments and memorials are not built in a political or geographical vacuum, they also invariably reflect selected aspects of national style, religious tradition, public expectation, and artistic skill. The absence of commonly accepted definitions of the Holocaust and the lack of consensus about appropriate rituals and symbols for its victims have in turn provided additional ground for volatile confrontations. Thus, in Israel the Holocaust is seen as part of a continuum of antisemitic persecution and provides moral justification for the creation of the state. In contrast, in the United States antisemitism is placed in a broader historical context that also includes racism, thus also focusing on the murder of other racial victims in the Holocaust, especially the Romani and Sinti (Gypsies). Further, in Germany the Holocaust is perceived as part of the continuity of German history; in Poland and the Soviet Union as part of the barbarity of World War II; and in Japan as a link to the contemporaneous nuclear apocalypse at Hiroshima. Despite certain common elements, these nations and sites do not reflect all victims of the Holocaust on their soils nor do their public monuments show sensitivity to all aspects of the subject.

In the immediate postwar period neither conventional nor innovative public sculpture seemed adequate

to the awesome artistic and social challenges involved in commemorating the victims of the Holocaust. Most European nations had not developed styles or conventions to mourn the mass dead of World War I. Furthermore, traditional funerary art in most war cemeteries used predominantly Christian iconography commemorating heroism and patriotism usually associated with military casualties. These symbols were inappropriate and even offensive to the victims of Nazi mass murder —Jews, Gypsies, the handicapped, and others—who frequently had neither specific grave sites nor known dates of death. The traditional portrayal of death as an individual or familial event did not fit the Holocaust, which required new styles of memorialization. Jean Améry felt that the experiences of surviving the concentration camps "led to the collapse of the aesthetic idea of death."[1] Nevertheless, sculptors, architects, and landscape designers had to find individual and collective symbols that would facilitate an understanding of the past in order to represent it for the present and the future. Memorials for the Holocaust thus had to be designed as special places separated from the flow of everyday life while simultaneously communicating emotion and instruction.

It is well known that many East European memorials do not mention Jews explicitly, thereby reflecting the ideological views of Communist regimes, which emphasize political resistance; similar approaches in non-Communist countries in the West are not common knowledge. These national memorials are often self-serving, attributing a national identity to the victims not granted to them in their lifetimes. Thus, a posthumous acknowledgment transforms Polish Jews into Poles and French Jews into French (photo 91).

This obfuscation of Jewish victims, who frequently are not separated from other categories of the persecuted, which are organized by nationality, stands in sharp contrast to American and Israeli memorials, where the reverse exclusion applies. Because the major impetus and financing for memorials in those two countries has come from Jewish survivors, it is uncommon to find explicit acknowledgment of Gypsies or the handicapped as victims.

After 40 years, we should at least be able to articulate our expectations of what memorials might look like at European sites where the Holocaust had once occurred and at distant localities that were not directly involved. Ought a monument built in Australia, Israel, Japan, South Africa, or the United States look different from those built in Europe? Are there appropriate iconographic traditions applicable to such monuments and memorials? There are no definitive answers to these and similar questions, although the patterns of the existing memorials provide several possible options for memorialization.

Let us consider the chronological development of continental European memorials since 1945. It is hardly surprising that in the first phase, the late 1940s and the 1950s, general conditions as well as the enormity of recent events did not permit elaborate com-

memorations or exhibitions attended by a broad public. Initially, many former concentration camps housed survivors and displaced persons (DPs). Nevertheless, during the first postwar decades nascent concentration camp memorials were established at selected concentration camps, often using only a portion of the camp terrain; at the same time survivors built the first museums and public monuments in Israel.

The first European memorials fell into one of two broad organizational patterns. In Eastern Europe the memorials were usually seen as forms of symbolic politics under the direction and financial patronage of the central government. In Western Europe the memorials were usually left to private and local initiative and thus developed in an ad hoc and piecemeal fashion. The ambivalencies and inadequacies of this initial phase in the institutionalization of the Holocaust were irreversible and provided the context for all subsequent developments. Thus, at Bergen-Belsen, where all vestiges of the historic camp had been burned by the British to prevent epidemics, only the Jewish memorial erected by survivors in April 1946 provided tenuous links with the past, since the impressively landscaped terrain of the former mass graves resembled a normal field or meadow (photo 76). Similarly, when the city of Berlin decided to remove all surface vestiges of the former Gestapo headquarters on Prinz Albrechtstrasse in the mid-1950s, it created the physical constraints of an empty rubble-filled lot that still hampers the design of a memorial in the 1990s.[2]

The situation of the Neuengamme concentration camp memorial in suburban Hamburg is probably typical. It was not protected as a landmark or historic site initially and thus the terrain was not preserved intact. In 1948 the city of Hamburg built a maximum security prison adjacent to the first memorial, and in the 1970s it constructed a juvenile correction facility adjacent to the prison. The two jails incorporated the former guard towers, barracks, *Appellplatz* (roll call square), and SS garage inside their walls. Other parcels of Neuengamme's real estate were leased for commercial purposes. Thus, the *Klinkerwerke*, a brick factory where prisoners had once labored, was leased to a builder of luxury yachts (photo 12).[3]

Elsewhere, in the Federal Republic of Germany, disquieting reminders of the past have been reutilized as prisons, as police or army barracks, and sometimes as municipal or commercial offices. The site of the former Esterwegen concentration camp is currently used for military maneuvers, and former barracks still serve as storage facilities for the West German army. The former SS barracks of the satellite concentration camp at Herbrueck houses a municipal finance office. The former canteen and laundry at the Flossenbürg concentration camp are today used by a local woodcutting concern; the site of the Kemna concentration camp in Wuppertal is now a factory. These pragmatic decisions not to remember the past in its most local and intimate associations make the Holocaust seem remote, inaccessible, and elusive in many localities.

Similar considerations and patterns also applied in the East. Thus, in the German Democratic Republic, at the Buchenwald concentration camp, the Soviet military occupied the Gustloff factory area where prisoners once labored, and at the Sachsenhausen camp the East German police utilized the adjacent former headquarters of the camp inspectorate; across town a brewery reoccupied the site of the first "wild" camp at Oranienburg.

To be sure, neither postwar German state contained the sites of the former killing centers within their boundaries, although both Germanies had euthanasia institutions, concentration camps, and slave labor facilities. Especially in West Germany, places with traumatic associations acquired the patina of normality. But all this applied not only to the Germanies but also to East European nations occupied by Germany. Thus in Poland, where most buildings of the former Lodz ghetto have survived, no commemorative or historical markers indicate for the visitor where the ghetto had once been.

During the immediate postwar period monuments were also erected in many European cemeteries and other public settings. Since traditional depictions of death as an individual or familial event often seemed inapplicable for mass killings, the rituals of burial and mourning were transformed by two formulas that could be translated into public sculpture. In the first death was depicted as the ordeal of a community. This was exemplified by the *Memorial of the Unknown Jewish Martyr* in Paris (1956, photo 90), the wall made from shards of Jewish tombstones at the Remah synagogue cemetery in Cracow (photo 135), and the memorials at the destroyed villages of Lidice and Oradour. The second formula was to depict death as part of patriotic national resistance, exemplified by the *Mausoleum to Jewish Martyrdom* in the Milan municipal cemetery (1947).

Two international sculpture competitions held during the 1950s also had ramifications for the design and iconography of monuments and public sculpture at Holocaust-related sites. In 1953 the Tate Gallery in conjunction with the Institute of Contemporary Art in London sponsored an international competition on the theme of "The Unknown Political Prisoner," and in 1958 the Auschwitz state memorial authority sponsored an international design competition for a memorial to be erected at Birkenau. Both competitions ended without the winning designs being translated into reality. The only maquette reformulated as an actual Holocaust monument was Mirko Basaldella's second-prize entry in the Tate competition, which was incorporated in the Italian memorial erected at Mauthausen (photos 78–80).

A number of coincidental factors contributed to the resurgence of interest in the Holocaust in the 1960s and 1970s. The trial of Adolf Eichmann in 1961 was widely seen on television in both Europe and the United States, and this trial preceded extensive media coverage of the Auschwitz trial in Frankfurt (1964–65). Simultaneously, Hollywood had also discovered the Holocaust and presented a sanitized version of reality in such popular dramatic films as *The Diary of Anne Frank* (1959)

and *Judgment at Nuremberg* (1961). Further, a new socially critical theater had developed in the Federal Republic of Germany during the 1960s, and plays by Rolf Hochhuth and Peter Weiss reached a wide general audience. These trends were mirrored in West German school curricula, where Hanna Vogt's text *The Burden of German Guilt*, published in 1961, sold nearly one-half million copies. Furthermore, a growing body of memoirs and histories also became available. These trends in theater, film, and publishing were reinforced by scholarly conferences and museum exhibitions about the European Jews and the Holocaust.

These convergent trends were also apparent in several new concentration camp memorials that opened during these two decades. The three major memorials of the German Democratic Republic opened at the beginning of the 1960s: Buchenwald in 1958, Ravensbrück in 1959, and Sachsenhausen in 1961. Similar facilities with ancillary documentary museums also opened elsewhere in Europe: in France at Natzweiler-Struthof in 1960, in the Federal Republic of Germany at Dachau and Neuengamme in 1965, in Italy at San Sabba in Trieste in 1965, and in Austria at Mauthausen in 1970.

Despite continued local hostility to these tangible reminders of an uncomfortable past, an informal coalition of survivors and the younger generation favored confronting the traumas of the Nazi era. The 1960s was the decade of the student protest movement in Europe, promoting open discussion and direct political action. *Aktion Sühnezeichen* (Operation Reconciliation) was founded in Berlin as a volunteer organization that placed young people as volunteer labor in concentration camp memorials, where they assisted in maintaining buildings and grounds, following the Protestant tradition of redemption through work and a belief in the efficacy of "involvement." This type of work also qualified as alternate military service in the Federal Republic of Germany. In the 1980s, *Aktion Sühnezeichen* created seminars for German memorials that later expanded into international symposia.

In the 1960s and 1970s monuments and public sculptures were also constructed in Israel, South Africa, and the United States, where substantial numbers of refugees and survivors had emigrated. Several of these sculptures provide examples of civic fervor rather than artistic judgment. A typical example was the 18 foot high bronze sculpture installed in April 1964 in Philadelphia at 16th Street and Benjamin Franklin Parkway near City Hall (photo 110). Designed by Nathan Rapoport, who had previously made the Warsaw Ghetto Monument, its motifs included an unconsumed burning bush, Jewish fighters, a dying mother, a child with a Torah scroll, and a blazing menorah. The downtown center-city site, visible daily to thousands of motorists and pedestrians, had little demonstrable resonance, in part a response to the florid and heavy-handed design and in part a reflection of its awkward location on an island on a heavily traveled urban street. It was perhaps still too early in the mid-1960s for the average American to perceive the Holocaust as more than an uncomfortable foreign experience.

During the 1960s and 1970s younger American

and European artists as well as survivor-artists incorporated aspects of the Holocaust in their work, thus popularizing and disseminating the theme and giving the concept more flexible meaning than its strictly historical definition. In the United States the sculptor Louise Nevelson completed a painted, wooden wall sculpture, entitled *Homage to Six Million* (1964), which was donated and installed at the Brown University Museum in Providence, Rhode Island. Audrey Flack, an American Jewish painter without direct personal experience of the Holocaust, completed a powerful oil painting about the Holocaust entitled *World War II: April 1945* (1976–77), which incorporated one section of Margaret Bourke-White's well-known photograph of Buchenwald survivors behind a barbed wire fence. Flack's work was initially displayed at the Meisel Gallery in New York. Similarly, survivor-artists like Alice Lok Cahana in the United States and Jozef Szajna in Poland completed environmental sculptures combining concentration camp artifacts with other media.[4] These paintings and sculptures are part of a tradition of socially critical modern art that enhances our understanding of public sculptures and monuments installed at European and other memorial sites.

The accelerating tempo of popular interest in the Holocaust at the close of the 1970s was also reflected in the growth of alternative city tours throughout the Federal Republic of Germany, where residents and tourists viewed sites of persecution and resistance. These tours, accompanied by appropriate literature, were usually sponsored by survivors (especially the Association of Former Victims of Nazi Persecution [VVN]), university students, and left-wing political groups (Social Democrats, Greens, and trade unionists). Historical markers, commemorative plaques, and inscriptions were placed at the locations of synagogues that had been destroyed during the November 1938 pogrom and also at the sites (including cemeteries) of many former local concentration and labor camps. International student work camps dedicated to the archeology and restoration of historic structures at the sites of German concentration camps provided a new generation with a sense of authenticity as well as catharsis. Thus, German and foreign students excavated and restored the Fort Obere Kuhberg in Ulm, an early camp that had existed from November 1933 to July 1935. Similarly, students placed historic markers throughout the memorial at Neuengamme. Concentration camp archeology became a social phenomenon reflecting a new level of historical responsibility and awareness among a minority of younger Germans.

These convergent developments help in part to explain the peculiar international resonance of the TV film *Holocaust*, aired in both the United States and Europe in 1979–80, the year that marks the beginning of the third and current phase in the postwar memorialization of the Holocaust. This period has been characterized by the development of local Holocaust centers, museums, and memorials on an international scale.

In 1981 the city of Hamburg responded to local pressure and constructed a small museum at Neuengamme and belatedly and grudgingly reclassified the remaining site as a landmark in 1983. New local memo-

rials were opened at Wewelsburg, Breitenau, and the Old Synagogue in Essen. Despite these promising local developments, the memorial at Dachau remained understaffed and underfinanced, even though it held mass appeal to more than one million annual visitors. Similarly, the inadequate and unstaffed mini-exhibit at Bergen-Belsen was left unimproved.

In the Netherlands a memorial museum was belatedly opened for part of the year at Westerbork in 1983, and a public sculpture to homosexual victims was installed in downtown Amsterdam in 1986. Furthermore, Austria in 1985 erected two small memorials at the sites of former Gypsy labor and transit camps: at Lackenbach in Burgenland near the Hungarian border and at Maxglan near Salzburg. In Poland and Czechoslovakia many of the existing sites of "martyrdom" were repaired and restored, icons in the perpetually shifting moods of remembrance and rejection. In France, however, most traumatic sites of the past were, in the words of Jean Améry, "overgrown with grass."[5] Despite local support, no museums or memorials were established at Gurs near Pau or at Les Milles in Aix-en-Provence in southern France, although a small memorial was installed at Drancy outside Paris in 1988.[6]

The overall pattern of memorials and museums that developed in the United States reflected different circumstances and conditions than those in continental Europe. Since the events of the Holocaust had not occurred on American soil, there were obviously no specific localities connected with the remains of either concentration camps or ghettos. Moreover, neither the victims nor the perpetrators had been American citizens during the years between 1933 and 1945. There were, nevertheless, four direct connections linking the United States with the events of the Holocaust: (1) The United States as a country was offering potential asylum for refugees from Nazi Germany and Europe; (2) The Americans were liberators, however accidental, of the concentration camps; (3) The United States served as the new home of many survivors and their children and also provided haven for some of the perpetrators; and (4) The United States played a role in developing the Nuremberg and subsequent postwar trials. These concerns were reflected in the humanitarian consensus of American historiography, which saw the United States as the land of immigration and recognized postwar justice as a belated response to Nazi barbarism and criminality.

Conditions in the immediate postwar period were not propitious in the United States for a broader reception of the Holocaust. Overshadowed by postwar industrial development, European reconstruction, the cold war, and the realities of nuclear competition, at first most Americans saw the Holocaust as an uncomfortable foreign experience whose primary impact was felt abroad. Furthermore, those survivors and DPs who came to the United States were occupied with the difficulties of building new lives, and the timing was not auspicious for reflection about the war years.

The resurgence of American interest in the Holocaust reflected the changing interests of a new postwar generation. The civil rights and desegregation movement of the 1950s and 1960s, growing opposition to the Viet-

nam war, and the student rebellion of 1968 destroyed an earlier uncritical complacency and historical consensus. Moreover, issues of ethical behavior raised by Watergate created a climate of opinion favorable to questioning governmental policies, thereby increasing possible reception of such events as the Holocaust. Furthermore, the rediscovery of genealogy and ethnicity during the 1970s contributed to the growing needs of a younger generation of Jews, who demanded information about the Holocaust. These factors contributed to the growth of publications, conferences, exhibitions, and institutions in the United States concerned with the Holocaust.

Since the beginning of the 1980s a network of nearly 100 local Holocaust centers exists in the United States. Most centers operate under Jewish auspices and serve their communities as basic educational resources; collectively, they created a national Association of Holocaust Organizations in 1987. Five institutions have a national constituency. These include: the Anti-Defamation League of B'nai B'rith in New York; the Museum of Tolerance under construction by the Simon Wiesenthal Center in Los Angeles; the Museum of Jewish Heritage planned in New York; the Facing History and Ourselves Foundation for curriculum development in Brookline, Massachusetts; and the United States Holocaust Memorial Museum under construction in Washington, D.C.

Two of these centers focus on education against racism, prejudice, and bigotry. The Anti-Defamation League is a Jewish self-defense organization that distributes publications, films, and other media about the Hol-

ocaust. Facing History is the most widely used Holocaust curriculum in the United States and focuses on critical thought about the role of the individual in society; its program has included pilot teacher training programs about the Holocaust, the Armenian genocide, and the Vietnam war. The Simon Wiesenthal Center is concerned with combating antisemitism and neo-Nazism. Its Museum of Tolerance will focus on the Holocaust in the context of twentieth century genocides and the struggle for human rights. The Center also published seven volumes of the *Simon Wiesenthal Center Annual*, an independent interdisciplinary journal about the Holocaust in the context of European Jewish history and Jewish immigration to the United States. The United States Holocaust Memorial Museum is a national museum about the Holocaust under construction on the national Mall in Washington, D.C. It will depict the fate of all victims, American involvement, and also postwar implications. These five national American institutions augmented by local centers offer broad public exposure to understanding the complex events of the Holocaust.

Several hundred public sculptures about the Holocaust have been installed in European and American cities since the 1970s. Most of these works at best have evoked sporadic public resonance, in part because of their unobtrusiveness, inadequate design, or stereotyped iconography. For example, the abstract geometric cubes of the Stuttgart monument to the victims of Nazi persecution (1970) serve local residents as a parking place for bicycles, since the explicit commemorative intent of these obscure, abstract embellishments to the

plaza in front of the old ducal palace is unclear to all but the initiated. Similarly, few pedestrians noticed the unobtrusive shingled sign in yellow and black commemorating the camps at the Wittenberg Square subway station in downtown West Berlin (photo 95), or the small inscribed square block dedicated to the Baum resistance group at the former Lustgarten on Unter den Linden in East Berlin. This is also true of the family group depicted in the Gypsy monument erected at Museumplein in Amsterdam (1978; photo 88). In American cities such as Youngstown (Ohio), Seattle, West Hartford (Connecticut), and Long Beach (New York), a variety of relatively standardized visual symbols have been used to depict the Holocaust: the star of David, prisoner triangles, symbolic urns, the Hebrew letter *chai* symbolizing life, the *shofar* (ram's horn), and stylized barbed wire fences. All of these symbols are certainly appropriate, albeit inadequate, as commemorative invocations in public sculpture.

A few works of sculpture have become embroiled in public debate. Such controversies reflect public taste and aesthetics as well as the political fears and aspirations and the quest for validation and legitimacy by various survivor communities. Thus, the installation of the *Homomonument* in Amsterdam (1987) involved the confrontation of ideological and cultural prejudices about the recognition of homosexuals and lesbians as Holocaust victims as well as confrontations about the design and the central downtown site at Westermarkt (photo 89). Similarly, the George Segal walk-in sculpture

The Holocaust (1984), cast from live figures and installed at Lincoln Park, overlooking the Golden Gate Bridge in San Francisco, has been embroiled in aesthetic and political debate from the beginning (photos 113–14). Nevertheless, the symbolical realism of Segal's style will be comprehensible to future generations, although the outdoor site is far removed from the historic European settings of mass murder during World War II.

Problems of context and content have also been important in the design of Holocaust memorials in Canada, Australia, and Japan. In Japan, the Auschwitz Memorial Pavilion for Peace that was to be constructed at Kurose in Hiroshima province was to link the symbols of atomic genocide and Auschwitz to other twentieth century genocides (in Armenia, Cambodia, and Biafra).[7] However, it was not to include references to Japanese militarism from 1931 to 1945, nor was it to refer explicitly to the Nanjing massacre or Japanese medical experimentation in Manchuria. These latter themes are dealt with explicitly in the Chinese Holocaust Museum in Beijing.

The common denominator of all Holocaust memorials—irrespective of location—is a universal willingness to commemorate suffering experienced rather than suffering caused. This generalization seemed especially appropriate for the planned central memorial in Bonn, which was introduced by Chancellor Helmut Kohl as "dedicated to the German victims of war and repressive rule." The confusion of perpetrator with victims under a common tombstone revealed the same questionable

sense of history that marked the 1985 controversy about the SS graves in the Bitburg cemetery visited by President Reagan and Chancellor Kohl.[8]

As chronological and geographical distance from the Holocaust increases, the problems of historical memory are also magnified, despite growing public familiarity with literal images of it distributed through the media of photography, film, and television. Initially, archeological ruins or remnants of former concentration camps formed the core of many memorials, sometimes with an adjacent documentation center or museum. During the three decades from 1950 to 1980, a modern sculpture park was often added to the site, as in the case of Mauthausen. Sometimes nations uncomfortable with their own past chose not to erect any memorials or chose to politicize such memorials in self-serving, inappropriate, or offensive ways. But where no historical ruins remained—for example, at Treblinka and Sobibor in Poland—public monuments and landscape architecture had to carry the burden of commemoration and historical explanation to a broad audience. This is especially true of memorials located outside continental Europe, where the audience's less immediate knowledge of the subject placed an even greater emphasis on the role of the artist. Classic public sculpture has been installed at several sites during the past 45 years, although evaluation of its aesthetic and didactic effectiveness has usually been measured by subjective criteria, that is, by personal taste. It is clear that there are at least several appropriate iconographies for the Holocaust; the most important considerations are open-mindedness and honesty in dealing with the intellectual and design challenges of building Holocaust monuments and memorials in the late twentieth century.

The new aesthetic trend of photographing Holocaust memorials poses additional problems. Individual settings photographed today without the full historical context have a haunting sense of beauty that seem inappropriate to their tragic settings and genocidal history. Nevertheless, the contrast between bucolic landscapes and the brutal camps was already inherent in the actual landscapes and physical layouts of virtually every concentration camp. Even today, nearly 45 years after the liberation of these camps, we are still confronted by the issue of defining appropriate memorial art for public spaces designed in fitting memory of all victims of the cataclysmic tragedy now known as the Holocaust.

NOTES

1. Jean Améry, *At the Mind's Limits: Contemplations by a Survivor on Auschwitz and Its Realities* (Bloomington: Indiana University Press, 1980), 21–40, about Améry's visit to Fort Breendonck where he had once been imprisoned.
2. See Sabine Weissler, ed., *Der umschwiegene Ort* (Berlin: Neue Gesellschaft für bildende Kunst, 1987).
3. See Fritz Bringmann and Hartmut Roder, *Neuengamme—Verdrängt, Vergessen, Bewältigt?: Die zweite Geschichte des Konzentrationslagers Neuengamme, 1945–1985* (Hamburg: VSA, 1987).
4. See Barbara Gilbert, ed., *From Ashes to the Rainbow: A Tribute to Raoul Wallenberg, Works by Alice Lok Cahana* (Los Angeles: Hebrew Union College-Skirball Museum, 1986); and Jozef Szajna, "Ich warne die Zeit," *Zeichen: Mitteilungen der Aktion Sühnezeichen* 16, no. 1 (March 1988): 22–24.
5. Jean Améry, *Örtlichkeiten* (Stuttgart: Klett-Cotta, 1980), 51–54.

6. The French government plans to restore the brick factory and murals of Les Milles outside Aix-en-Provence and tentative discussions for a memorial museum at Rivesaltes for all French internment and transit camps were reported in the French press during 1990. Nevertheless, the absence of any French social and political consensus for preserving these transit camp sites will probably prevent the implementation of these plans.

7. As far as could be ascertained at this time, construction in Kurose has been halted because of inadequate funds. Nevertheless, my observations concerning the intended program still seem relevant.

8. See Ilya Levkov, ed., *Bitburg and Beyond: Encounters in American, German, and Jewish History* (New York: Shapolsky, 1987); and Henry Friedlander, "The Bitburg Affair," *Together* 2, no. 1 (Jan. 1987): 1, 16–17.

TWO

CONCENTRATION CAMP ARCHEOLOGY

The Landscapes of Memory

The ruins of Nazi concentration camps number in the thousands. These disquieting archeological remnants usually include barbed wire, guard towers, empty stone or wood barracks, crematoria ruins, stone quarries, underground jail cells, rusty railroad tracks, broken cemetery headstones, and mass graves. Despite the ravages of time, neglect, deliberate destruction, and vandalism during the 45 years that have elapsed since the end of World War II, these sites often still serve as fragile and tenuous reminders of some aspects of the Holocaust.

As events themselves fade into memory and myth, the terrain and landscape have also inevitably changed: roads have been built, surrounding land has been alienated for commercial use, and historic buildings have been destroyed. It is frequently impossible for visitors to isolate the sites of former concentration camps from nearby modern obtrusions.

Nevertheless, the environmental power of the surviving structures at Mauthausen and Auschwitz-Birkenau contrast dramatically with the empty, bucolic landscapes at Bergen-Belsen, Gurs, and the killing centers at Belzec and Chelmno. Those pastoral scenes make the Nazi past remote, inaccessible, and elusive. The photographs in this section reveal the contemporary archeological remnants of the Holocaust. These relics of the Nazi era provide the historical framework and environmental context for disparate contemporary Holocaust memorials.

19

1. Dachau: Path to the crematorium facing south with guard tower in the distance, reconstructed in 1965.

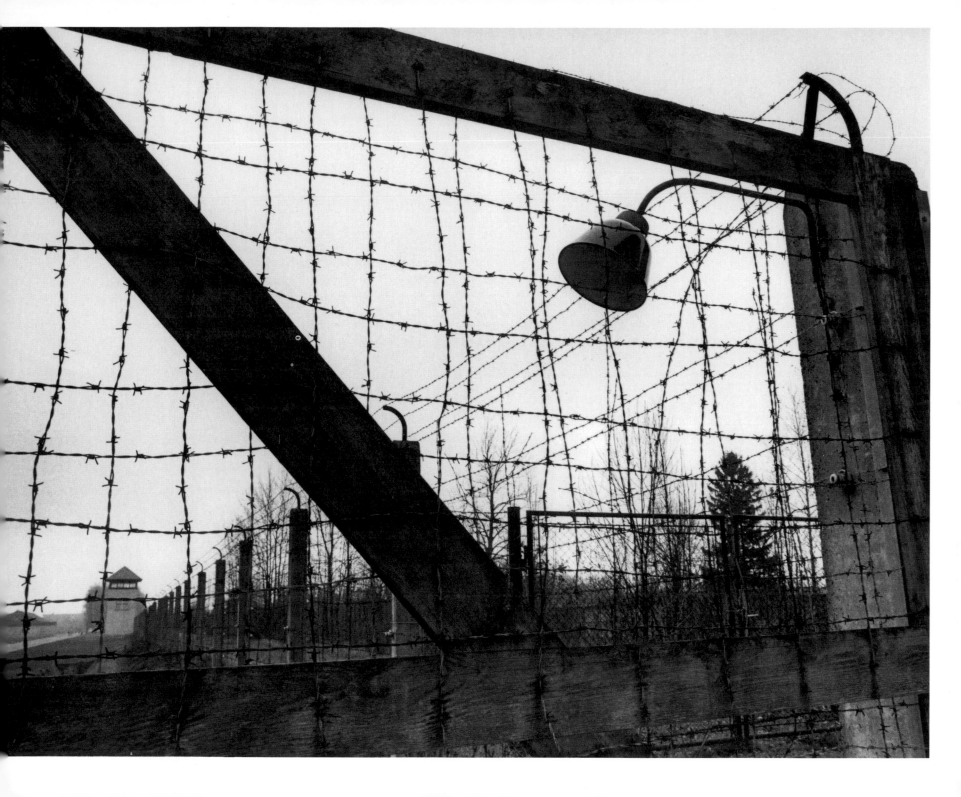

2. Dachau: Entrance (*Jourhaus*) to the camp, with the slogan "work makes one free" (*Arbeit macht frei*). SS guard rooms were located on both sides of the entrance. In the background is the *Appellplatz*, where prisoner roll calls were held twice daily.

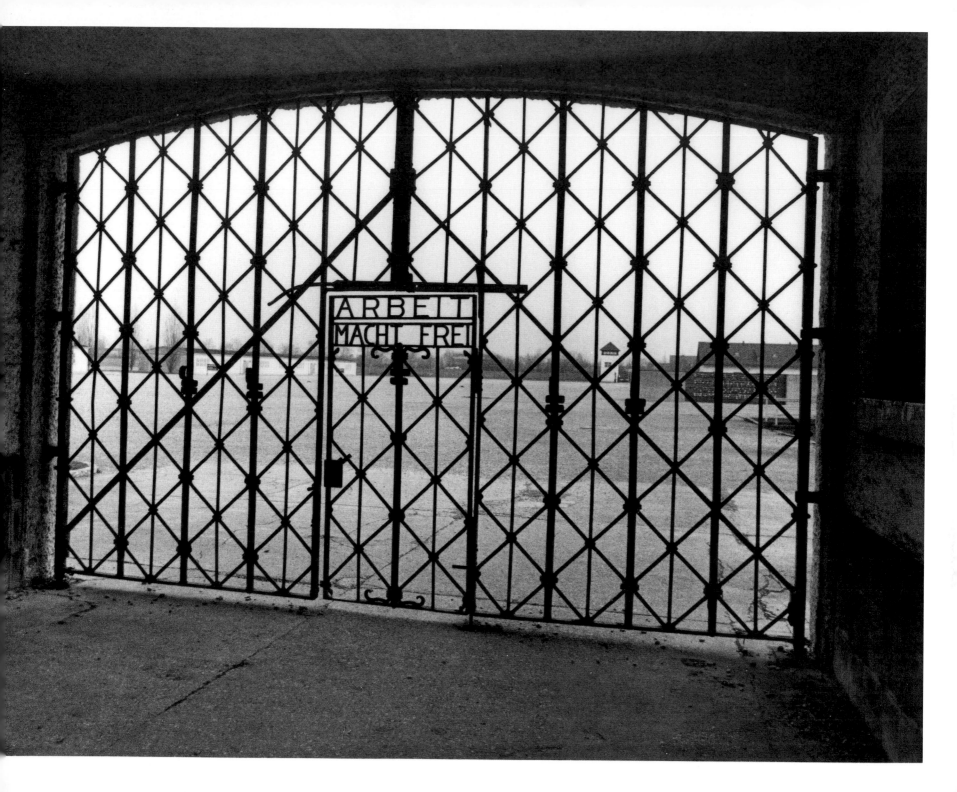

3. Dachau: View of the camp prison (*Lagerarrest* or *Bunker*), facing west from the entrance.

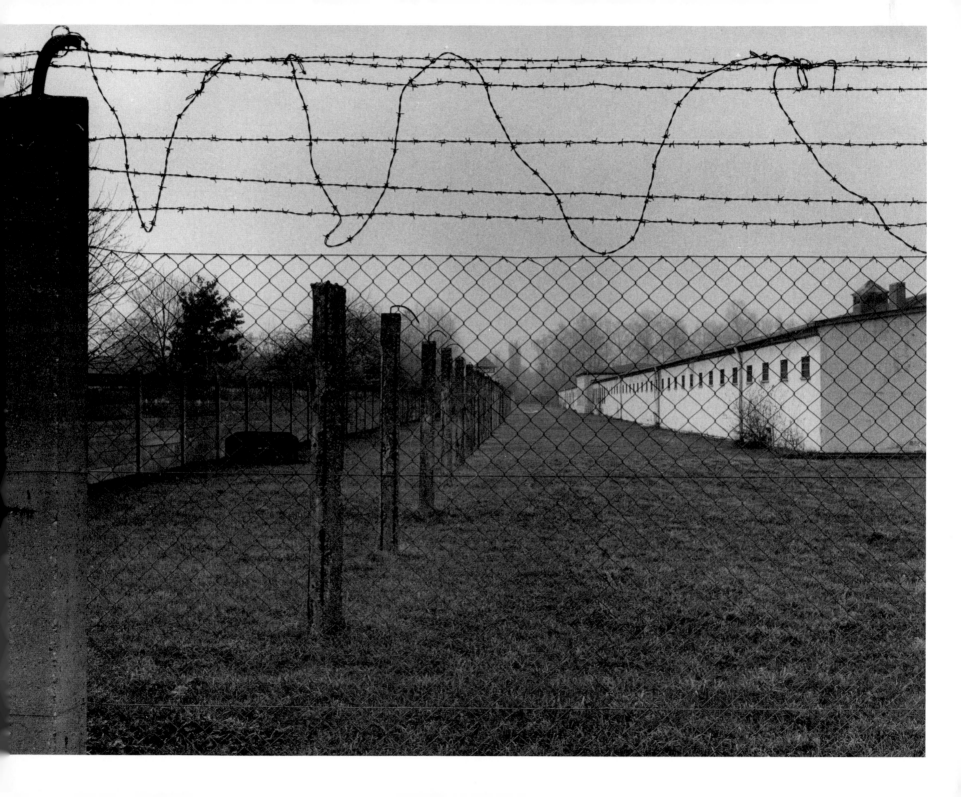

4. Dachau: The first crematorium, built by the prisoners in 1940.

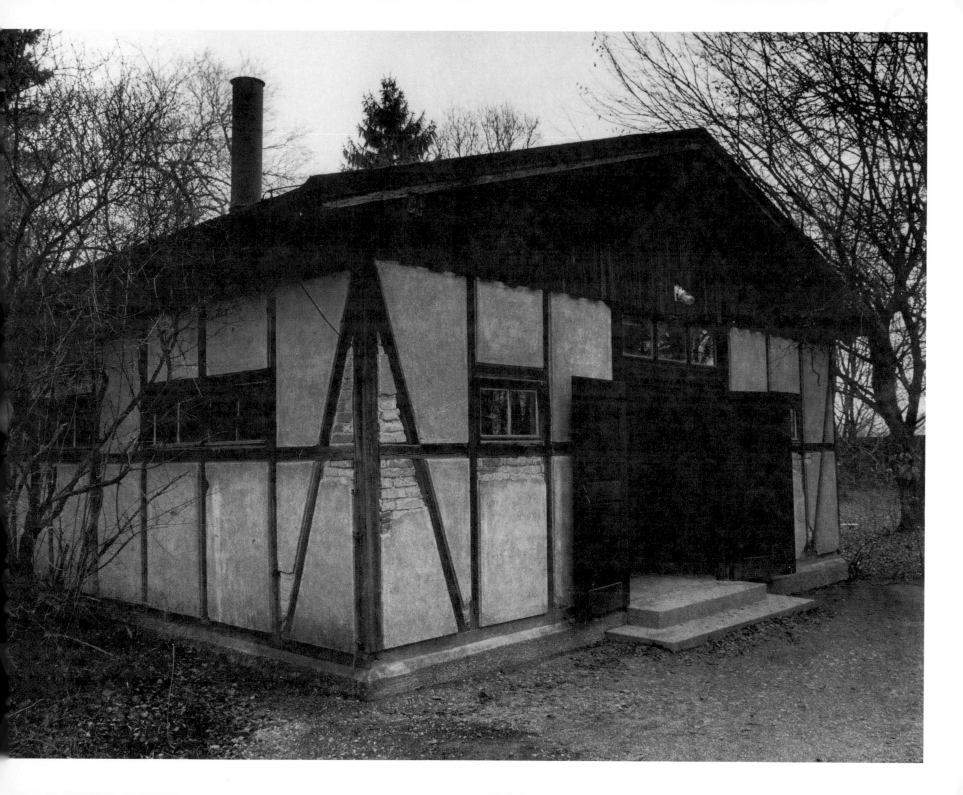

5. Dachau: Exterior of the enlarged crematorium building, known as Barrack X, built in 1942. It contained four ovens for handling the increasing number of prisoner corpses and a gas chamber that was never used.

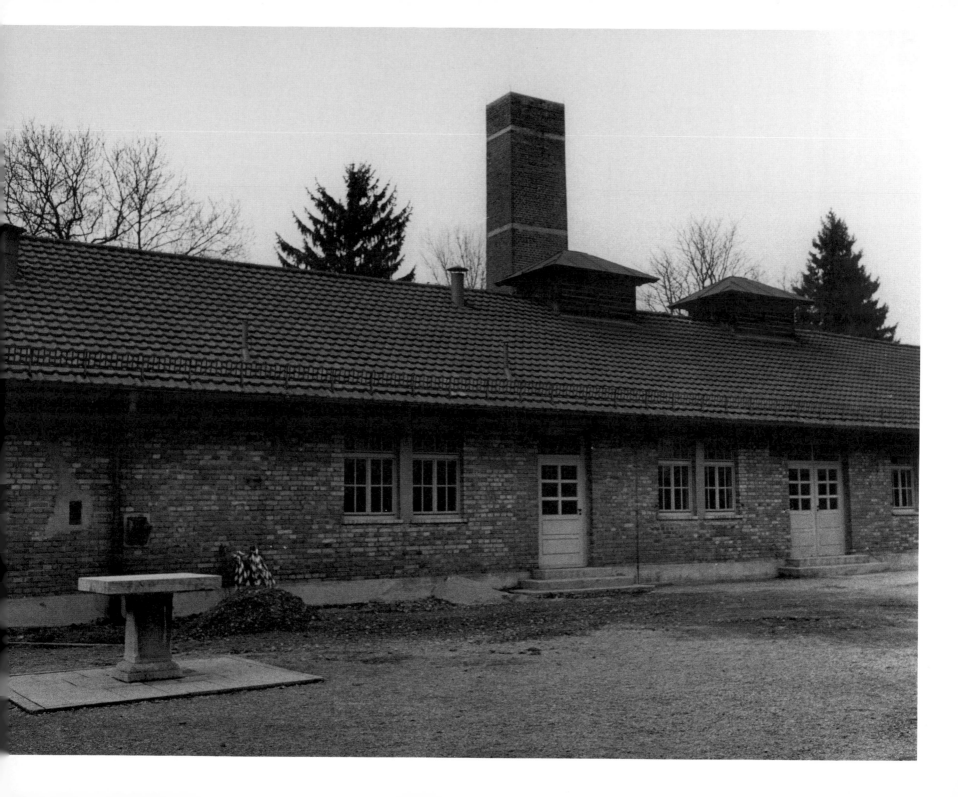

6. Dachau: Entrance to the gas chamber, disguised as a shower (*Brausebad*). It was located in Barrack X, the large crematorium. Built in 1942, this gas chamber was never used since Dachau prisoners selected for "gassing" were transported to the so-called euthanasia institution at Hartheim near Linz.

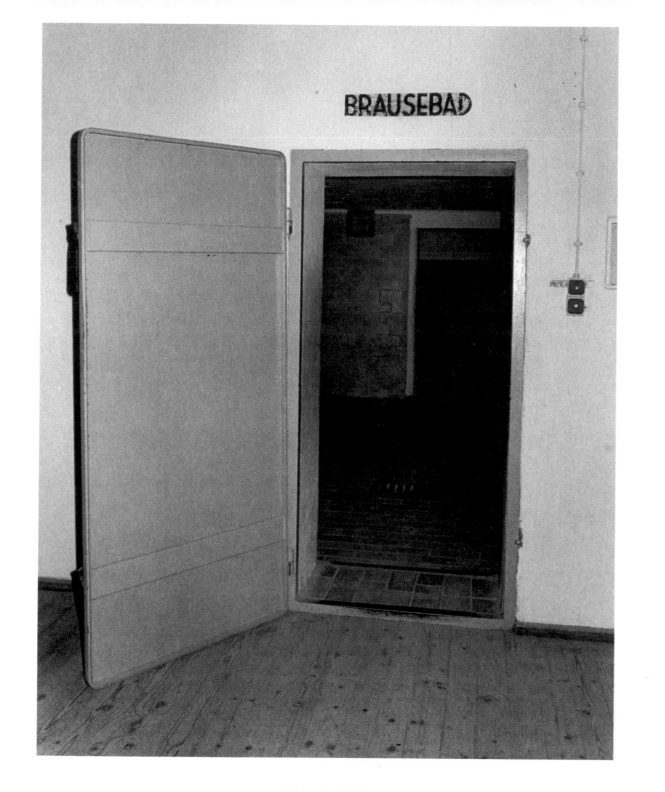

7. Dachau: Interior of the gas chamber in the large crematorium.

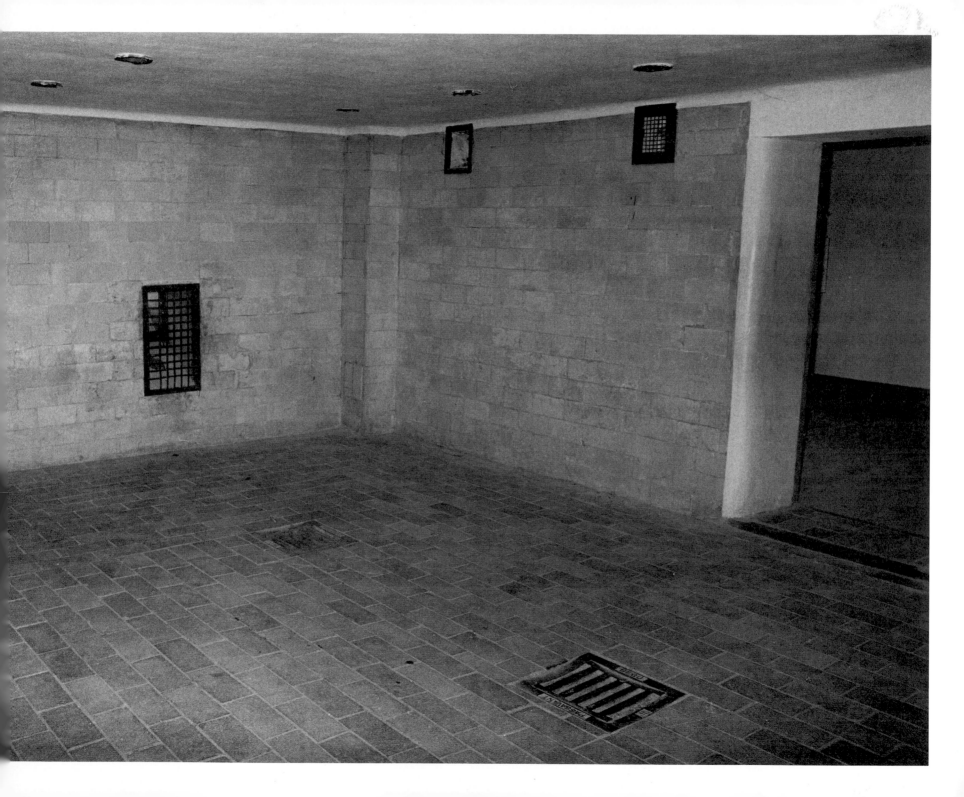

8. Dachau: Doors of disinfection rooms in the large crematorium.

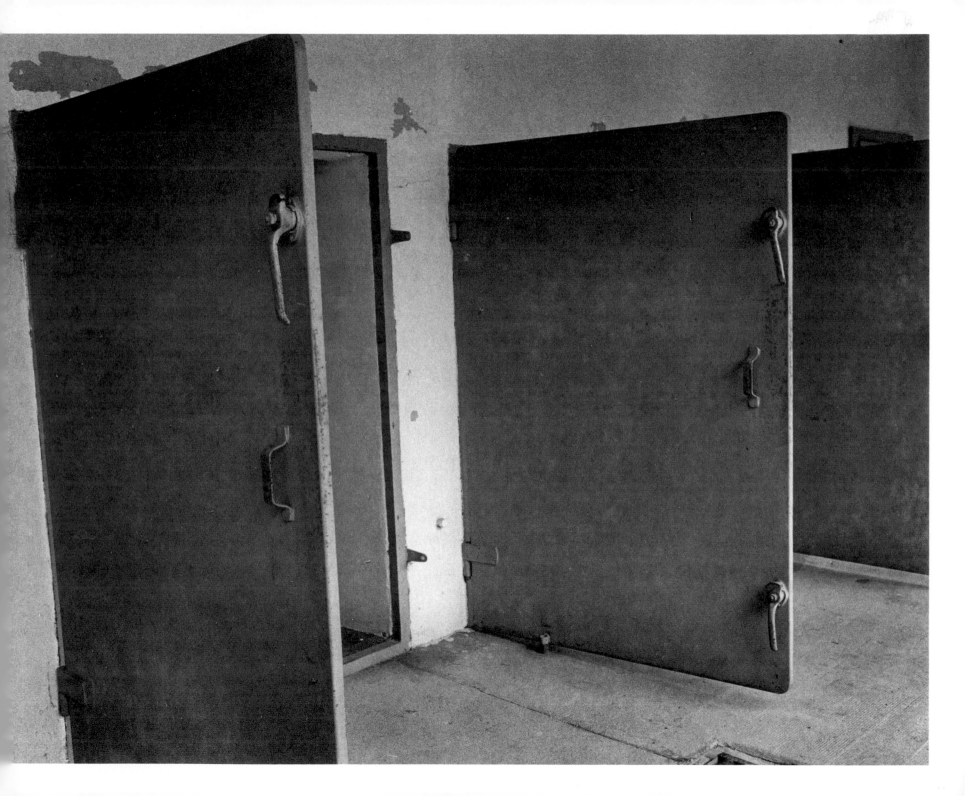

9. Dachau: Original crematorium wall.

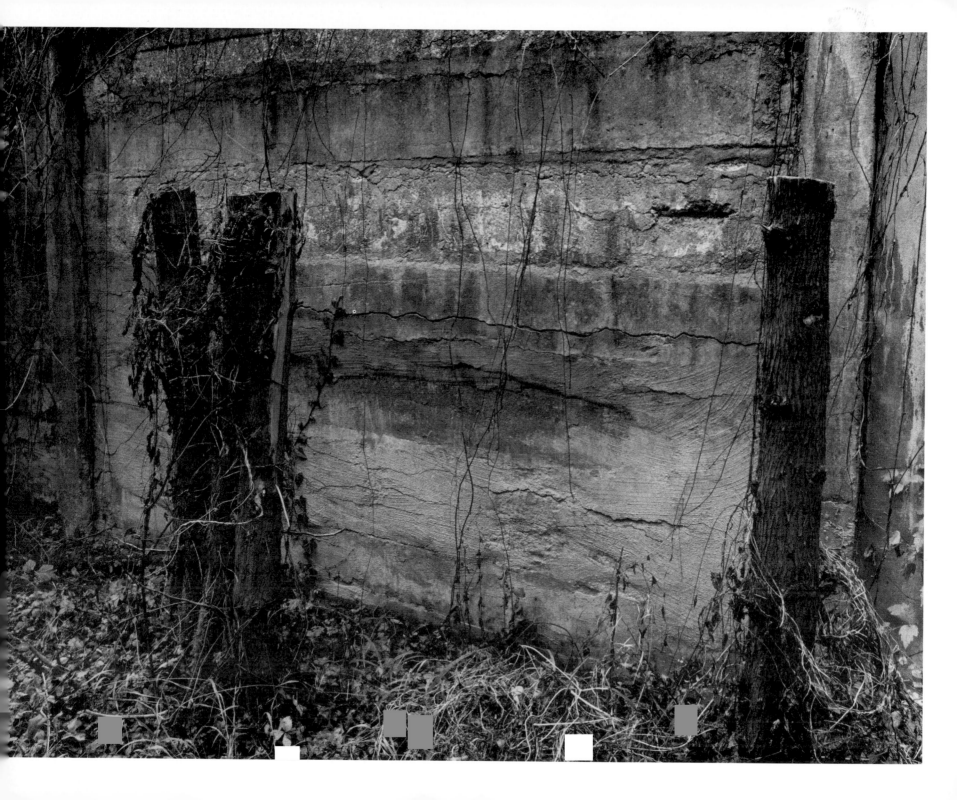

10. Neuengamme: A leftover hand-printed sign from the January 1984 sit-in by Hamburg citizens demanding landmark status for Neuengamme. The sign states:

We citizens of Hamburg place the remains of the former Neuengamme concentration camp under protection as a historical landmark. The conservation of these architectural remnants will serve to preserve the memory of crimes committed at this site, and of forced labor, suffering, and death of deportees from 23 nations. May these buildings serve as witness that such injustice never be repeated.
This demand is made by the Initiative for a Neuengamme Documentation House, VVN, Action Reconciliation, Landesjugendring, the Hamburg Teachers' Union et al. This private initiative was necessary, because the city of Hamburg has not deemed it essential to preserve this place of martyrdom by protecting this site.

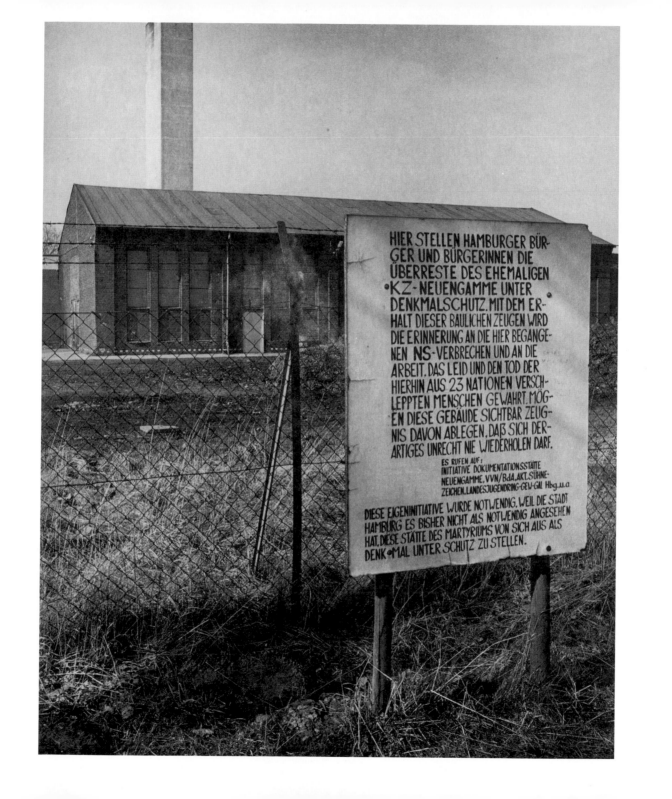

11. Neuengamme: The maximum-security prison erected in 1950 next to Neuengamme. The former concentration camp guard towers, barracks, and SS garage are inside the prison walls, thus destroying the unity and integrity of the memorial site.

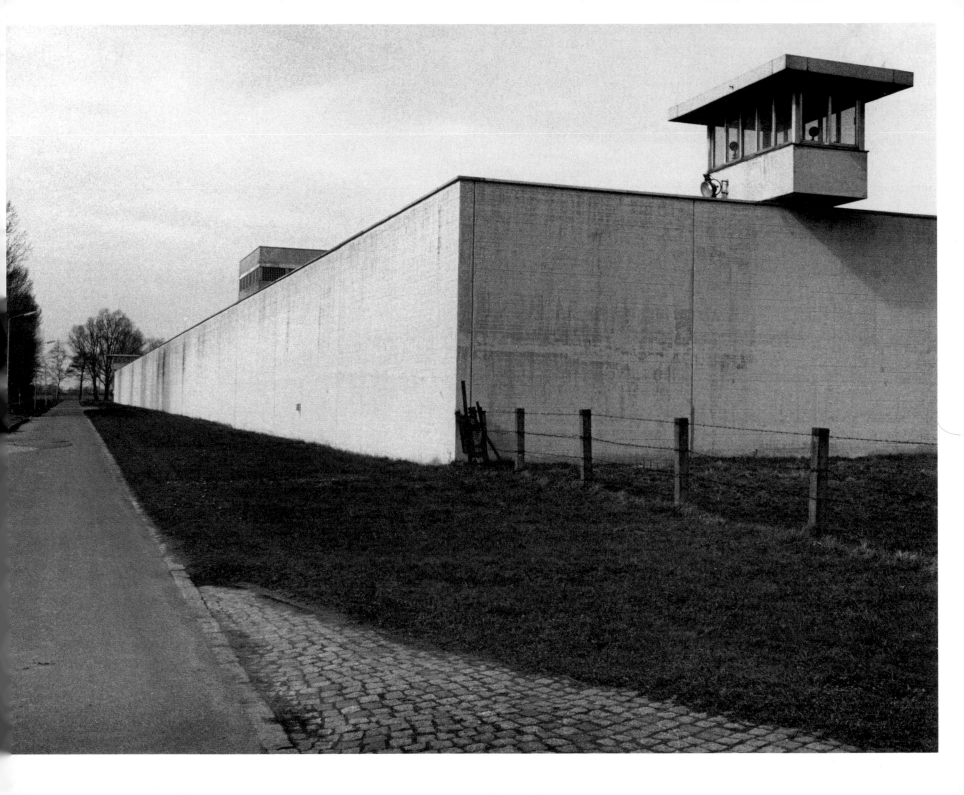

12. Neuengamme: Porter's building and loading ramp for the *Klinkerwerke* (a brick factory where prisoners once labored). The *Klinkerwerke* had been leased by the city of Hamburg to a commercial boat builder. It is currently being renovated as an exhibition pavilion.

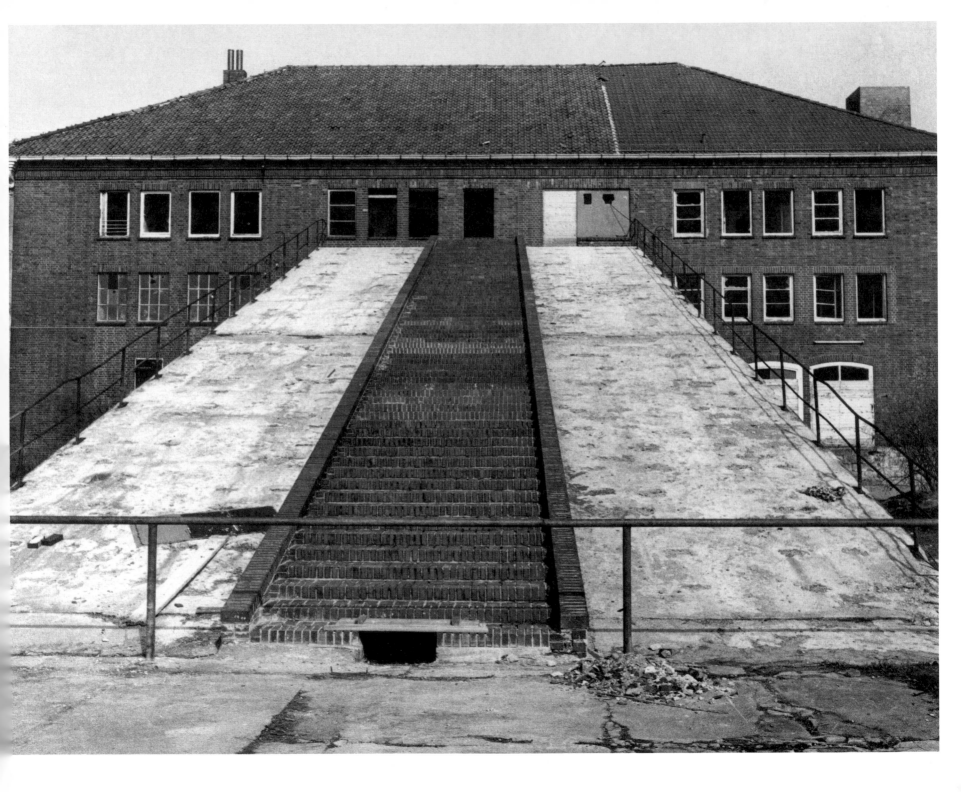

13. Mauthausen: The 186 "Steps of Death" (*Todesstiege*), made from loosely aligned chunks of stone and built by the prisoners, are located on steep cliffs approximately 300 ft. above a granite quarry. The prisoners hammered and hauled every stone required to build these steps and also hewed the granite needed to construct the 93 buildings and walls of the Mauthausen concentration camp. Prisoners detailed to punishment labor (the *Strafkommando*) were often required to carry stone blocks weighing from 66 to 132 pounds on their shoulders, while marching at double-time, vulnerable to the shouting, whipping, and abuse of the SS guards. Adjacent to the 186 steps is the quarry rim, which the SS ironically called "the parachute jump" because Jewish and political prisoners were sometimes thrown to their deaths from there into the quarry pit below.

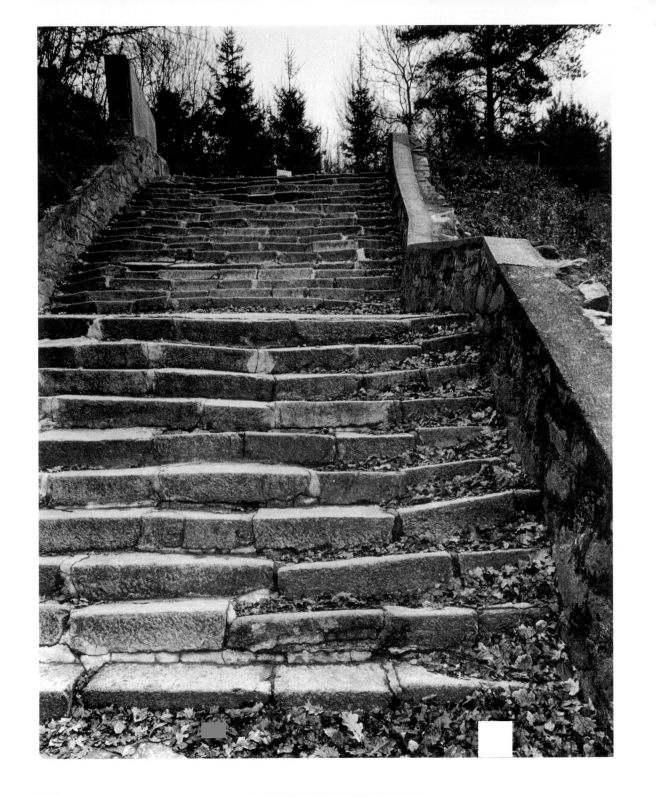

14. Mauthausen: Courtyard and guard towers at entrance, where prisoners were often brutally beaten on arrival; on the left, the roofs of prisoner barracks.

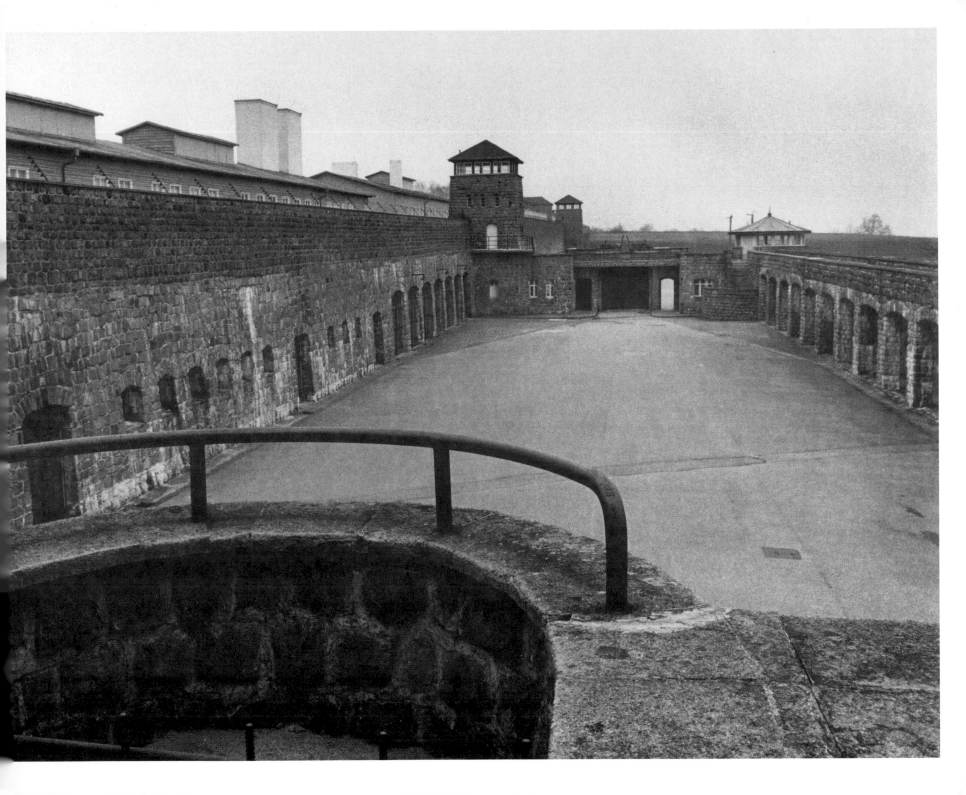

15. Mauthausen: Ramparts and guard tower.

16. Mauthausen: The door of the gas chamber, disguised as a shower, is located in the basement of the camp infirmary (*Krankenbau*). The adjacent basement complex of rooms includes a small autopsy room, the morgue, a crematorium, and an execution chamber, where prisoners were hung or shot from behind.

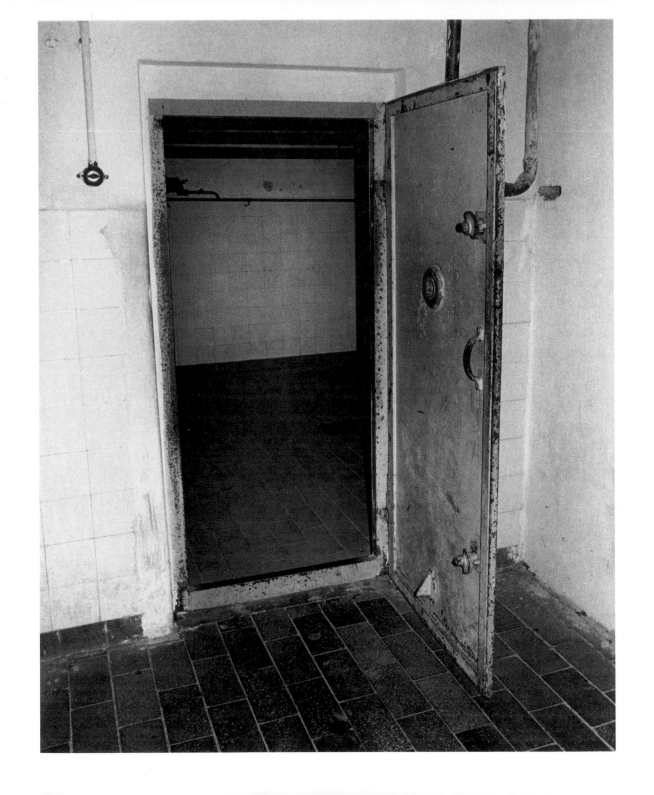

17. Sachsenhausen: Camp entrance (*Jourhaus*) with adjacent SS guard rooms.

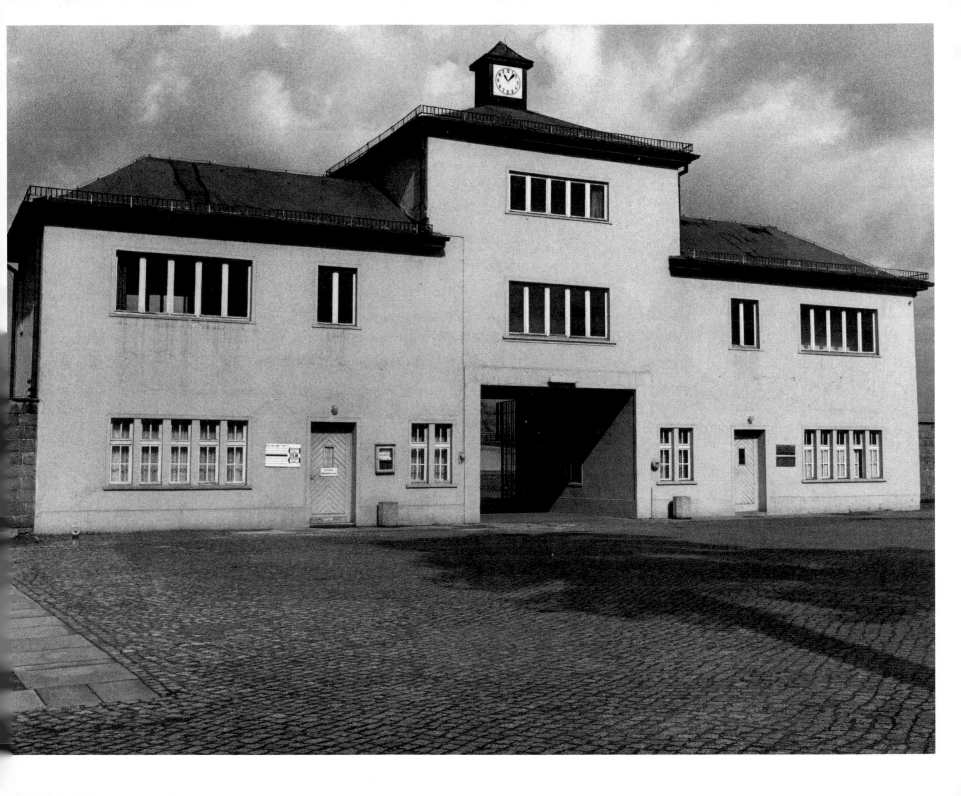

18. Sachsenhausen: Guard tower and outer walls.

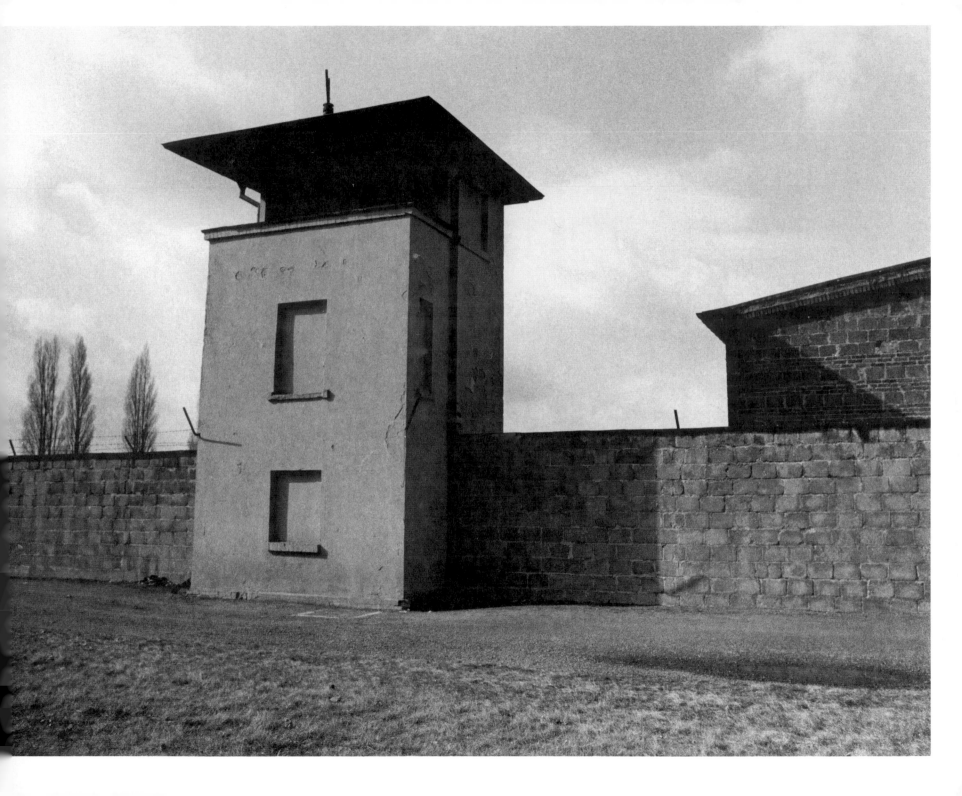

19. Sachsenhausen: The pathology barrack.

20. Sachsenhausen: One of three basement storerooms for corpses, located in the basement of the pathology barrack. These white tiled vaulted chambers covered 230 square meters (approximately 2,429 square feet) and served as a morgue for up to 5,000 corpses. Initially, Sachsenhausen had no crematorium and SS physicians conducted autopsies, dissections, and medical experiments in this building.

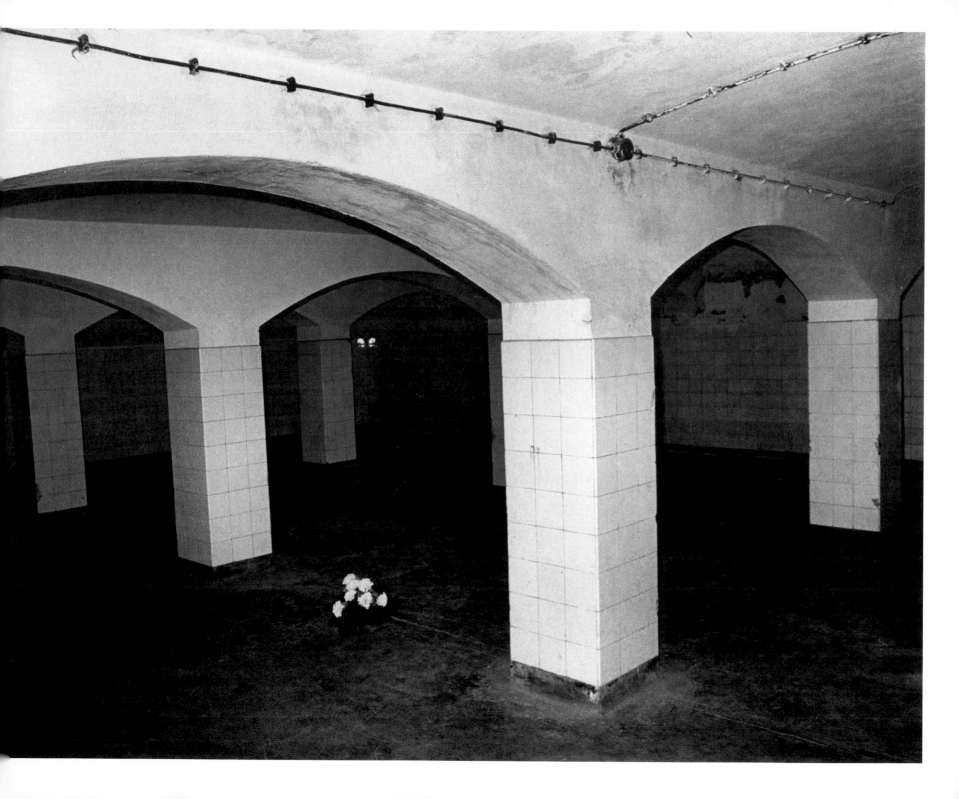

21. Sachsenhausen: First floor interior of the pathology barrack.

22. Sachsenhausen: The pillories used for torture, interrogation, and punishment of prisoners; inmates were suspended from the posts with arms chained behind their backs for hours at a time. The posts are adjacent to the prison and the underground bunker containing unlighted subterranean cells for solitary confinement.

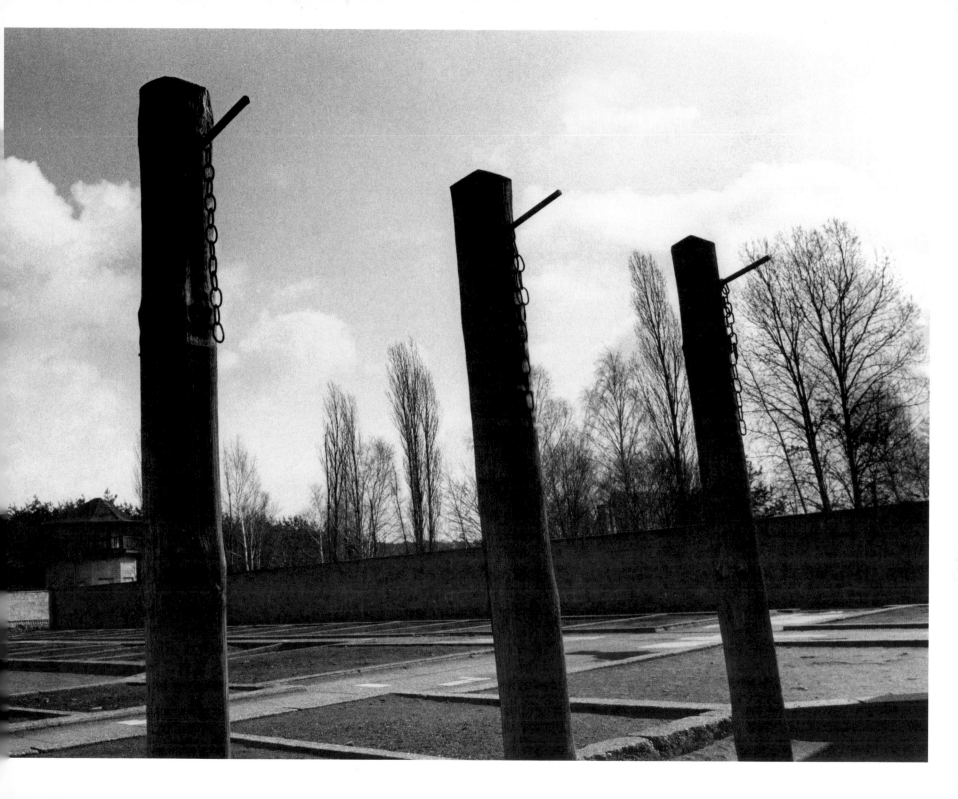

23. Sachsenhausen: A sign at the perimeter wall, warning: *"Neutral Zone! [Violators] will be shot instantly without warning."*

24. Sachsenhausen: Warning signs with skull and crossbones are placed in front of the inner walls of the camp, where the original two-story guard towers with machine guns and searchlights stand at intervals of approximately 500 ft. Prisoners who went beyond these signs were "shot while trying to escape."

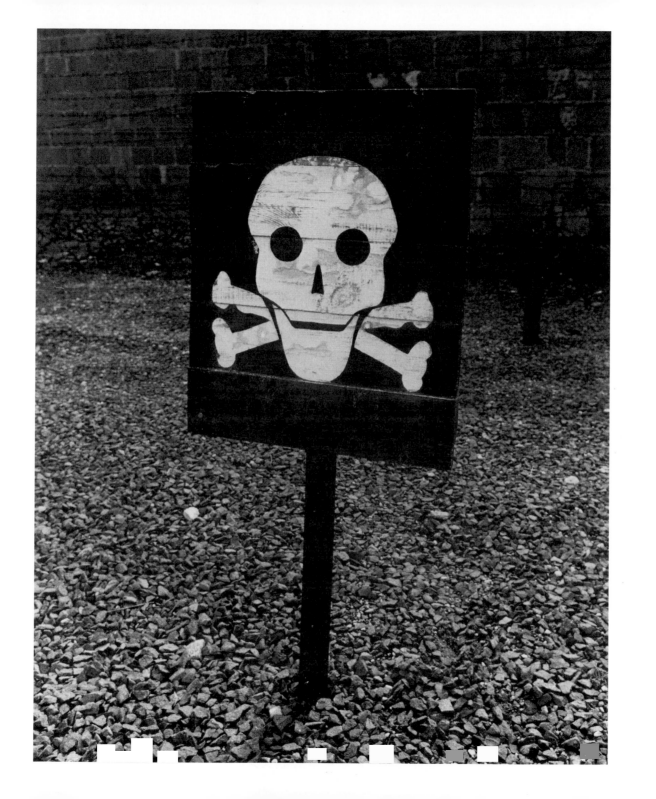

25. Buchenwald: Main gate (*Jourhaus*) with clock stopped at the moment of liberation.

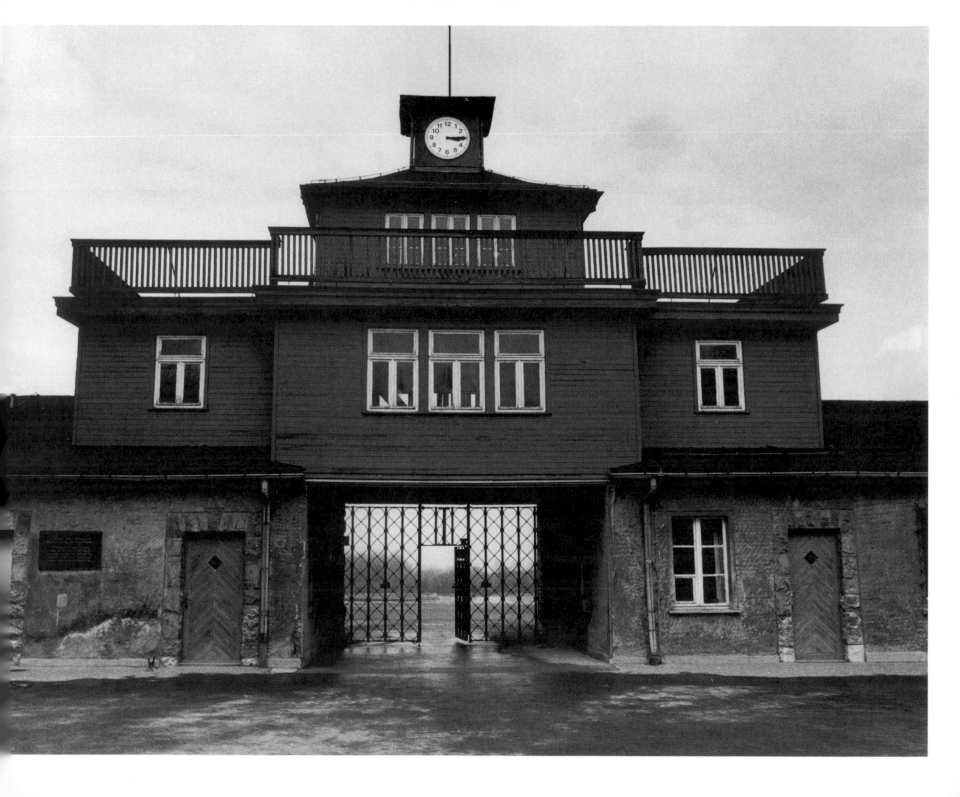

26. Buchenwald: Detail of main gate with the slogan *Jedem das Seine* (To each accordingly).

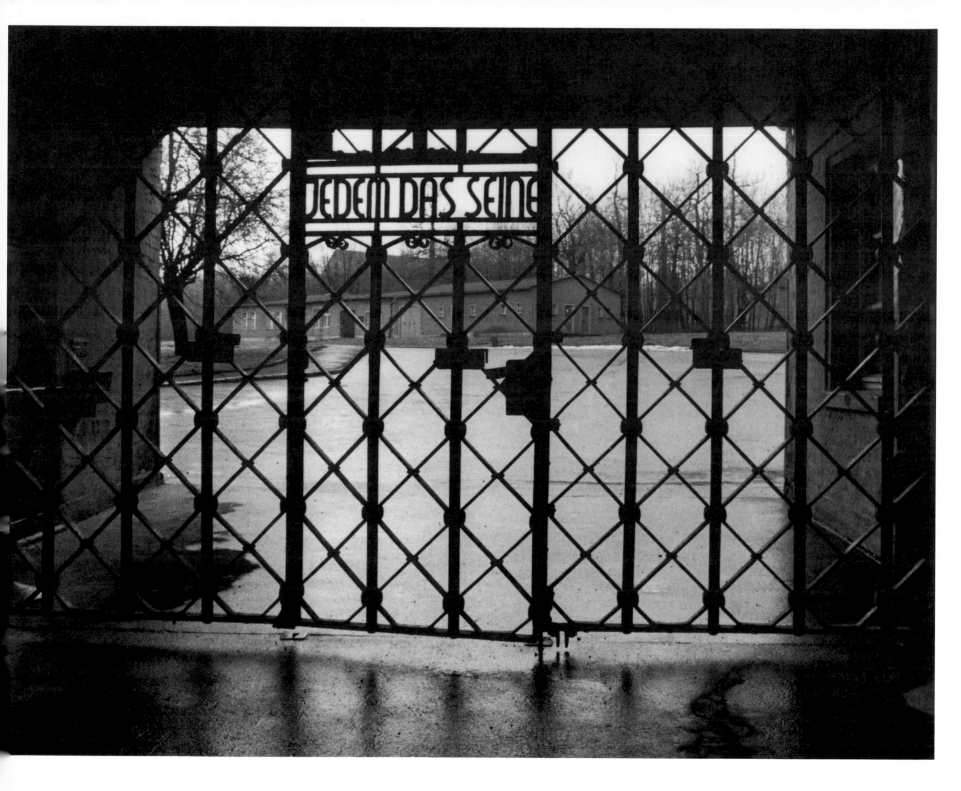

27. Buchenwald: The detention cells (*Bunker*) adjacent to the entrance. The window covers on these darkened punishment cells prevented prisoners from seeing outside their cells, thus reinforcing their sense of confinement and isolation.

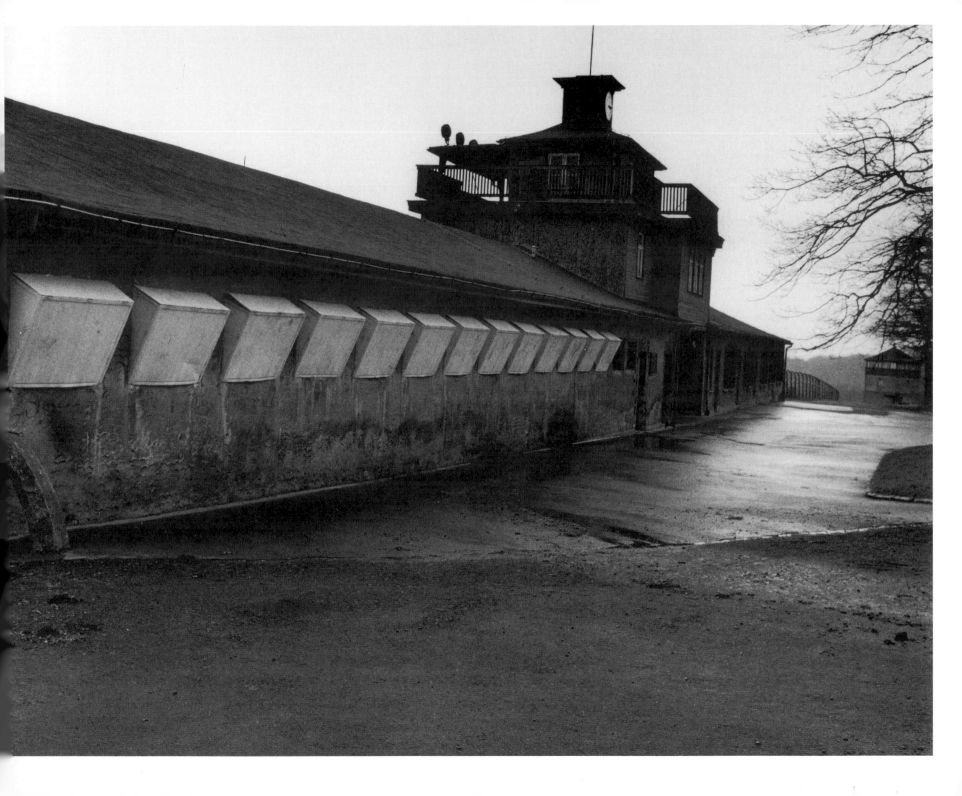

28. Buchenwald: Cellar room, located in the crematorium basement, with 48 meat hooks for hanging prisoners in pairs, strapped back to back.

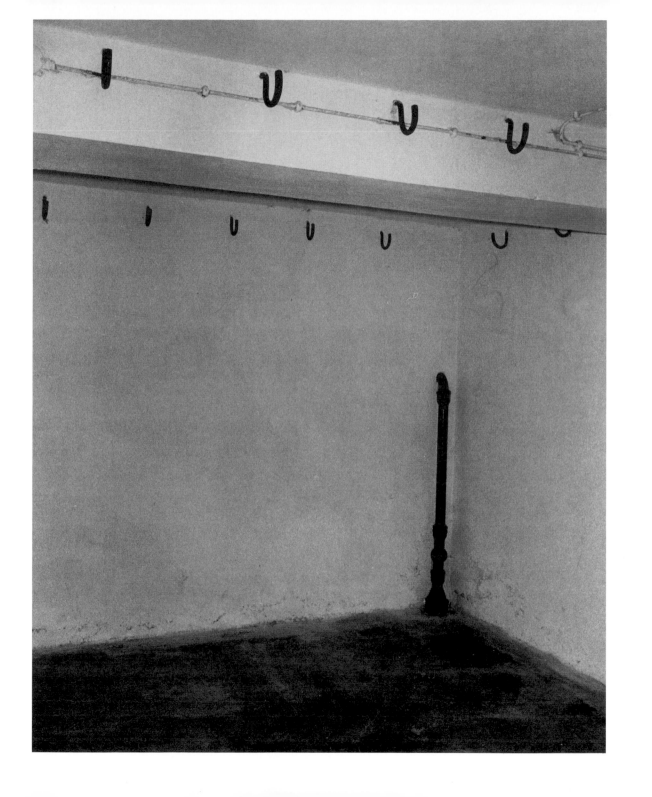

29. Buchenwald: The walls of this cellar room are peeling and gouged, showing the kick marks of dying prisoners.

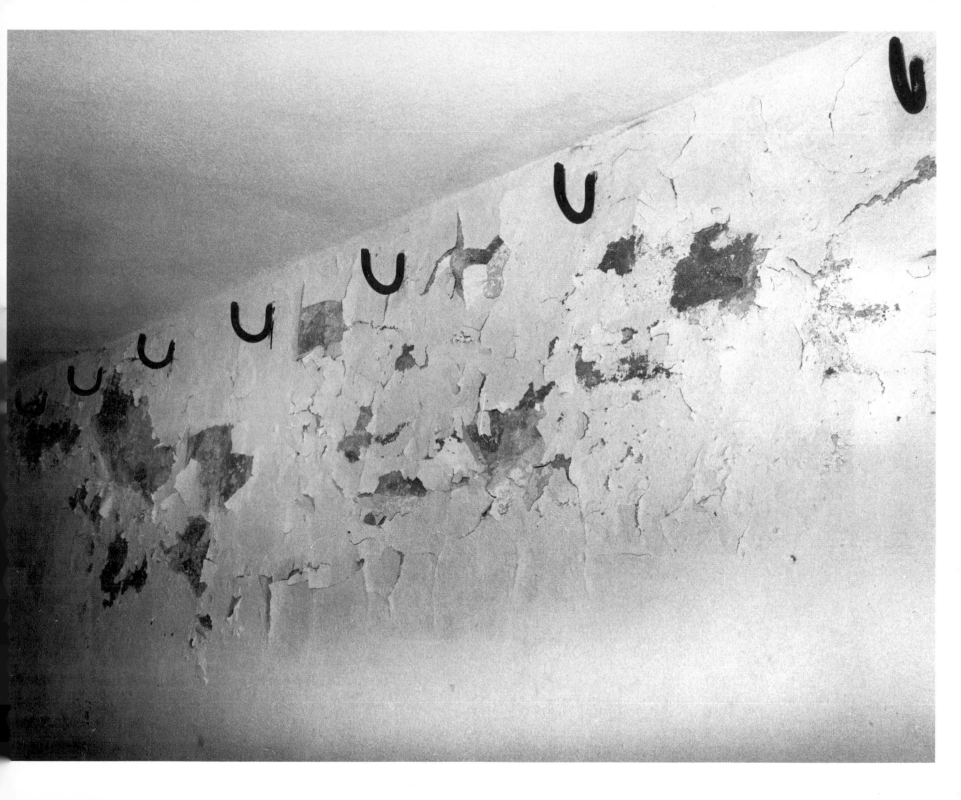

30. Buchenwald: Fragment of the electrified barbed wire perimeter fence.

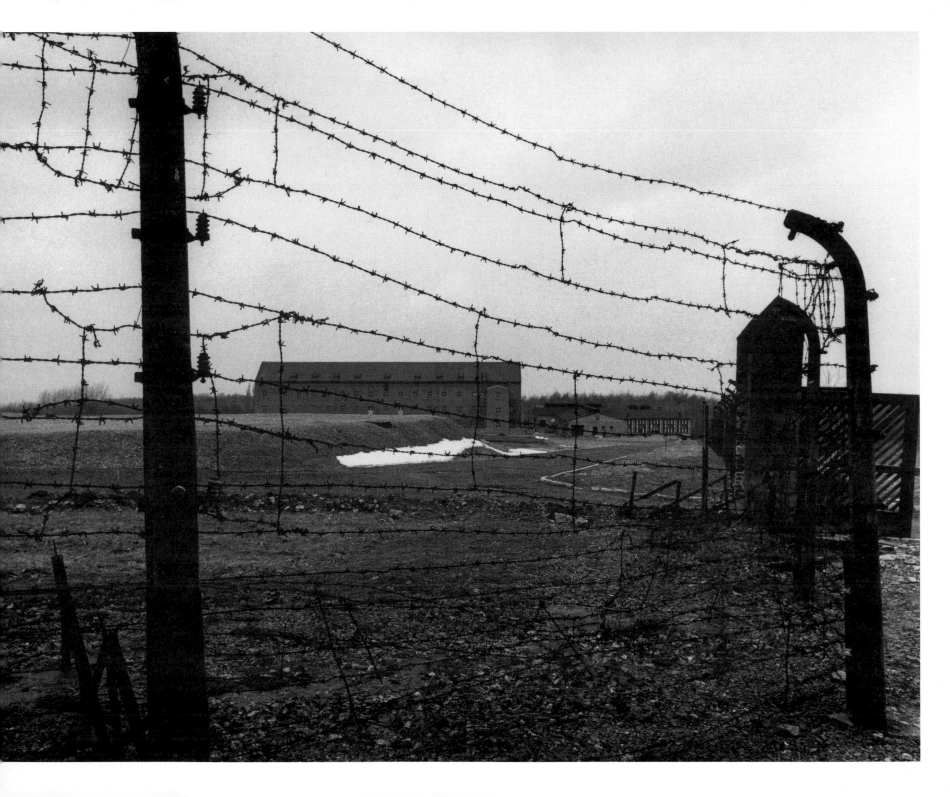

31. Buchenwald: Crematorium interior.

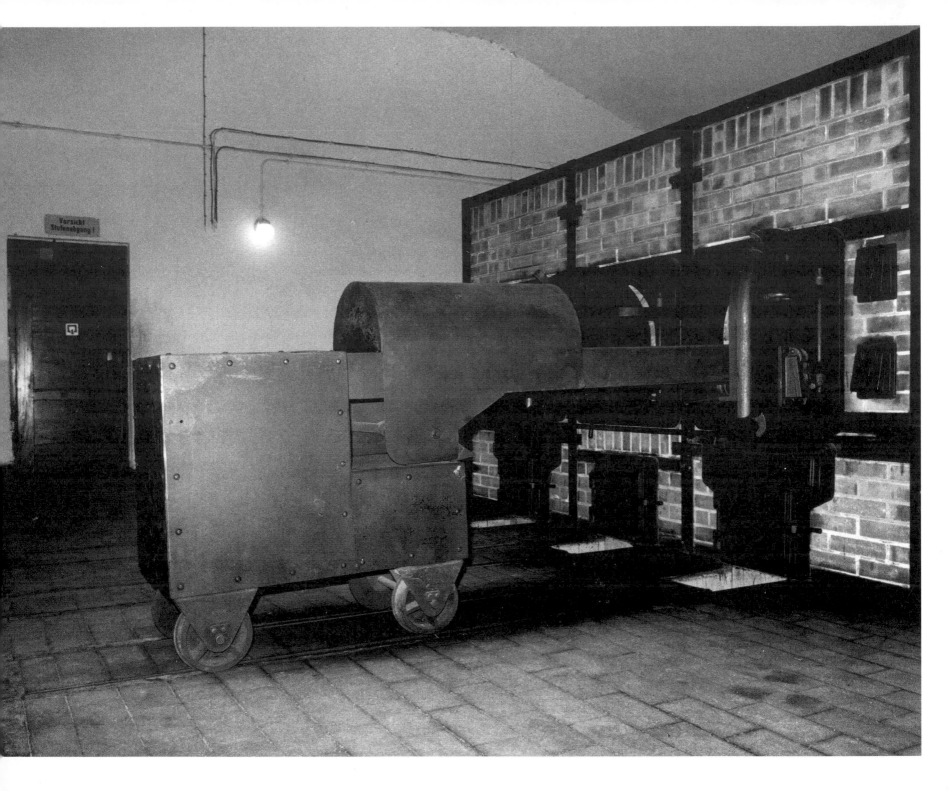

32. Auschwitz: Entrance to the the main camp; on the right, sign warning against approaching the electrified fence.

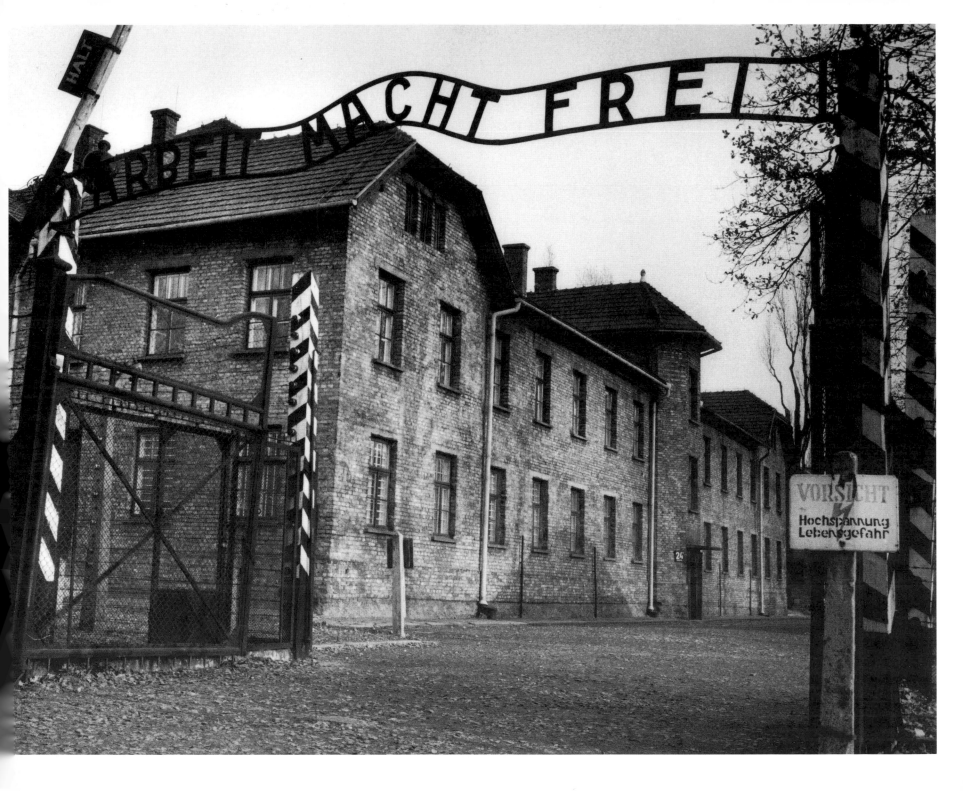

33. Auschwitz: Street scene in the main camp, photographed from the roof of the building containing the first crematorium and gas chamber, where Soviet prisoners of war and Jews from Upper Silesia were killed in 1941 and 1942. The small box on the roof was used for the insertion of Zyklon B crystals into the first improvised gas chamber. This building is located just outside the main fence of the camp. The photograph also shows a sentry box at the barbed wire camp fence and a row of two-story red brick buildings and cobblestoned streets, with lawns and tall trees lining the sidewalks.

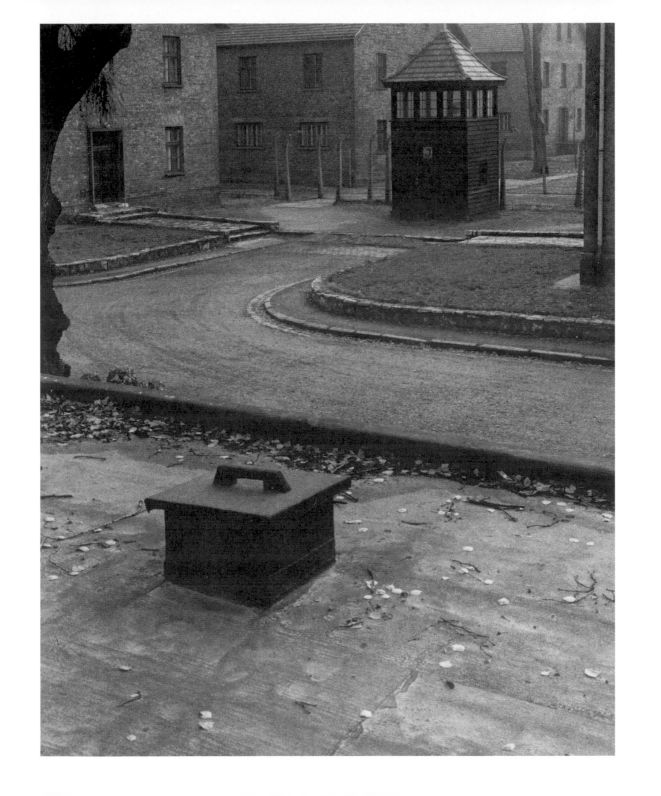

34. Auschwitz: Street scene in the main camp, with roller used by prisoners for building streets and roads.

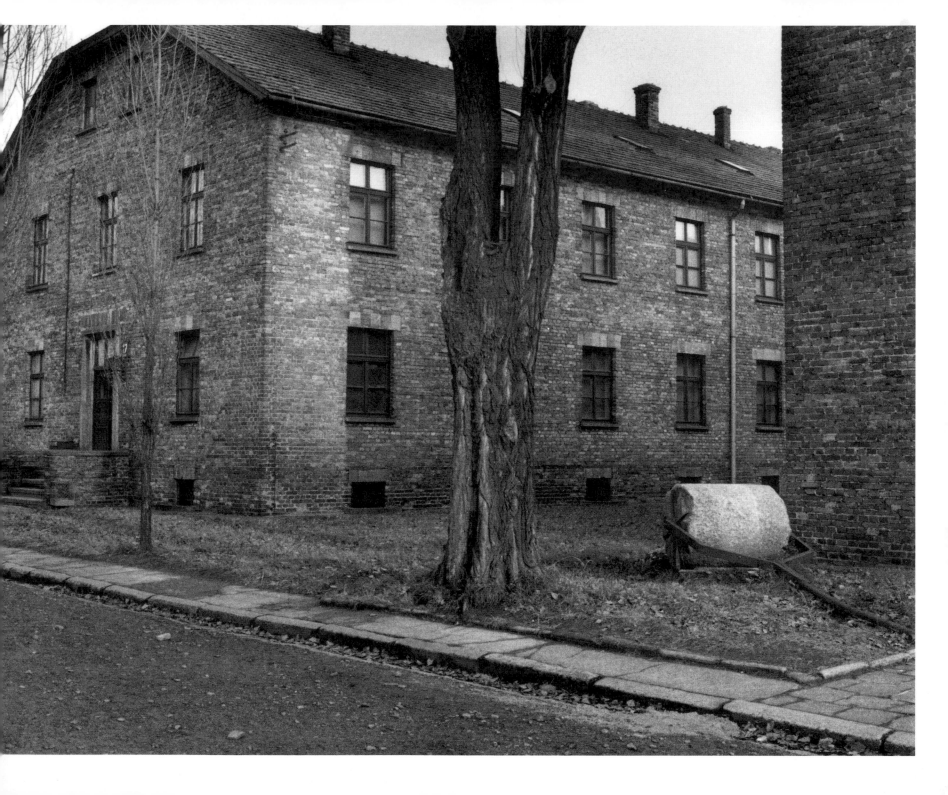

35. Auschwitz: Collective gallows at the *Appellplatz*, located between Barracks 16 and 17.

36. Auschwitz: The "Wall of Death" in the courtyard of Barrack 11 with camp prison on the left. At least 20,000 Polish political prisoners were executed there. Wood covers were attached to cell windows to prevent prisoners from observing the shootings in the courtyard.

37. Auschwitz: Crematorium I is a small structure with a tall chimney. The mortuary of this building contained the first gas chamber, used from early 1942 to the spring of 1943. In 1944, the building was converted into an air raid shelter.

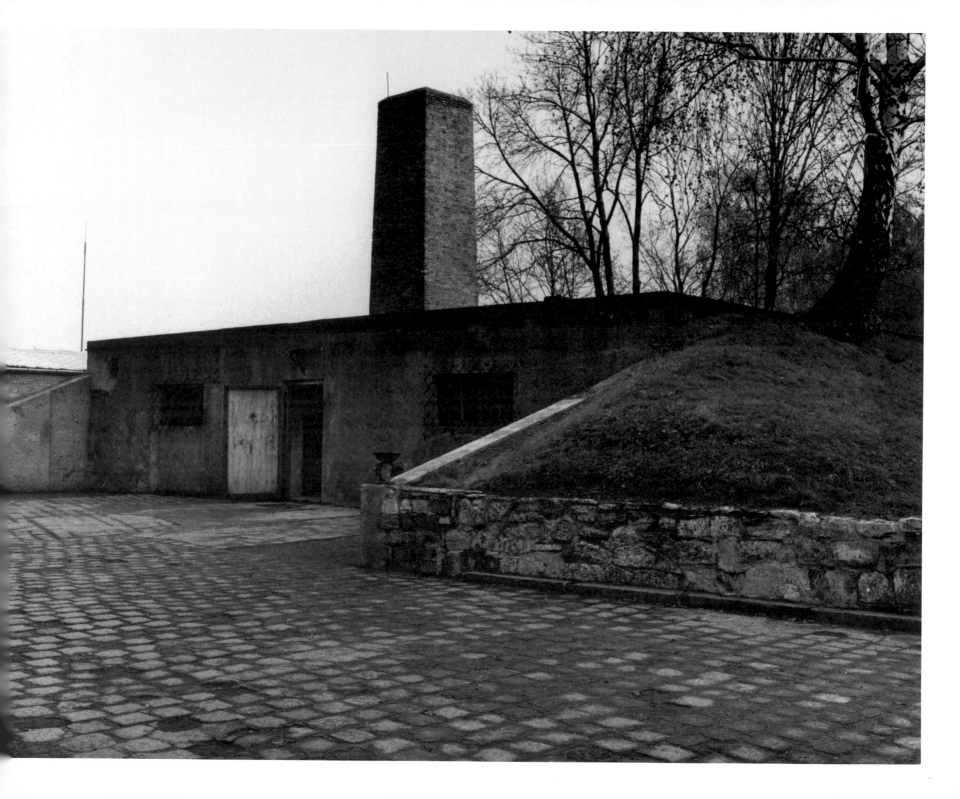

38. Auschwitz: Kittens in rust-colored paint drawn on the wall of a ground floor washroom in Barrack 7.

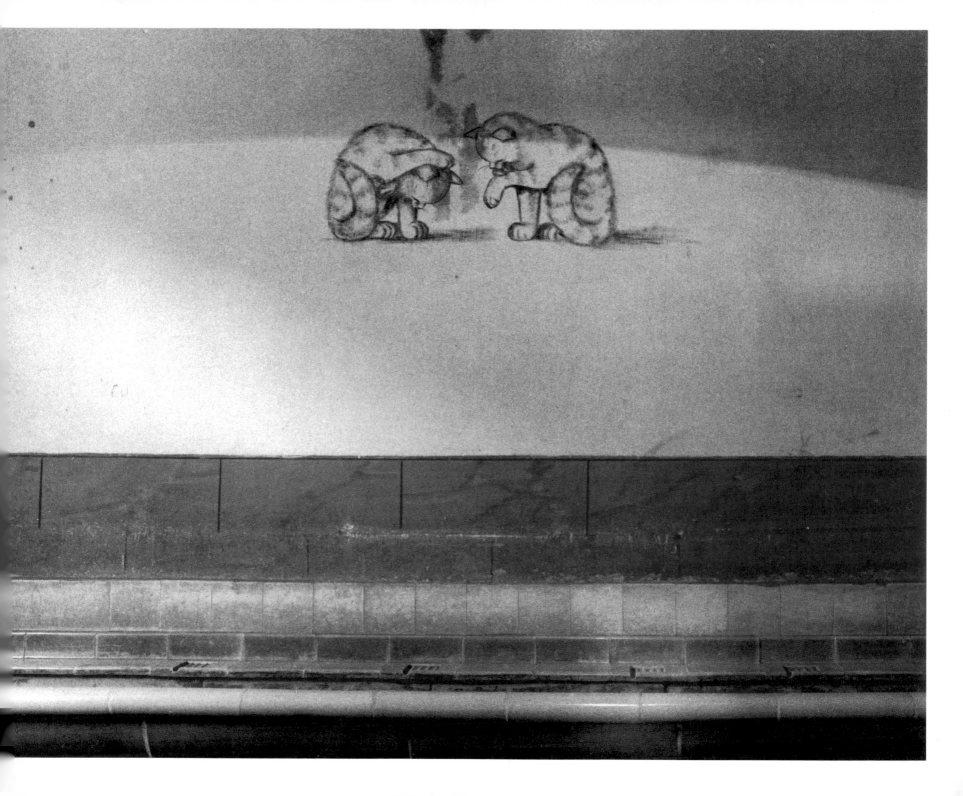

39. Birkenau: Entrance gate from inside the camp. The main gate also served as the SS guard house and was large enough for a train to go directly into the camp. The maintenance problems at the vast Birkenau complex are clearly visible; note the loose barbed wire, which is periodically replaced to retain the original tension.

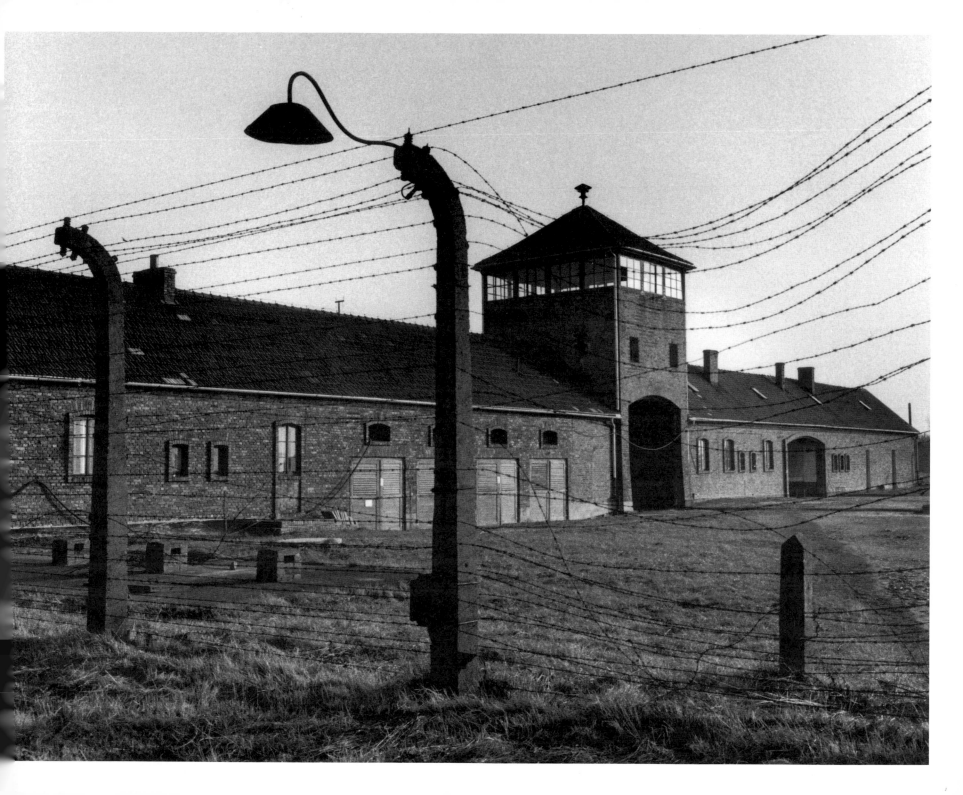

40. Birkenau: On the right, part of the women's camp with brick barracks. Note the end of the railroad spur and electrified barbed wire.

41. Birkenau: Contemporary graffiti on the stone wall of Section A, Barrack 16 (a women's barrack).

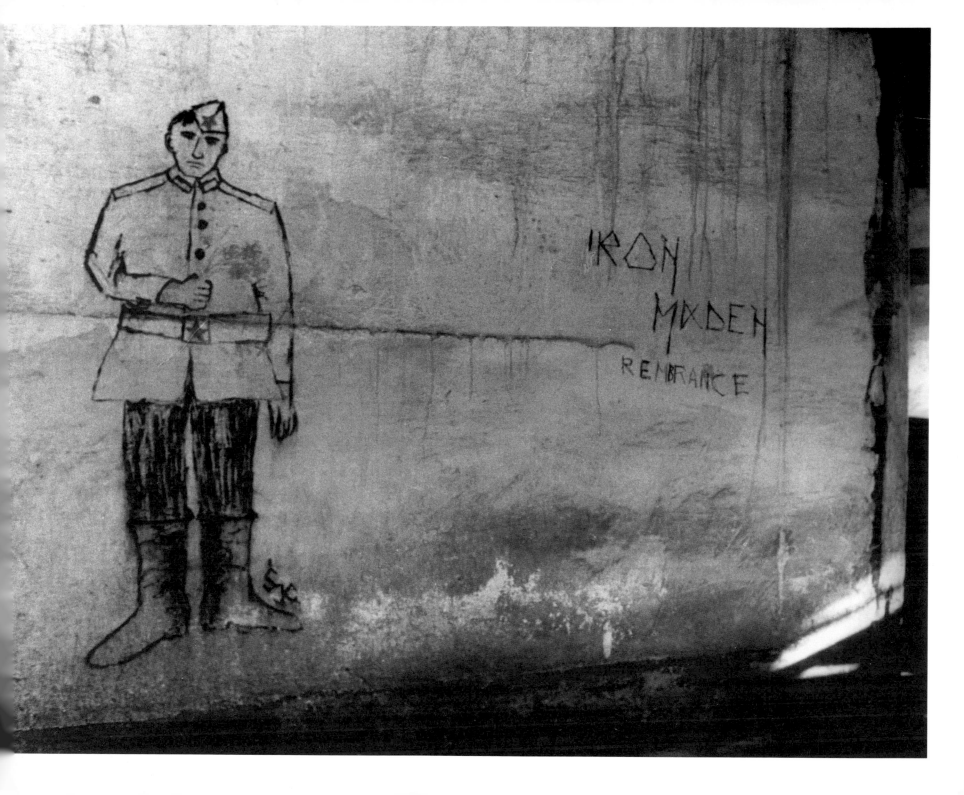

42. Birkenau: The ruins of Crematorium II. The basement contained a subterranean gas chamber with five furnaces, an electric elevator for hauling up corpses, and an undressing area; the latter also served as a mortuary. Construction began in the summer of 1942 and was completed by March 1943. In late 1944, the SS dismantled Crematorium II, sending some parts to the Gross-Rosen concentration camp and dynamiting the rest in November 1944 to eliminate evidence of the mass murders.

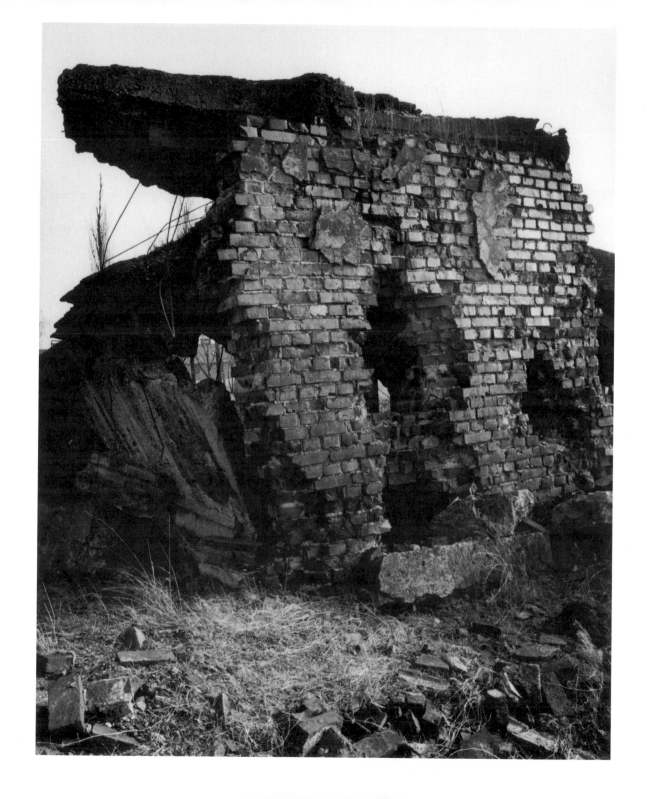

43. Birkenau: The ruins of Crematorium III. The basement contained a subterranean gas chamber with five furnaces and an undressing area. Used from June 1943 to November 1944, this crematorium was dismantled and dynamited by the SS in November 1944.

44. Birkenau: Prisoner cutlery in a ditch at *Canada* (the name of the former warehouse for prisoners' personal effects), destroyed by the Germans to obliterate all evidence of Nazi crimes before the arrival of the advancing Soviet army.

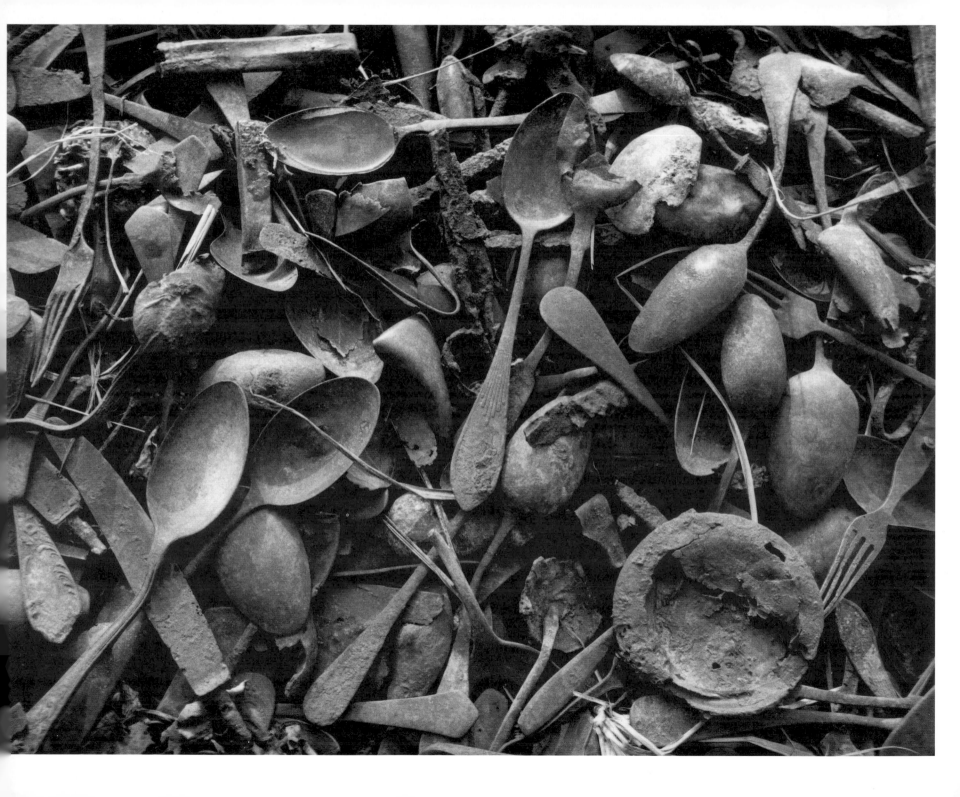

45. Cracow, Podgorze district: Fragment of the Nazi ghetto wall on Lwowska Street.

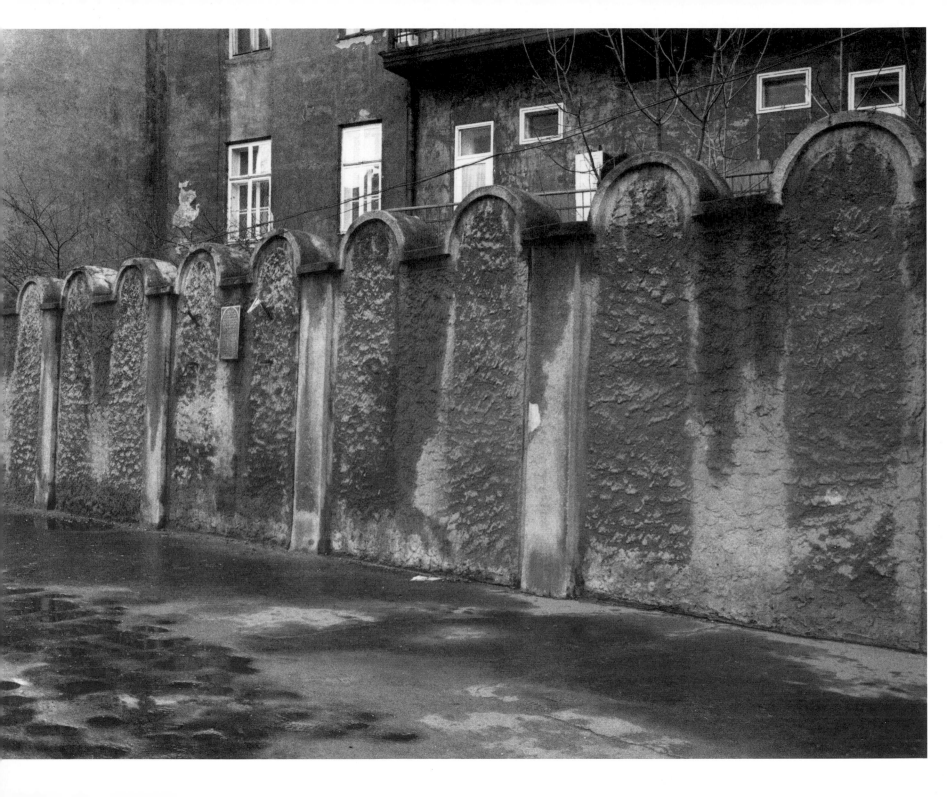

46. Warsaw: The courtyard of Paviak prison at Dzielna 24/26, inside the former Warsaw ghetto. On the right are fragments of the original entrance gate and also the prison wall with bars entwined in barbed wire.

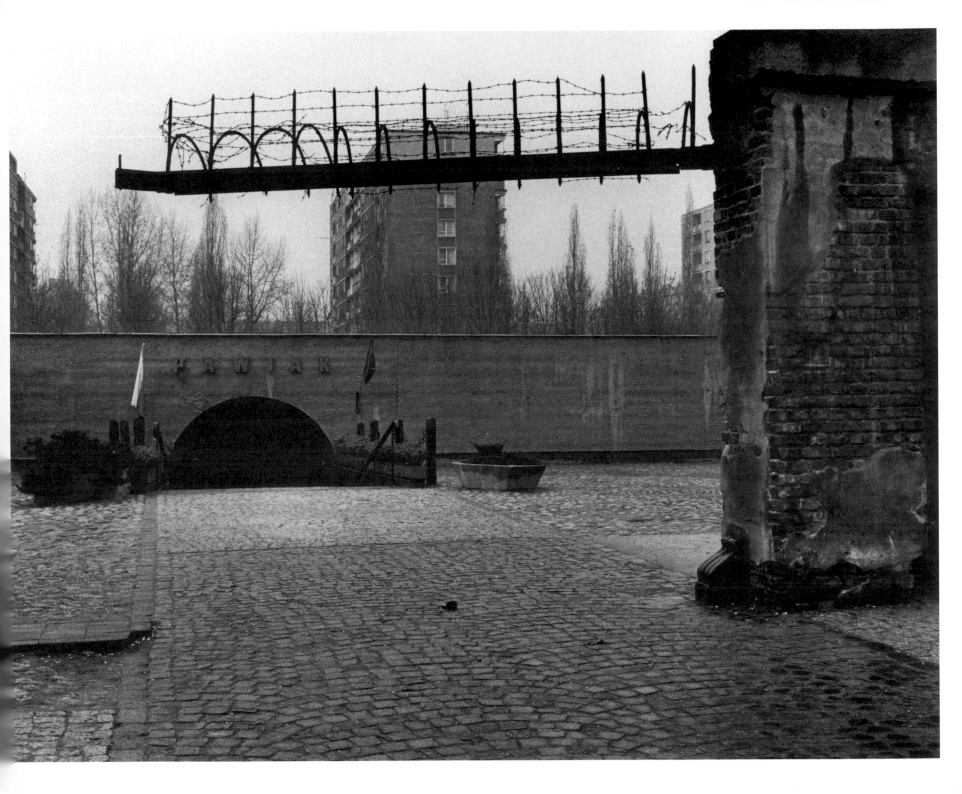

47. Maidanek: The crematorium, built in 1943, containing furnaces, morgue, and gas chamber; the Lublin suburb of Majdan-Tatarski is visible in the background.

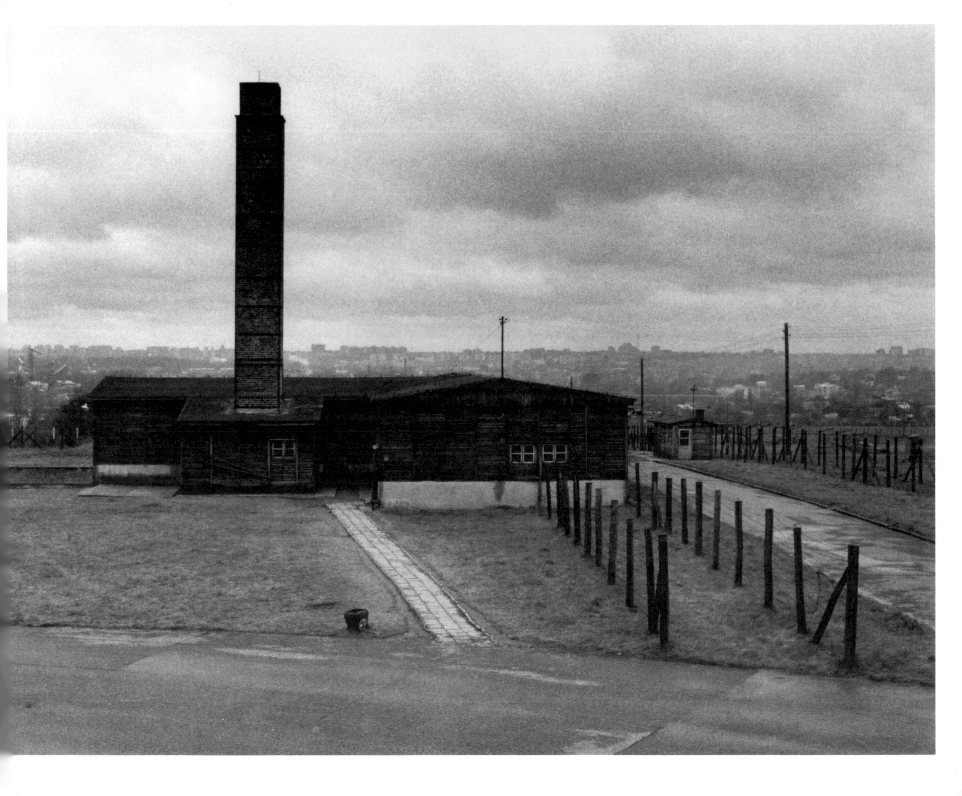

48. Maidanek: Sentry tower at the border between camp subsections (also called "fields").

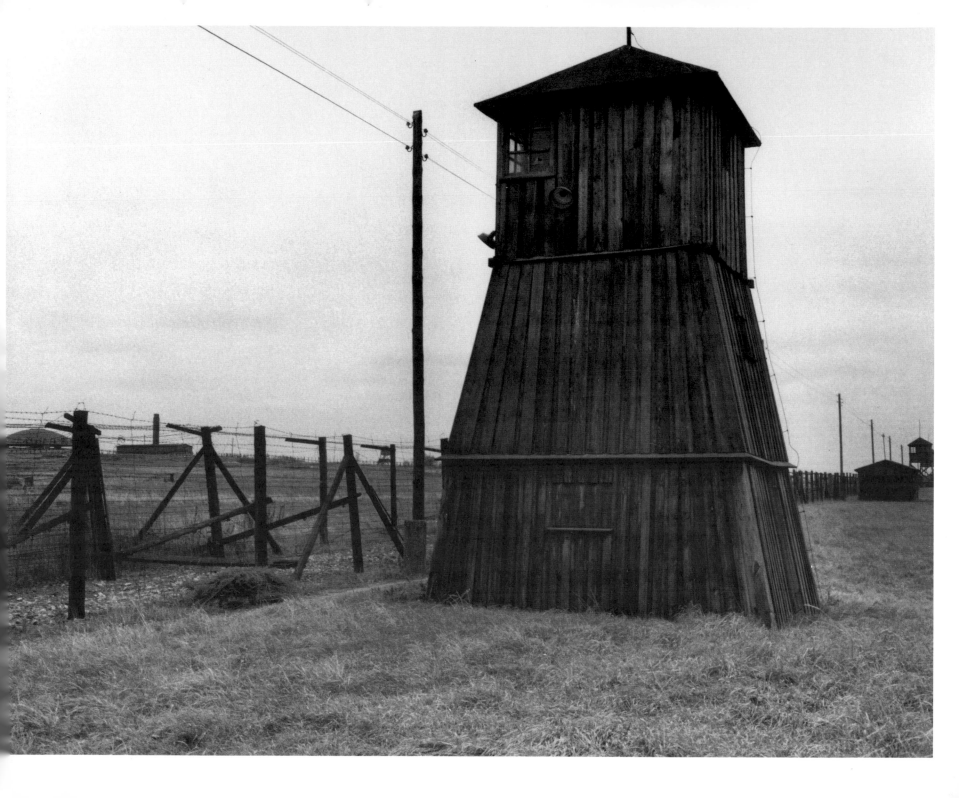

49. Maidanek: Electrified barbed wire and double rows of posts with guard towers separate the camp sections.

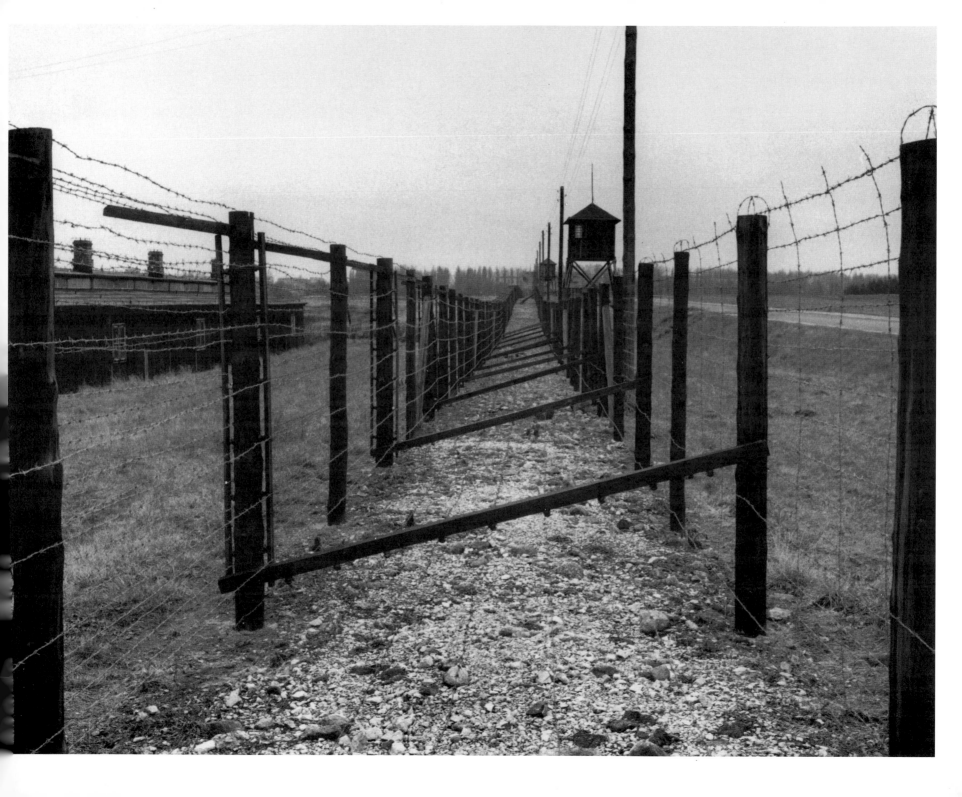

50. Maidanek: Barrack exterior. These wooden barracks contained tiny skylights instead of windows. Each barrack— erected from plans for Army horse stables (Model 260/9) and designed to hold 52 horses—measured 128 ft. x 28.8 ft. x 6.4 ft. Each barrack contained up to 250 tiered bunk beds. Most barracks leaked and few had sewage or sanitation facilities before 1943.

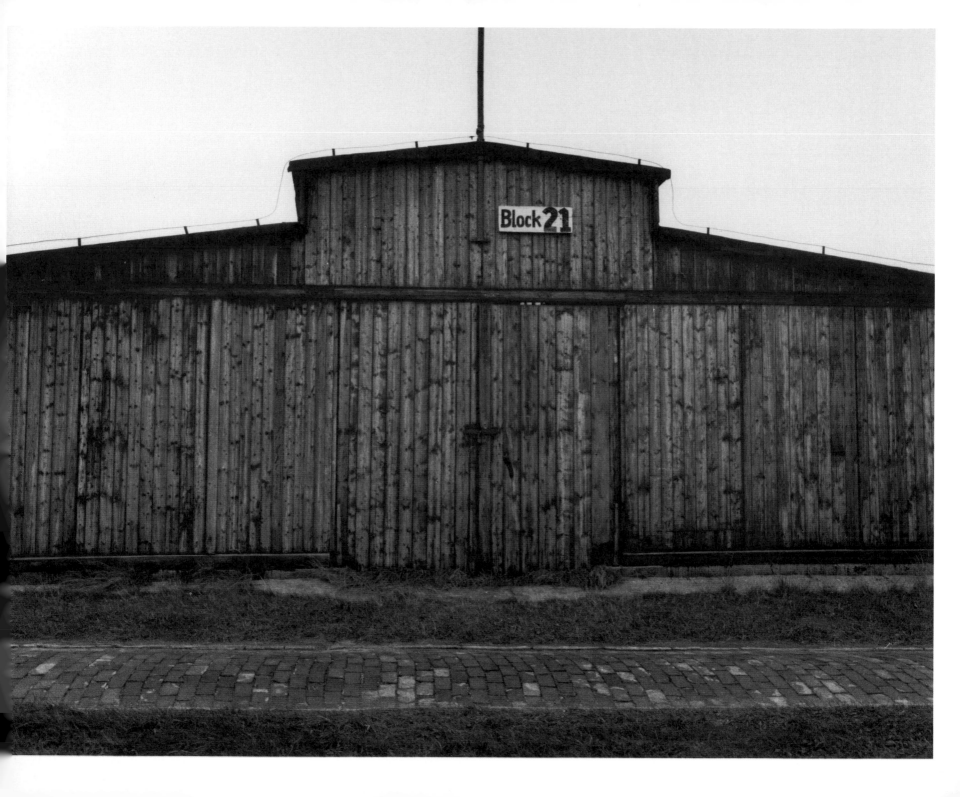

51. Maidanek: The column with three eagles, designed by the Polish prisoner artist Albin Maria Boniecki, was built by the prisoners in May 1943. The base of the column contains a handful of the victims' ashes.

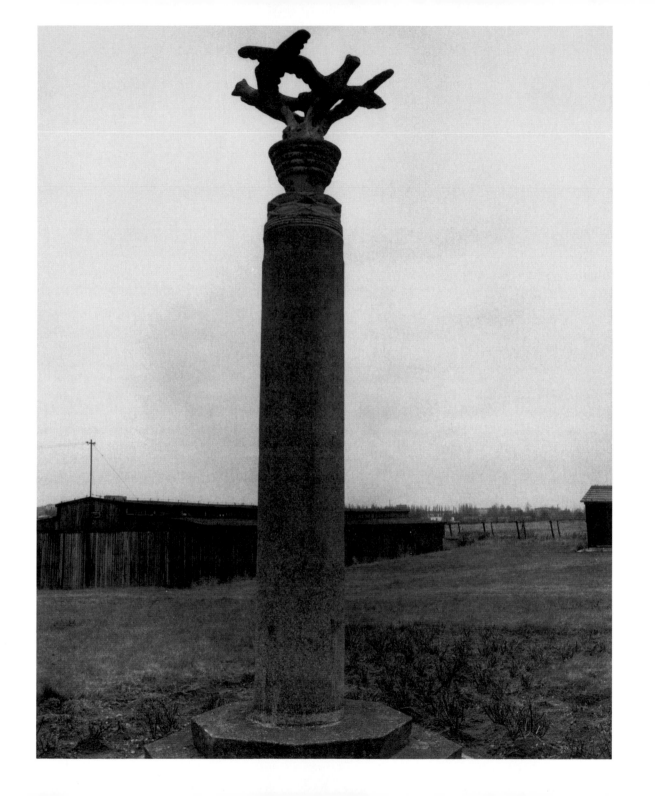

THREE

THE GENERATIONS OF MEMORY

The diversity of public sculpture about the Holocaust reflects the changes in postwar political culture as well as the reception of the Holocaust by three different postwar generations. Holocaust monuments created immediately after the war served primarily as memorials to the dead. Initially, monuments were few in number and relatively inconspicuous. Exemplified by the starkly functional gravestone for the Jewish dead at Bergen-Belsen erected in October 1945, the first European and Israeli monuments modified the traditional secular tomb of the unknown soldier and extended it to Jewish victims of Nazi mass murder.

By the 1960s the focus of memorial sculpture was transformed and extended. In this period memorials were designed for the living and also as signposts for the future. Increasing chronological and geographical dis-

tance from the Holocaust yielded both innovation and kitsch. The former was exemplified by the symbolic graveyard of stones at Treblinka (photos 57–62) and the latter by the florid pseudo-classicism of Nathan Rapoport's Philadelphia *Monument to the Six Million Jewish Martyrs* (photo 110). At Mauthausen the traditional and the experimental blended in Mirko Basaldella's Italian memorial, with the imposition of a jagged barbed wire cage adjacent to a wailing wall containing cameo photographs provided by the families of the deceased (photos 78–80). Perhaps the most provocative work was the use of a blackened and leafless tree outside the former Paviak prison in Warsaw. This tree was one of the few objects to survive the razing of the Warsaw ghetto in April 1943; by its mere existence it symbolized death and resurrection simultaneously (photos 66–67).

By the 1980s Holocaust sculpture, although still primarily commemorative in nature, was designed to communicate with a broader public. Changing public tastes allowed artists to choose their own styles. But the didactic needs of transmitting distant events to a new generation necessitated varying degrees of realism. Although no single style dominated the new memorials, a broader range of artistic and iconographic solutions was introduced to a growing public eager to understand the Holocaust. Thus, architects, sculptors, and landscape designers confronted new challenges and, concomitantly, greater risks. The inability to define appropriate styles for public art about the Holocaust resulted in pointless debates in the media about whether art and the Holocaust could coexist.

The photographs in this section illustrate the diversity of works and iconographic solutions employed at a variety of sites over the last 45 years.

52. Birkenau: Terraced cobblestones near the ruins of crematoria II and III lead to the international memorial at Auschwitz-Birkenau.

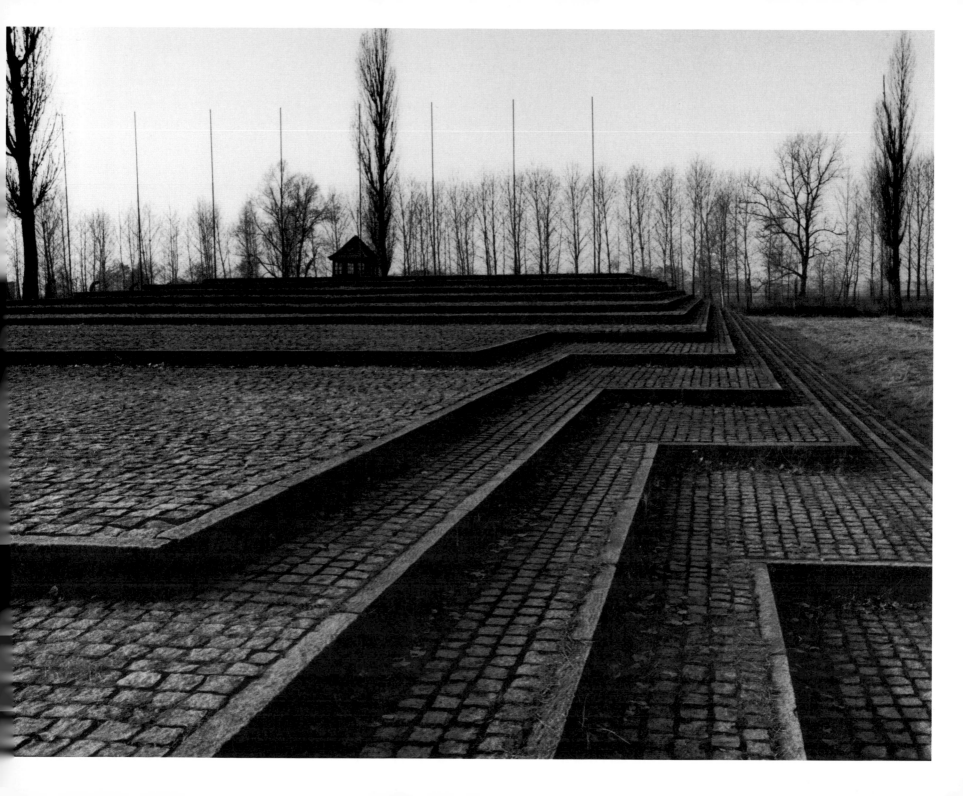

53. Birkenau: An unsuccessful international competition for a memorial at Auschwitz-Birkenau was held under the chairmanship of the British sculptor Henry Moore in 1958. Although more than 400 designs were submitted, none were accepted. In 1967 it was decided that no single artist was capable of completing such a commission. The Auschwitz memorial authority therefore decided to combine elements from several different submissions and hired an international team of sculptors and architects, including Pietro Cascella, Jerzy Jarnuszkiewicz, Julian Palka, Giorgia Simoncini, Tomaso Valle, and Maurizio Vitale, to complete the memorial at Birkenau.

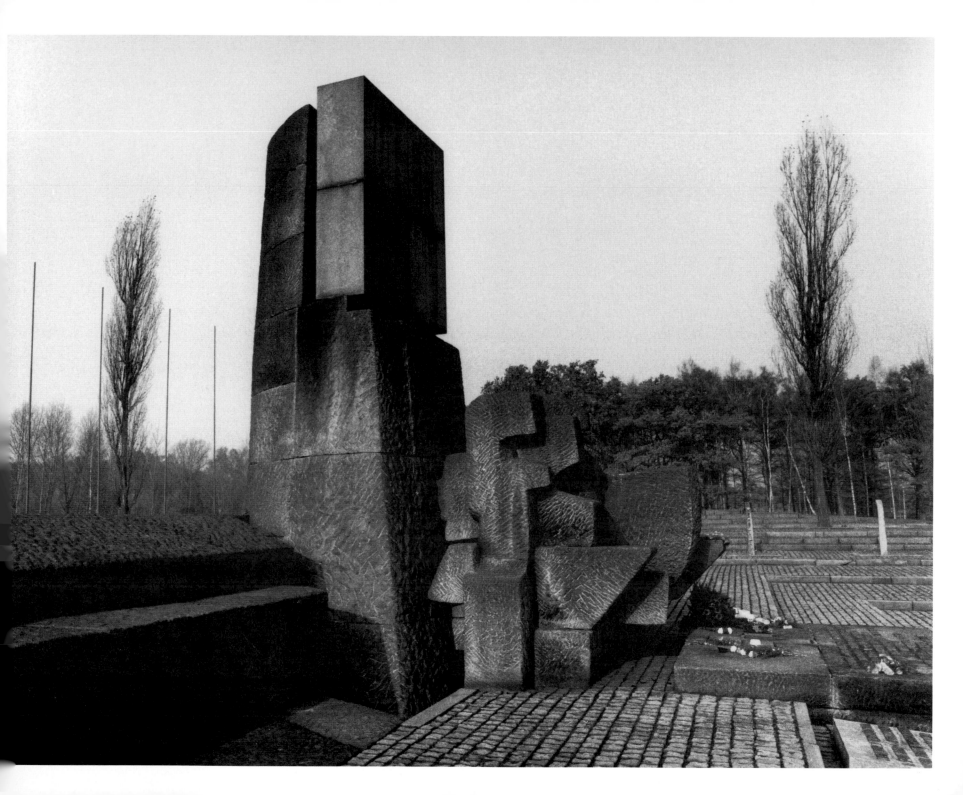

54. Birkenau: Memorial plaques in English, French, German, Hebrew, Polish, Romani, Russian, and other languages dedicated "to the four million victims" are located next to the international memorial. It was never clear to most visitors that the original plaque substituted figures about the mortality of all prisoners murdered in Poland (Jews, Gypsies, Soviet POWs, Polish nationals, members of the resistance, and others) for those killed only at Birkenau. This resulted in more than a decade of debate about Auschwitz mortality statistics in the international press. The plaques were removed in the spring of 1990 and will be reinstalled with the mortality statistics for those murdered at Auschwitz and Birkenau.

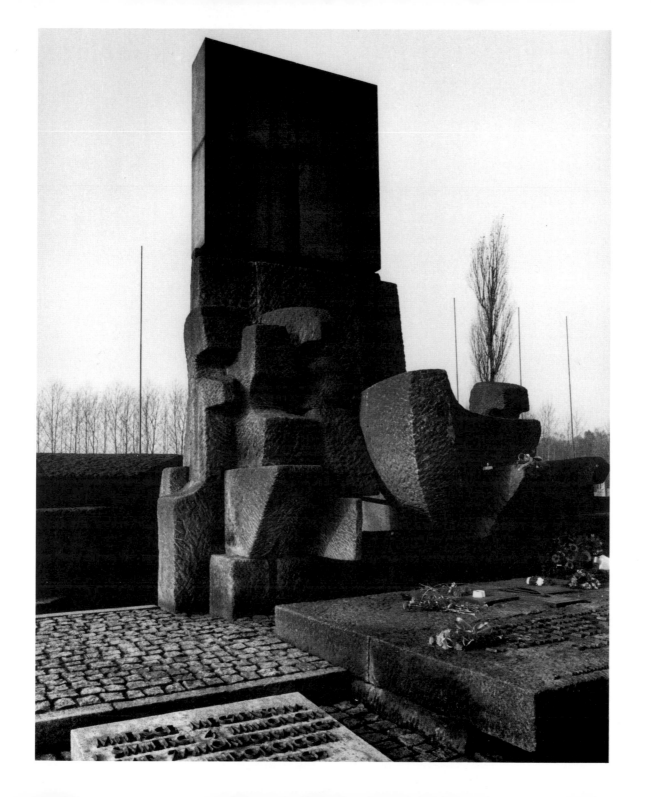

55. Monowitz: Located in the village of Monowice about 8 kilometers (about 5 miles) from Auschwitz, the memorial commemorates the victims of the vast slave labor complex known as Buna-Monowitz, or Auschwitz III, where factories spread over 14 kilometers (about 8.69 miles). The factories, including synthetic rubber, petroleum, pharmaceutical, and chemical plants, erected after February 1941, resulted in enormous profit for both industry and the SS since prisoners were worked to death on meager rations while the SS and industrialists pocketed their wages. Auschwitz III included 37 subsidiary camps, where approximately 150,000 prisoners perished. Many of the original factories are still utilized as part of the Polish chemical industries. The memorial consists of stylized granite blocks stacked in the shape of concentration camp perimeter posts without the electrified barbed wire; the posts are mounted on a triangular base, since the triangular patch was used in the camps to designate various prisoner categories and nationalities.

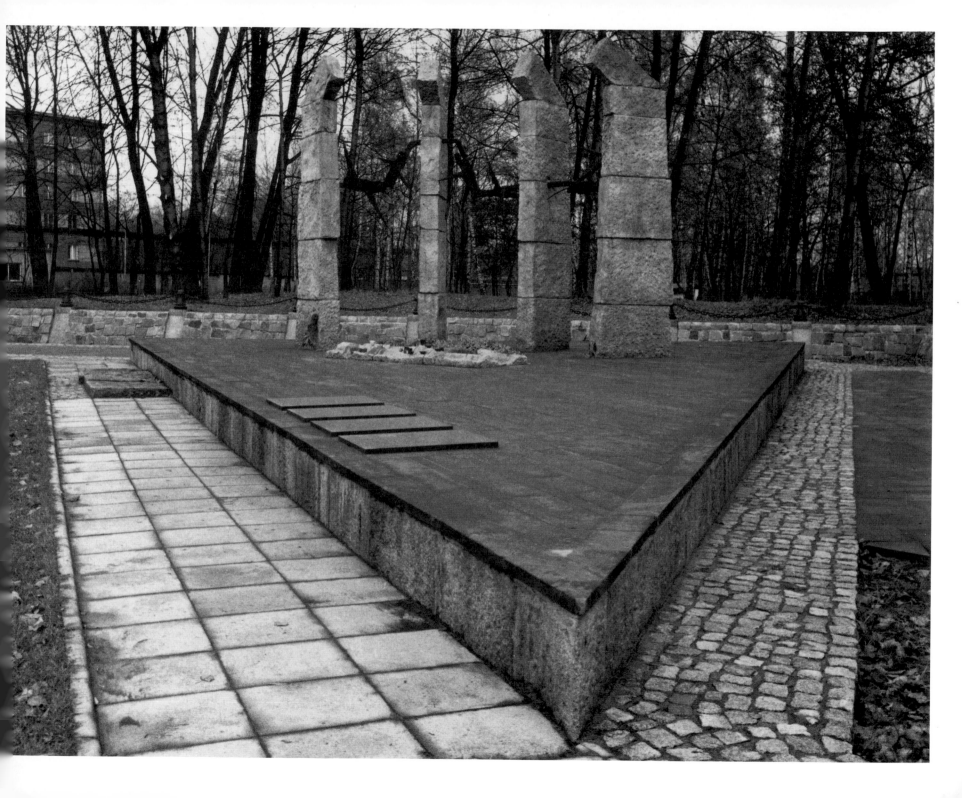

56. Plaszow: Located less than ten minutes by car from downtown Cracow, Plaszow was initially created in late 1940 as a forced labor camp; it became a concentration camp after January 1944. It held about 150,000 prisoners, of whom 80,000 perished, including Belgian, French, and Polish Jews as well as Gypsies, Poles, and Soviet POWs. The large memorial, designed by Ryszard Szczypczynski and Witold Ceckiewicz in 1964, consists of a sculpture without specific iconographic reference to the Jewish victims and an adjacent freestanding monument with Polish and Hebrew inscriptions for the Jewish victims at Cracow-Plaszow.

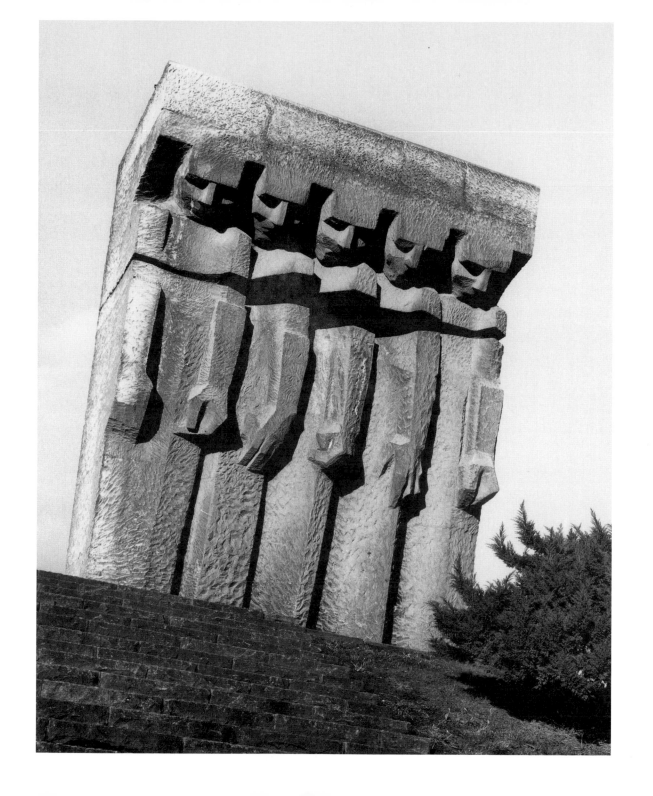

57. Treblinka: The railroad tracks at the village of Treblinka, linked by a 2.5 mile rail spur to the extermination camp. Until late August 1942, regularly scheduled passenger trains as well as deportation transports passed through the Treblinka village station. After 1 September 1942, the Treblinka village station was closed to normal passenger traffic in order to expedite the killing process.

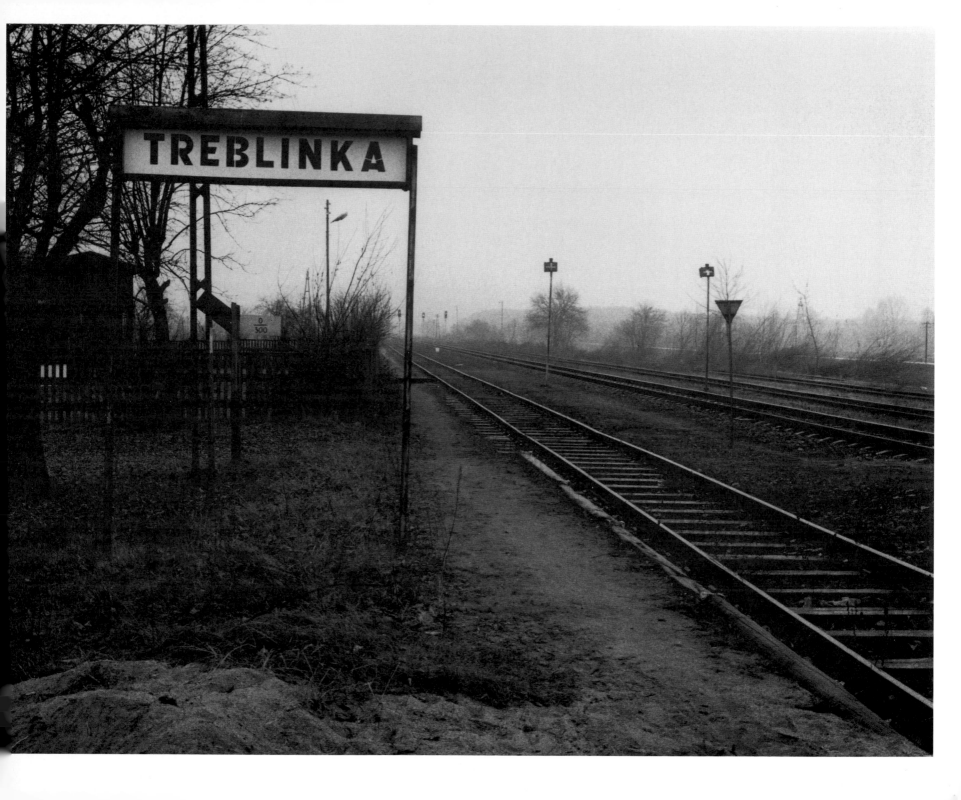

58. Treblinka: Concrete slabs stretching into infinity represent a symbolic railroad.

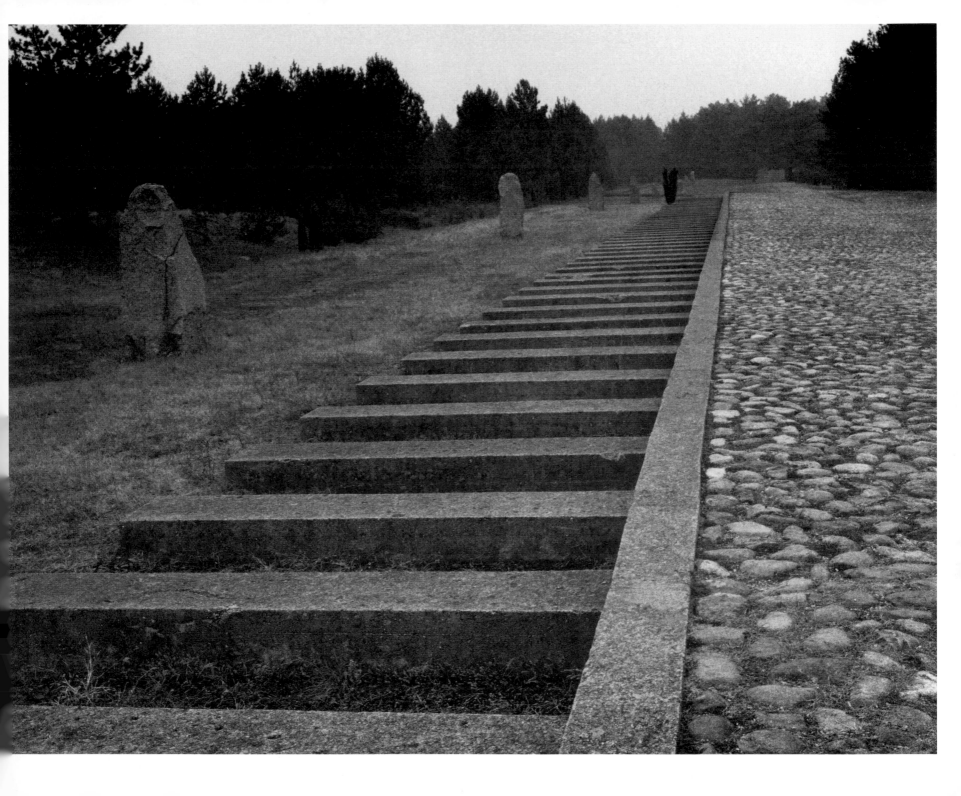

59. Treblinka: None of the original structures exist at Treblinka. The Treblinka killing center opened in July 1942 and was closed in November 1943. A revolt by the prisoners destroyed most of the camp in August 1943. The Germans also erased all physical evidence of the killing center and plowed over the land to hide their crimes. When the Treblinka memorial opened in May 1964, it contained about 17,000 jagged rocks of various shapes and sizes forming a symbolic cemetery. Many stones are inscribed with the name of a Jewish community destroyed during the Holocaust.

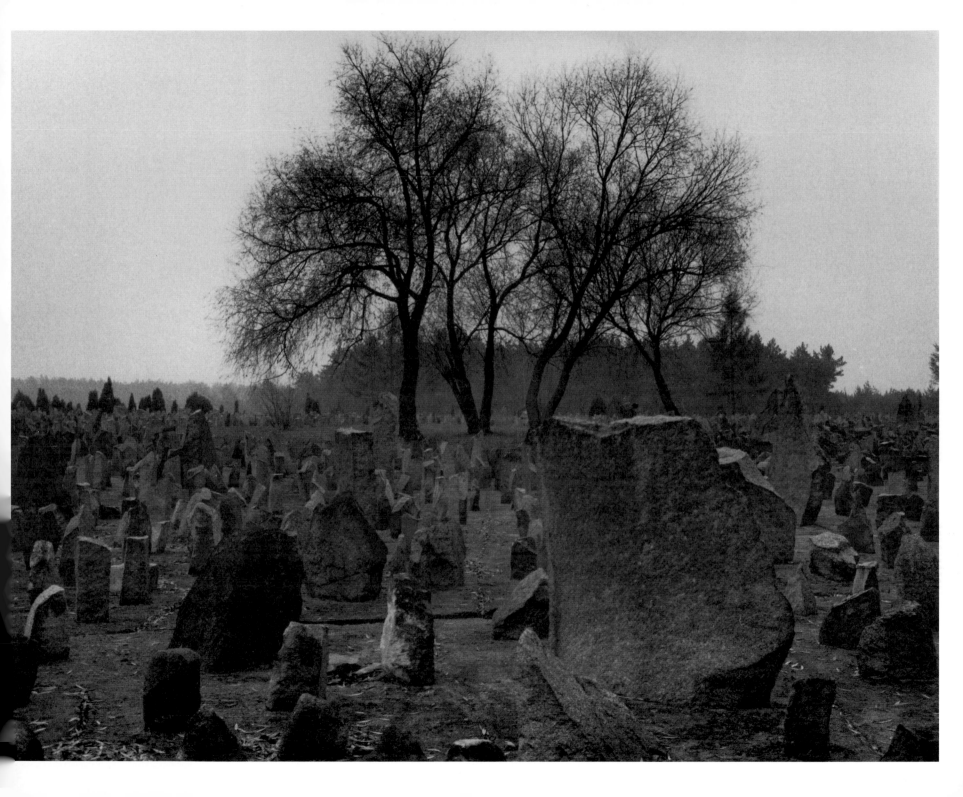

60. Treblinka: The memorial, designed by the Polish sculptors Adam Haupt and Franciszek Dusenko, was funded by public subscription (1961–64). The inscription on the rock to the left of the memorial for Warsaw Jews states "Never again" in several languages.

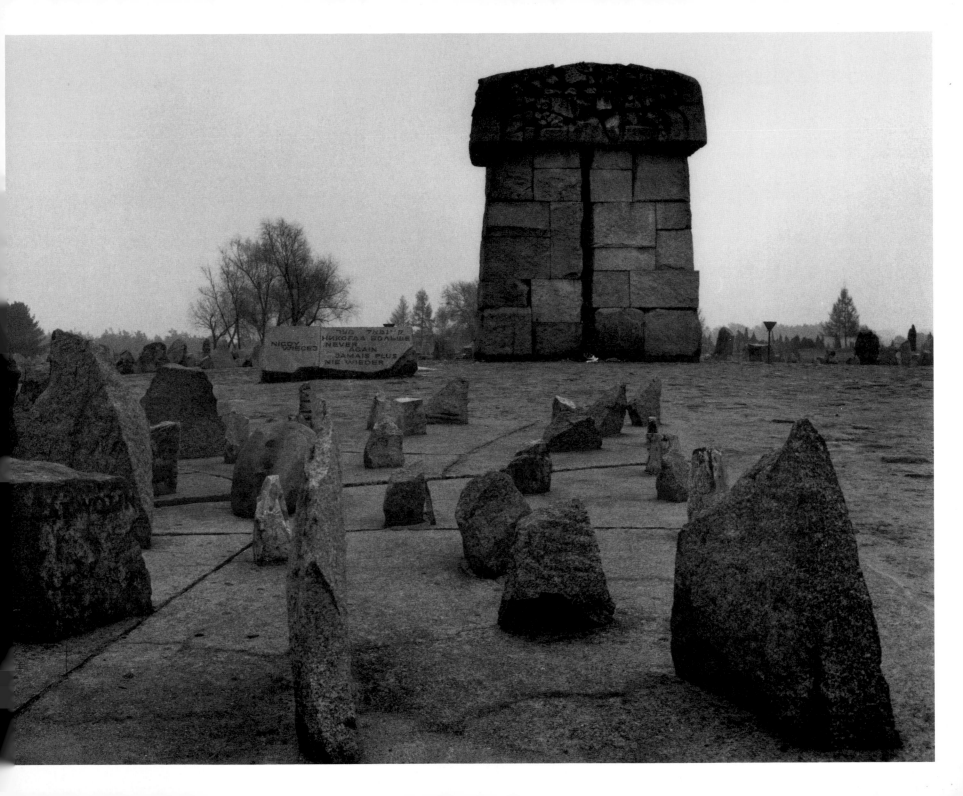

61. Treblinka: The central stone memorial for the Jews of Warsaw is 7 meters high (close to 22 feet). The stone is divided into two segments, separated by a narrow opening. This fissure symbolizes the irreparable breach of Jewish life in Poland after Treblinka; it also serves as a metaphor for the broken tablets of Moses.

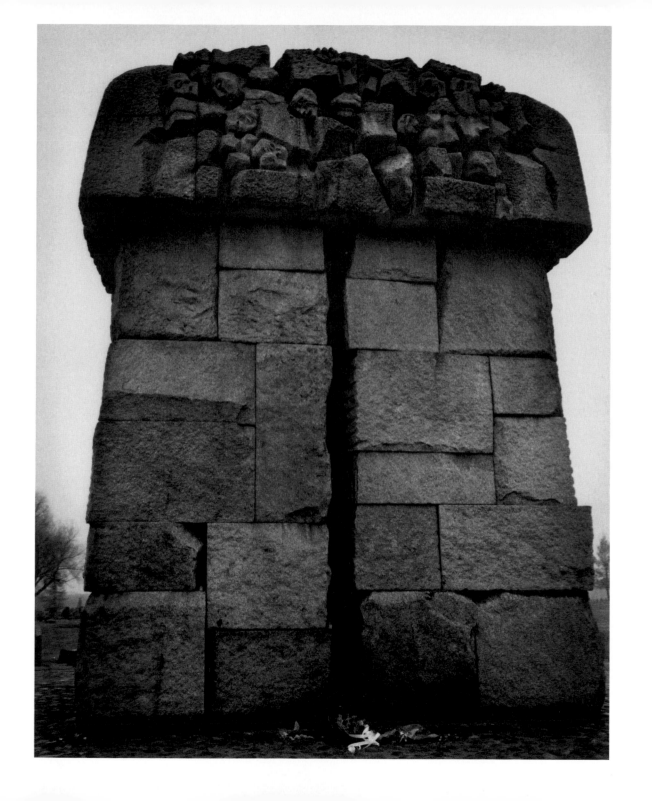

62. Treblinka: A shattered menorah is engraved near the top of the monument. This subtle iconography, sensitive to Jewish concerns, is unusual in memorials built in communist Poland.

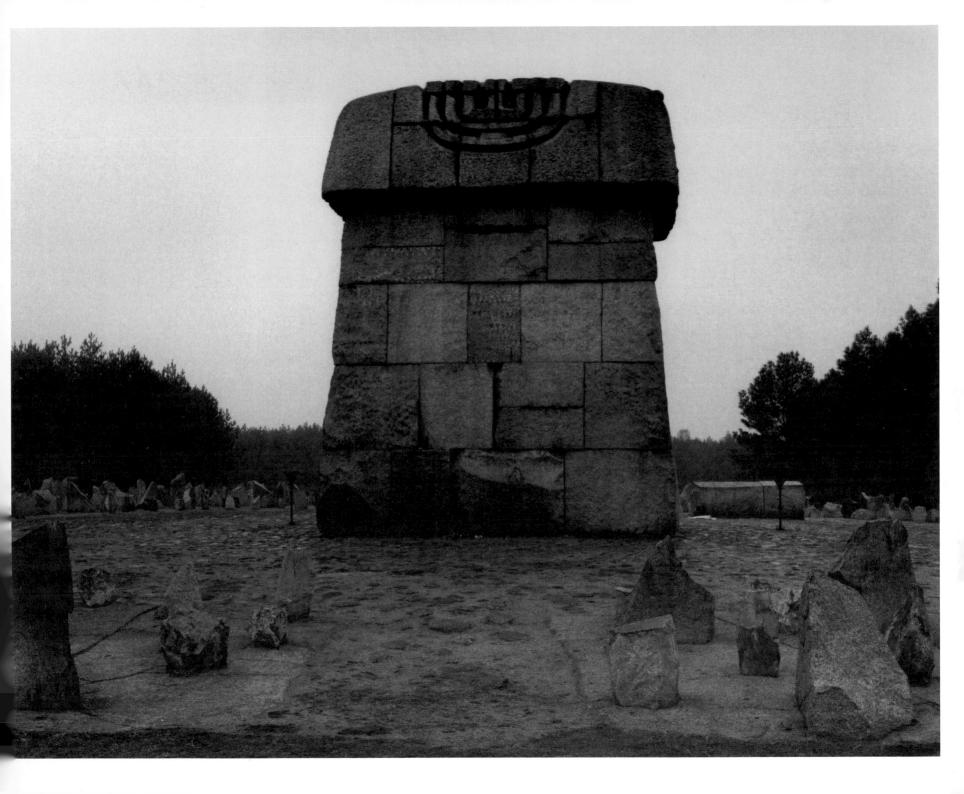

63. Maidanek: The memorial has two components. The first section, known as the Monument of Struggle and Martyrdom with the adjacent Memorial Road, consists of massive blocks of irregular stone forms resting on two monoliths, symbolizing a valley of death. This abstract sculpture has a faint resemblance to the shape of a menorah. The sculptor Wiktor Tolkin and the architect Janusz Dembek completed this work in 1970 after winning a juried competition for the monument.

Wiktor Tolkin (b. 1922) was arrested in 1942 and deported via Paviak prison to Auschwitz (1942–August 1944) and Sandbostel, a satellite of Neuengamme. He also designed the memorial at Stutthof. (See Wiktor Tolkin, "Die Denkmäler in Stutthof und Majdanek," *Zeichen* [March 1988]: 20–21.)

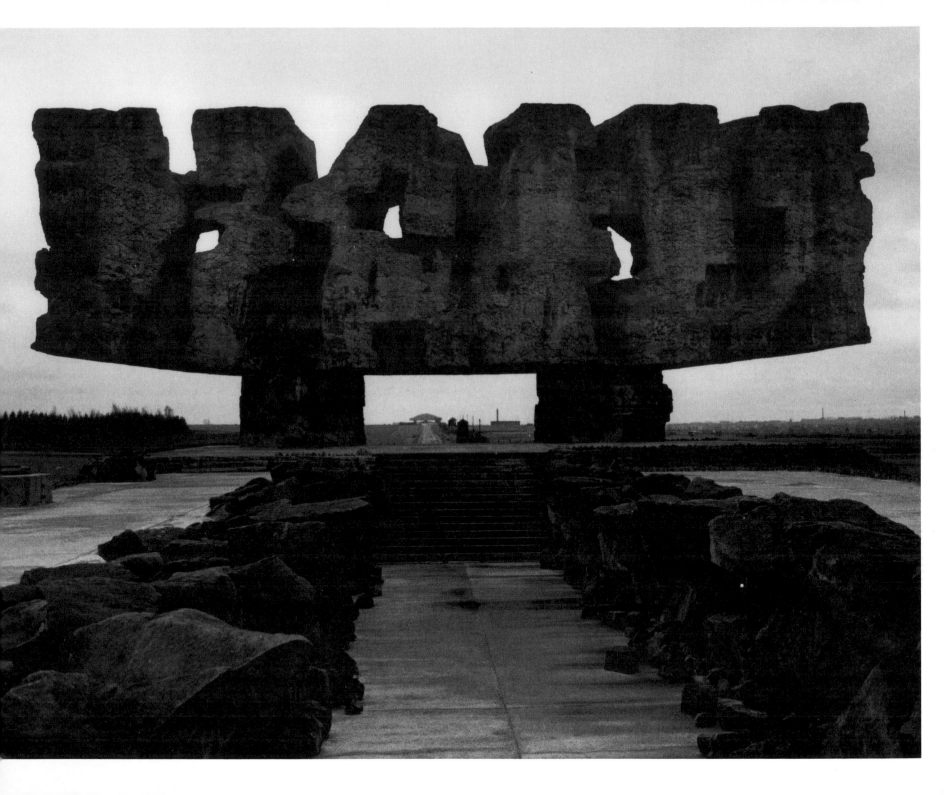

64. Maidanek: The second part of the memorial, known as the Mausoleum or Pantheon, is shaped like an urn covered by a raised stone dome, allowing visitors to enter under the dome, or lid. This mausoleum consists of a 4,429 cubic foot mountain of ash from the Maidanek crematorium. The inscription states: "Let our fate be a warning."

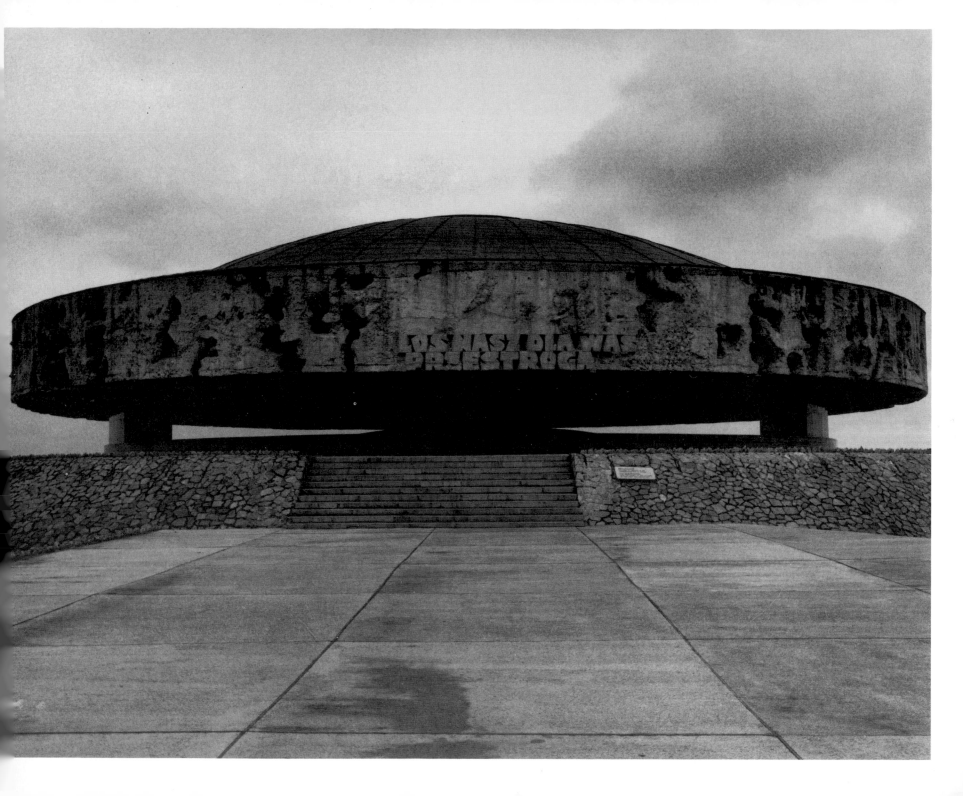

65. Maidanek: Sculpture from the special exhibition "Against War" installed outside Barrack 62; this barrack houses a gallery of modern art about the Holocaust.

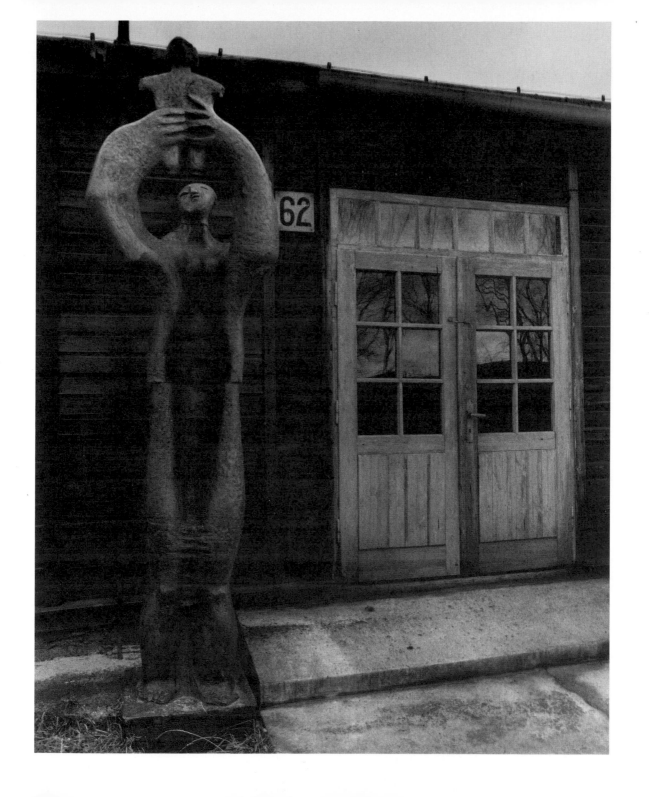

66. Warsaw, Paviak Prison: The burned tree outside the former Paviak jail on Dzielna Street is one of the few objects to survive the destruction of the Warsaw ghetto.

Paviak, built in 1835, was originally used as a jail for Polish revolutionaries who fought against Tsarist rule in the nineteenth century. After the German occupation of Warsaw, Paviak was located inside the ghetto boundaries. It held more than 99,000 Polish and Jewish prisoners between 1939 and 1944; one third of them were murdered there or deported to concentration camps. The prison was spared during the destruction of the ghetto in April and May 1943 and turned into a concentration camp. The jail was razed during the 1944 uprising.

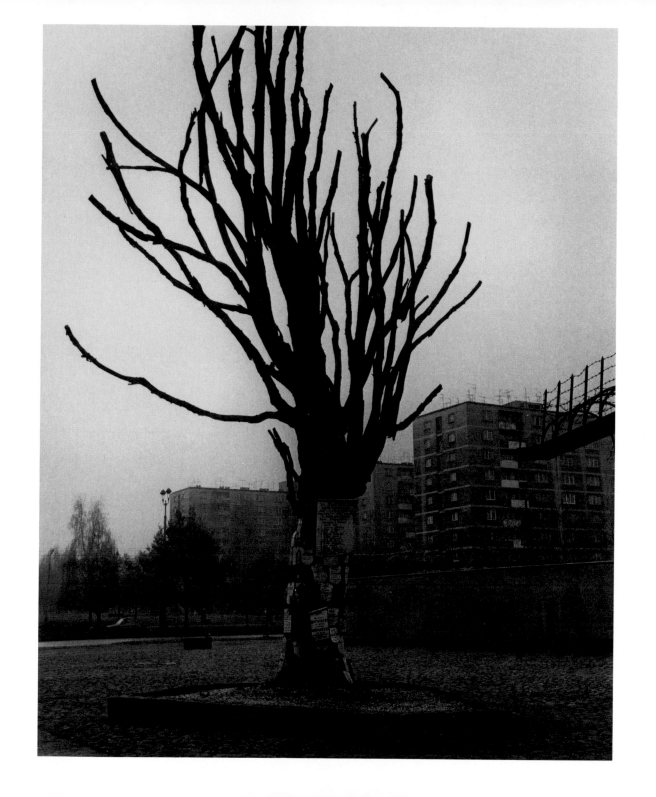

67. Warsaw, Paviak Prison: The individual plaques nailed to this blackened and leafless tree commemorate Polish political prisoners killed at Paviak. There are few signs for Jewish prisoners who also died in this prison.

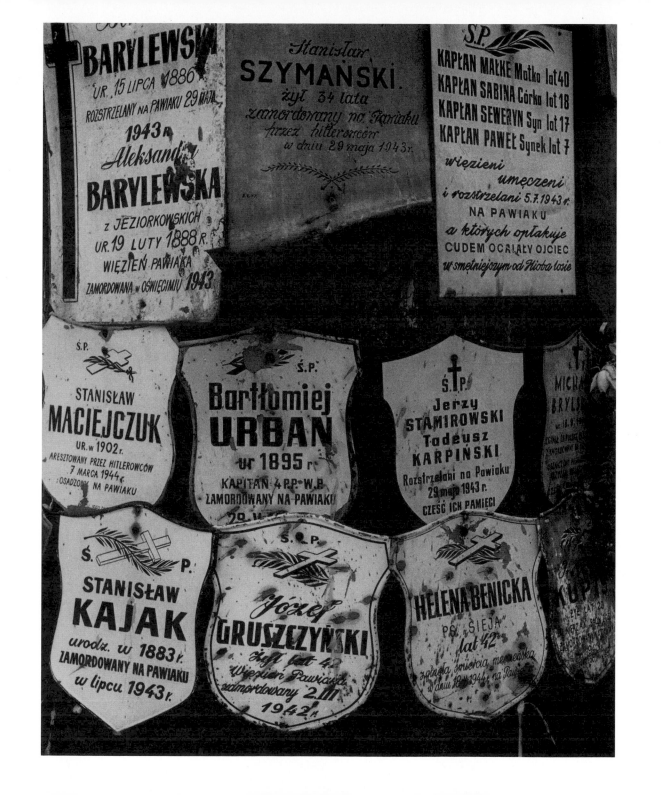

68. Ravensbrück: Will Lammert's two bronze statues of women prisoners standing watch in front of mass graves; the statues are facing the lake across the courtyard. The mass graves are located alongside the original camp wall. The names of the 20 countries of origin of the victims are inscribed in bronze letters on the camp wall behind each grave. Lammert initially conceived of these figures as part of the main Ravensbrück memorial sculpture, which was completed posthumously by Fritz Cremer. Lammert's premature death resulted in the separate installation of these two female figures (1954–57).

Will Lammert (b. 1892, Hagen – d. 1957, Berlin) was initially apprenticed as a wood and stone sculptor in the atelier of Moshe Kogan and attended the Hamburg commercial art academy. His career was interrupted by military service and severe wounds in World War I. He set up an independent atelier as a sculptor in Hagen (1918–22) and Essen (1922–31). In 1931 he won the prize of the Prussian State Academy of Art, enabling him to study in Rome at the Villa Massimo for two years. As a member of the Communist party since 1932, he was forced to immigrate to Paris after the Nazis assumed power in 1933. His atelier and works were destroyed by the Nazis. Lammert was expelled from France in 1934 because of his political activities and went to the Soviet Union (Moscow and Kazan). He returned to Berlin in 1951 and worked on the Ravensbrück memorial from 1954 until his death in 1957.

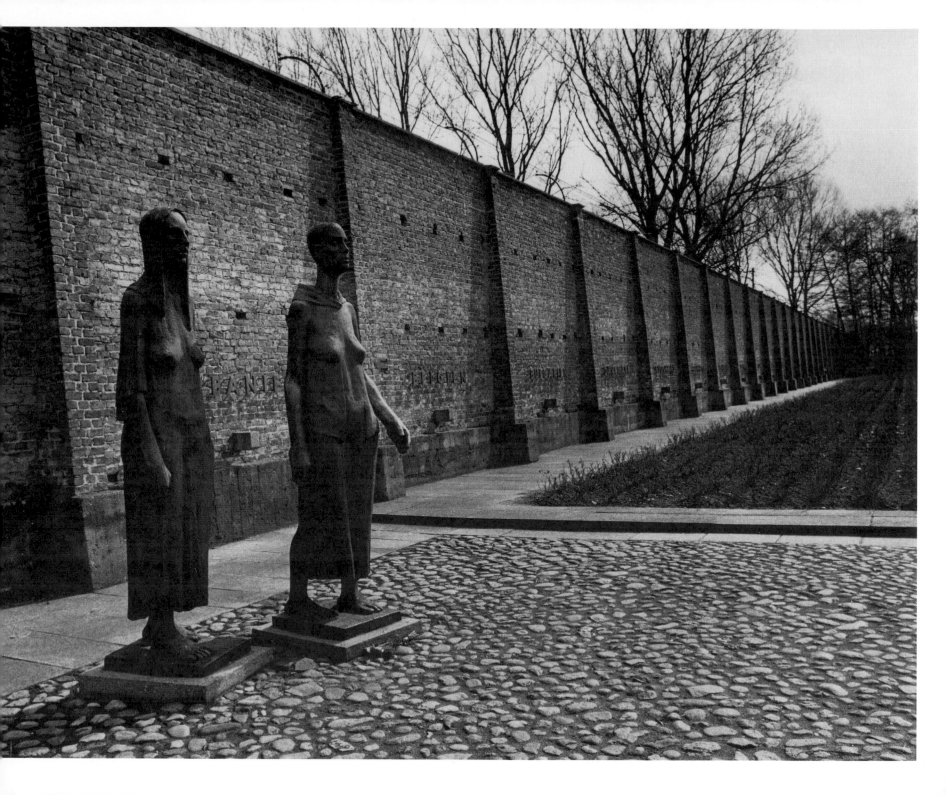

69. Ravensbrück: Lammert's two bronze statues of women prisoners.

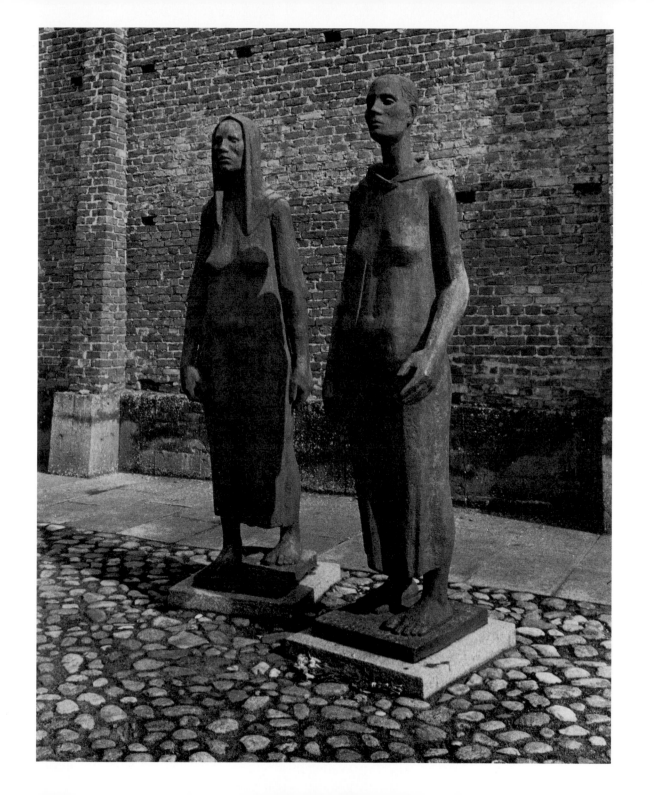

70. Sachsenhausen: A three-sided equilateral concrete obelisk inscribed with inverted red triangles, called the *Tower of Nations*; it faces the *Appellplatz* and semicircular barracks. René Graetz's sculpture *Liberation*, commemorating Soviet liberation of the camp, is in front of the obelisk.

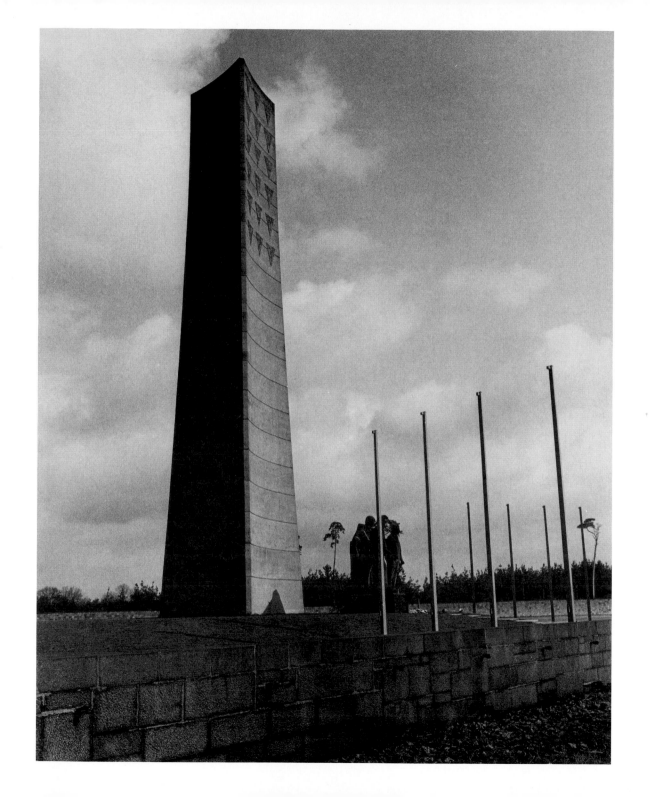

71. Sachsenhausen: White sculpture of fettered prisoners at the European Antifascist Exhibition Pavilion.

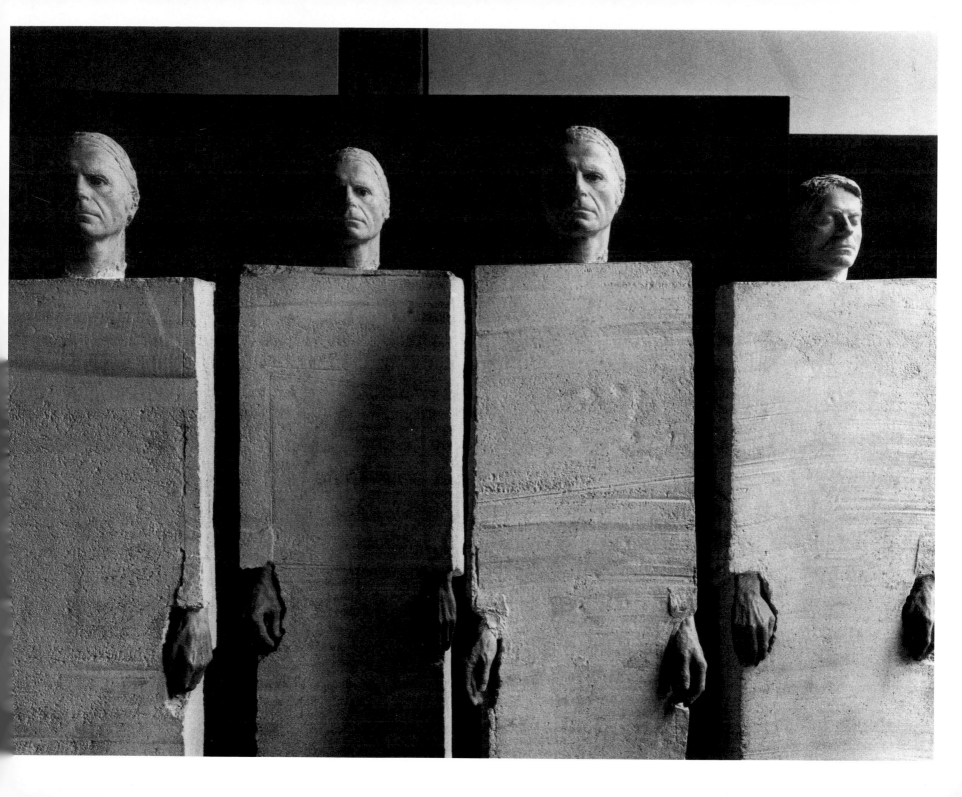

72. Dachau: Nandor Glid's bronze international memorial (1968) located at the axis of the former *Appellplatz*, facing south toward the barracks. Glid's memorial is 16 meters long (ca. 52 ft.) and 6.3 meters high (ca. 20.47 ft.). A smaller replica of this work (30 ft. long x 12 ft. high) was installed at Yad Vashem in 1979.

 Nandor Glid (b. 1924, Subotica, Yugoslavia; resides in Belgrade) escaped from Szeged concentration camp in October 1944, where his family (Yugoslav Jews) was killed. He subsequently fought with Tito's partisans. After the war he attended the Belgrade School of Applied Art and was part of the team that designed the Yugoslav memorial at Mauthausen in 1957. Since 1975 he has taught sculpture at the faculty of applied art in Belgrade and was appointed in 1985 rector of the Art University. He has done several memorial sculptures about the concentration camps.

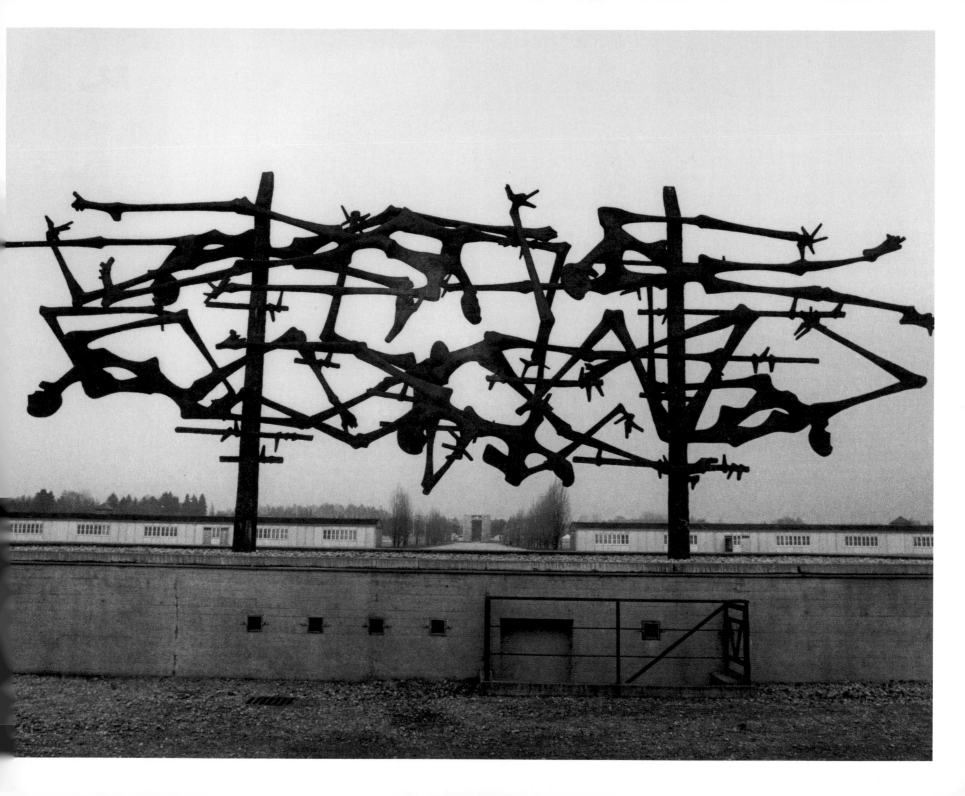

73. Dachau: The Jewish Memorial Temple, built in 1965, is located behind a stylized barbed wire fence. Behind it is the Catholic *Todesangst Christi* Chapel—literally the "Christ–Fear of Death" Chapel—built in 1960.

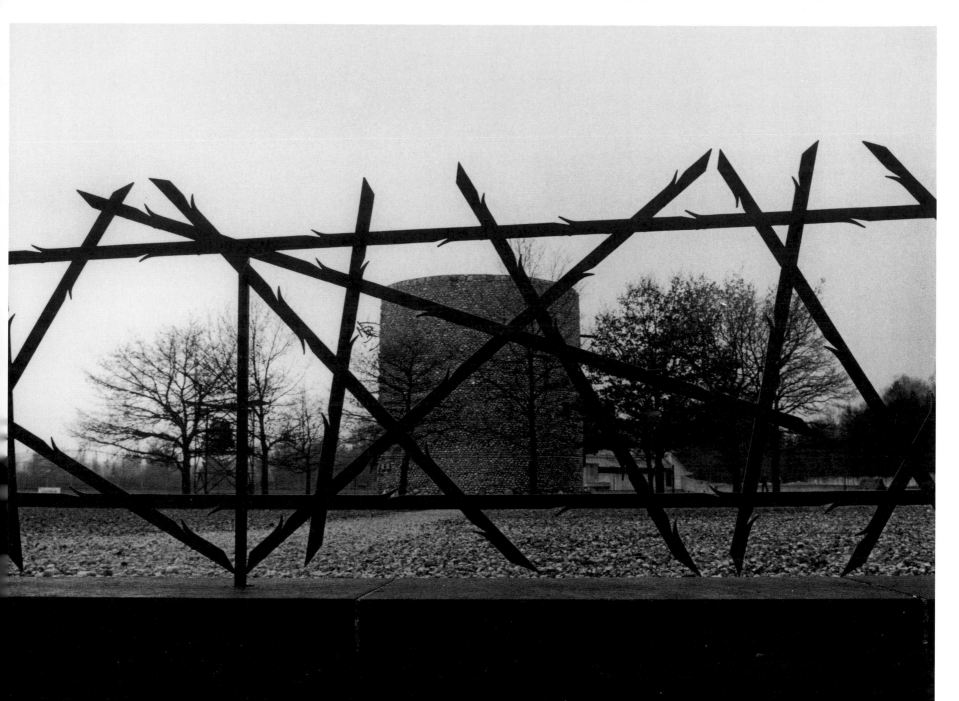

74. Neuengamme: Françoise Salmon's bronze sculpture, *The Unknown Prisoner*, (1.85 meters high, or ca. 6 ft.) was installed outdoors at the intersection of two freestanding walls in 1965. The inscription carved nearby reads: "Your suffering, fight, and death must not have been in vain."

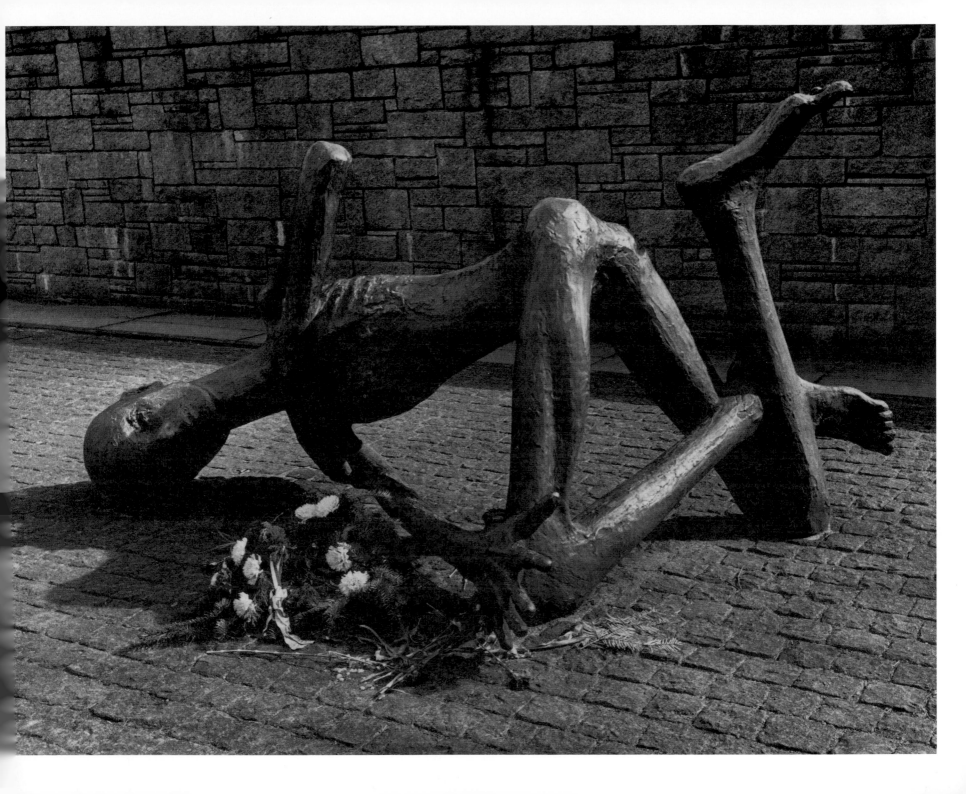

75. Neuengamme: Hebrew flagstone in honor of the Jewish dead.

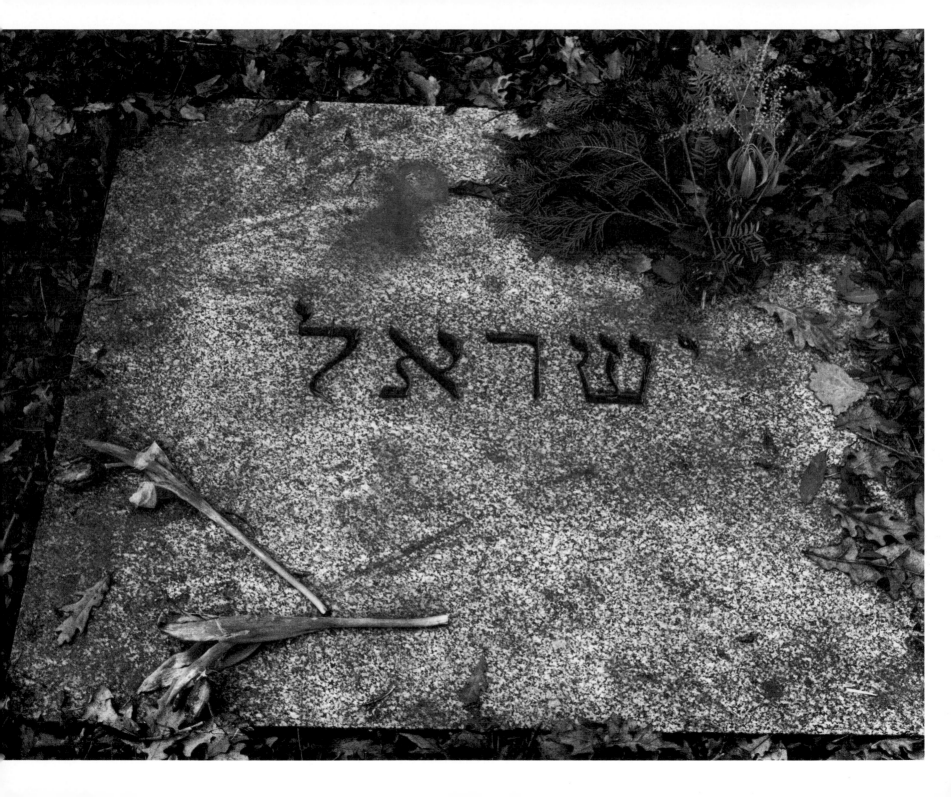

76. Bergen-Belsen: The oldest Jewish memorial was installed in April 1946 between the mass graves with inscriptions in English and Hebrew.

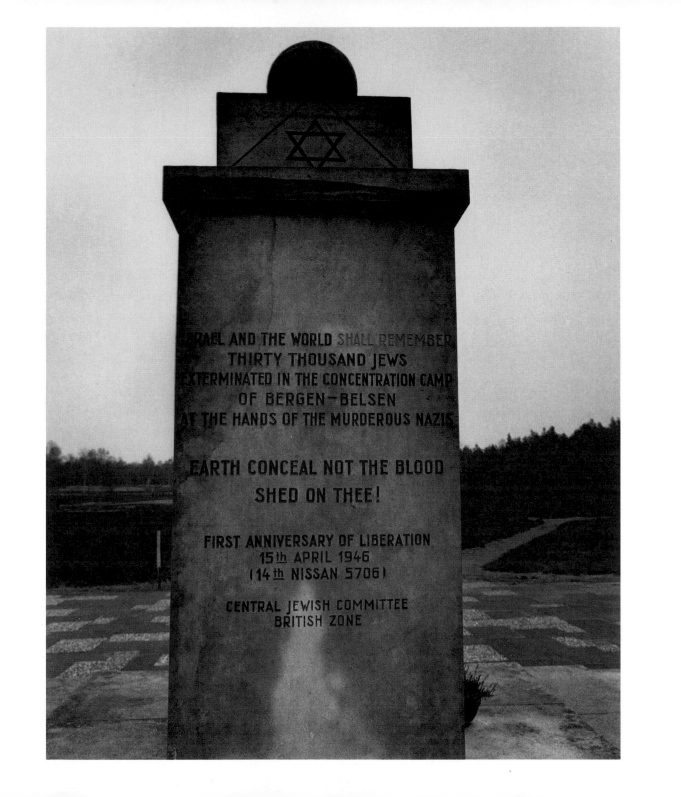

77. Mauthausen: The monument for Jewish victims, a menorah with seven arms symbolizing a cosmic tree, was erected in 1976 and occupies a total site of 15 meters (ca. 49 ft.). It was designed by two Viennese architectural engineers, Lazar Segal and Breitner. The skeletal frame is made from rolled steel installed on a concrete pedestal. The work seems to be designed against the force of gravity, with a relatively narrow base supporting the bulk of the weight in the branchlike arms. The arms were made from hollow steel molds and are 5 meters high x 5 meters wide (ca. 16 x 16 ft.). The total steel weight of this sculpture is about 4,500 kilograms (roughly 9,900 pounds; nearly 5 tons). In 1982 the press reported that cracks were visible in the base and that rust had appeared on the steel arms.

The sculpture park at Mauthausen links the two main historic sections of the camp, serving as physical and psychological breathing space between the historic structures of the camp and the death steps leading to the stone quarry. The more than 20 monuments added piecemeal over forty years provide a microcosm of different national memorial styles. It is increasingly difficult for new public monuments to find suitable spatial relationships to the works already installed on this grassy stretch of land where SS barracks once stood.

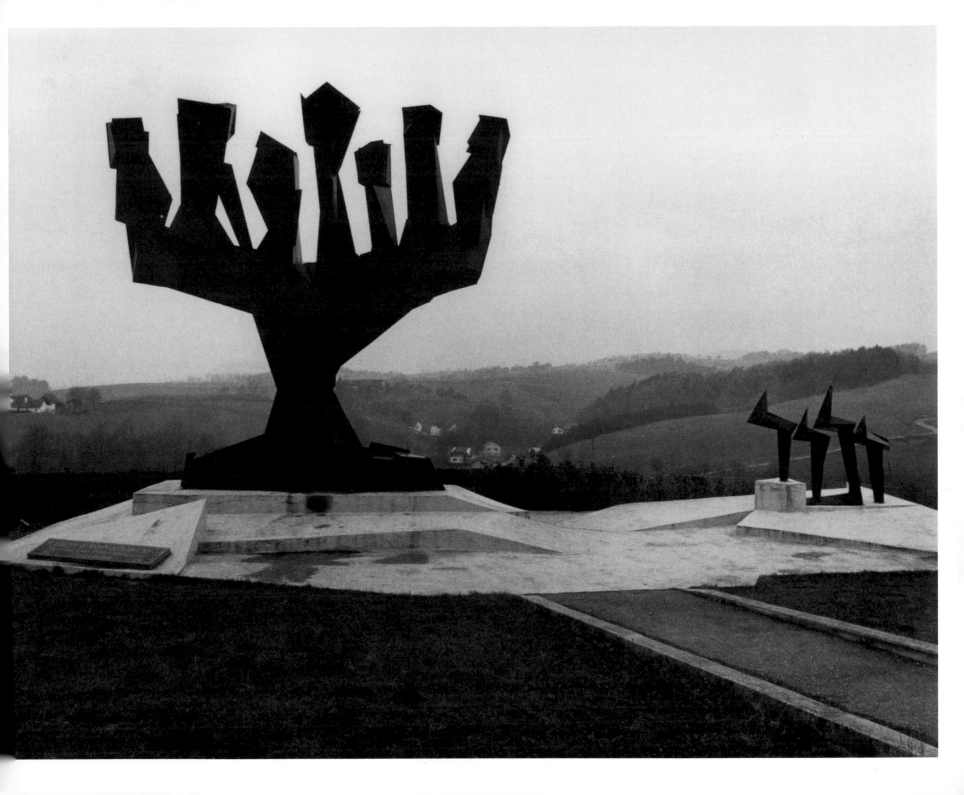

78. Mauthausen: The Italian memorial was designed in the form of a "wailing wall," with space reserved for individual memorial plaques and cameo photographs mounted by the families of the deceased. The granite wall is 2 meters high (ca. 6.5 ft.) and was built by the Italian sculptor Mirko Basaldella and a Viennese engineer Hans Bauer.

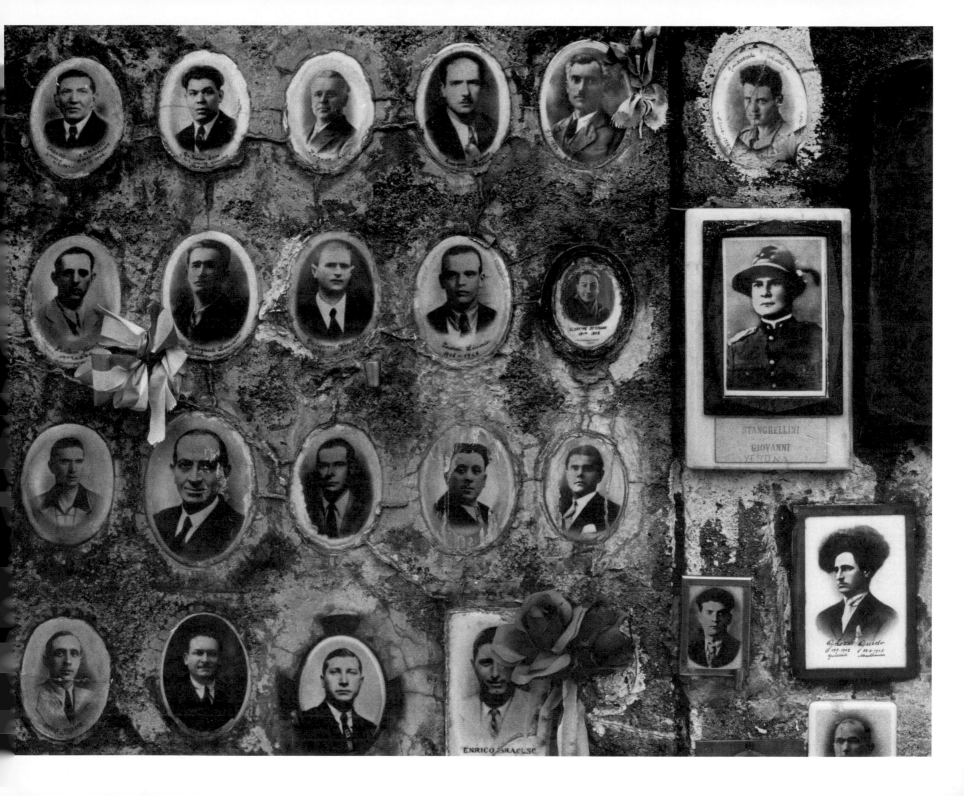

79. Mauthausen: A section of Basaldella's and Bauer's Italian monument.

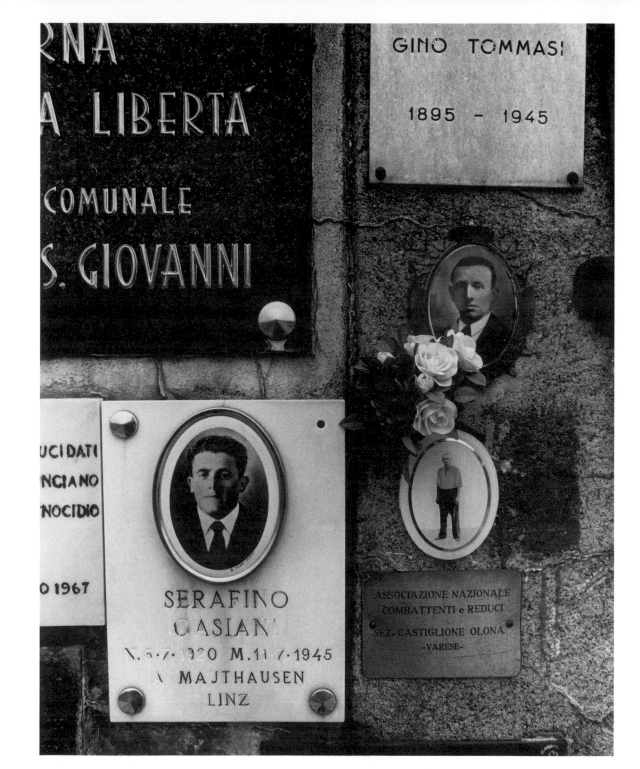

80. Mauthausen: The jagged cage with protrusions suggesting both bayonets and barbed wire stands adjacent to the wailing wall. This segment of the Italian memorial was designed by Mirko Basaldella in 1955. Basaldella reformulated his second prize submission from the 1953 London sculpture competition on the theme of "the Unknown Political Prisoner." His initial maquette (1953) was a dense but delicate latticed wire cage, lacking the power of his Mauthausen monument.

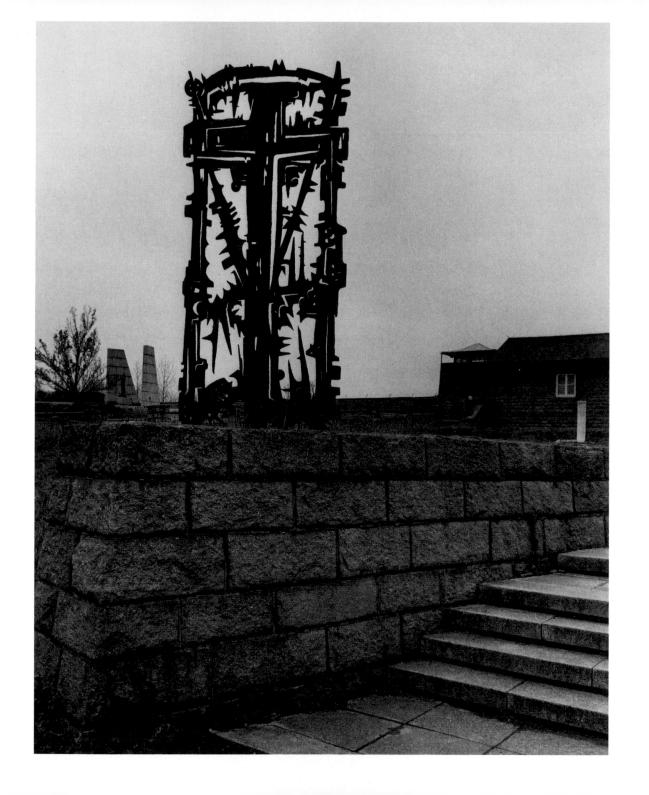

81. Mauthausen: The memorial for 7,000 Spanish Republican prisoners who died at Mauthausen, erected in May 1962. On the left the Czech memorial installed in 1959 is also visible.

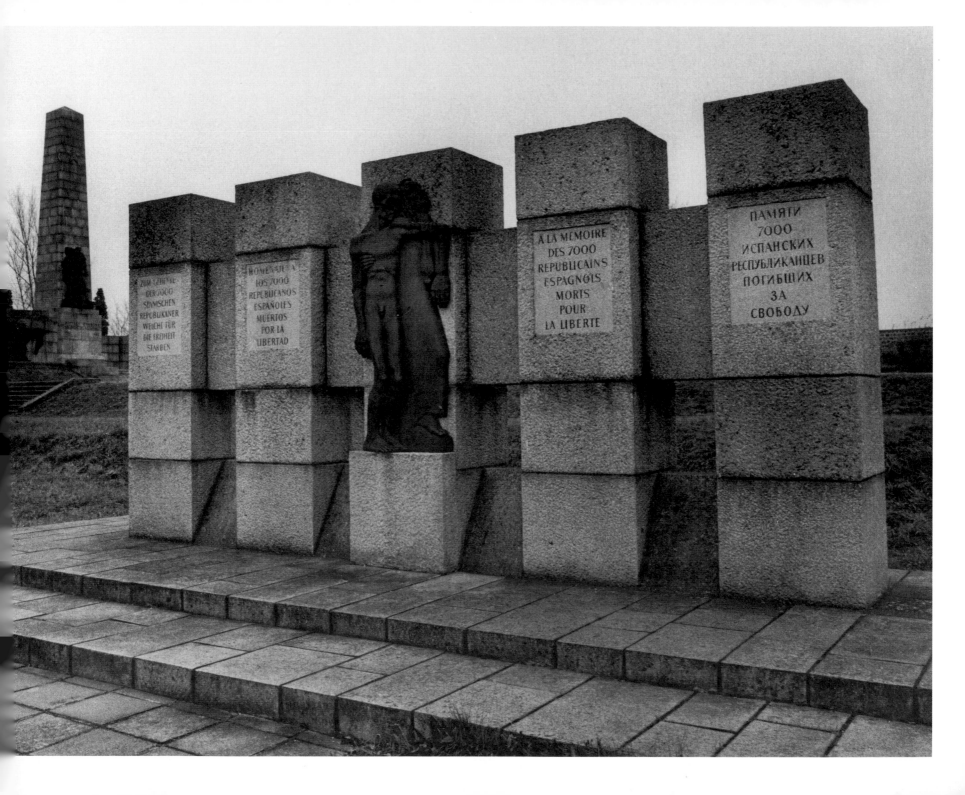

82. Mauthausen: The Hungarian memorial, designed by the sculptor Agamemnon Makrisy and the architect Istvan Janaky, was built in 1964. The base consists of four uneven granite blocks, whose height ranges on an incline from .7 to 2.08 meters (ca. 2.3 ft. to 6.69 ft. high). Atop this base are nine bronze figures without individualized features; each figure is 2.8 meters (ca. 9 ft.) high. Each group of three figures was cast from the same mold so that the figures look identical from every direction. As the viewer moves, the figures always appear the same, thereby representing prisoner solidarity.

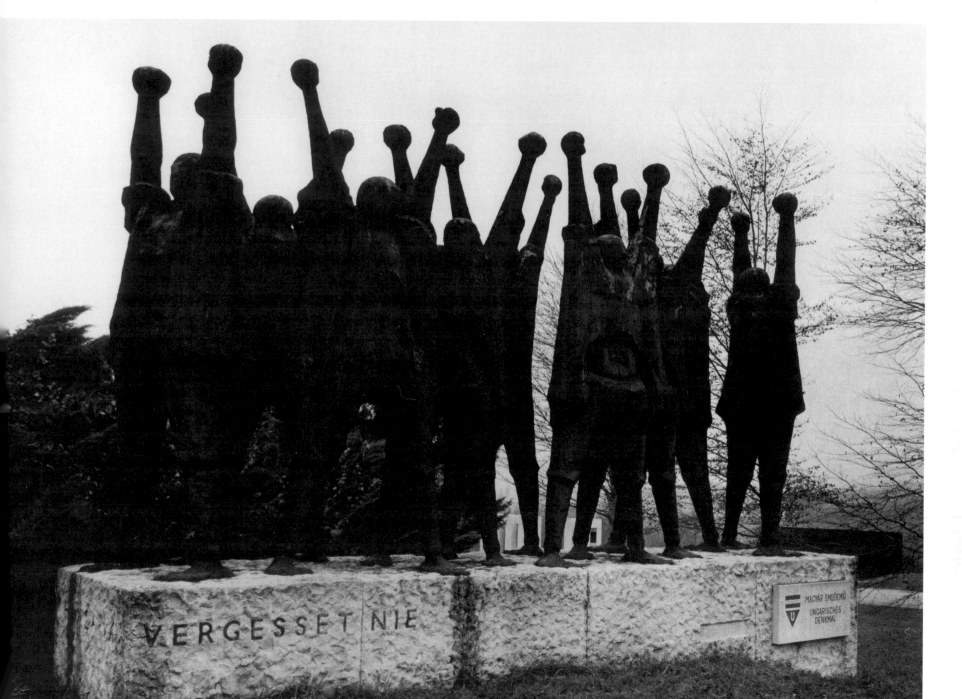

83. Mauthausen: The memorial from the German Democratic Republic was created by the Buchenwald collective with Fritz Cremer as sculptor (1967). The seated grief-stricken woman is sculpted in bronze and is 2.5 meters (ca. 8 ft.) high; the figure is on a pedestal 1.25 meters x 1.4 meters (ca. 4 ft. x 4.5 ft.).

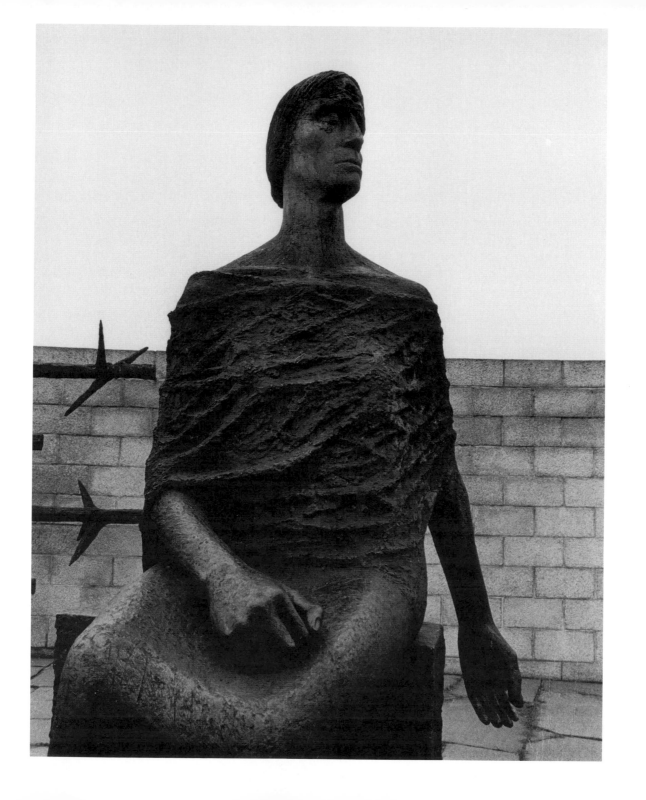

84. Buchenwald: The postwar monument park at Buchenwald —designed by the architects Ludwig Deiters, Hans Grotewohl, Horst Kutzat, and Kurt Tausendschön—was planned as an integral whole, unlike most other concentration camp memorials. It was the largest of the three memorials in the German Democratic Republic and integrates freestanding reliefs, sculpture, landscaping, and architecture on terraced slopes (600 x 520 meters or 1950 ft. x 1690 ft.) of the Ettersberg mountainside overlooking Weimar. The extensive scale of the memorial dwarfs the historic concentration camp. This neoclassical bell tower, roughly eight stories or 55 meters high (178.75 ft.), has the Fritz Cremer heroic sculpture *Revolt of the Prisoners* at its base.

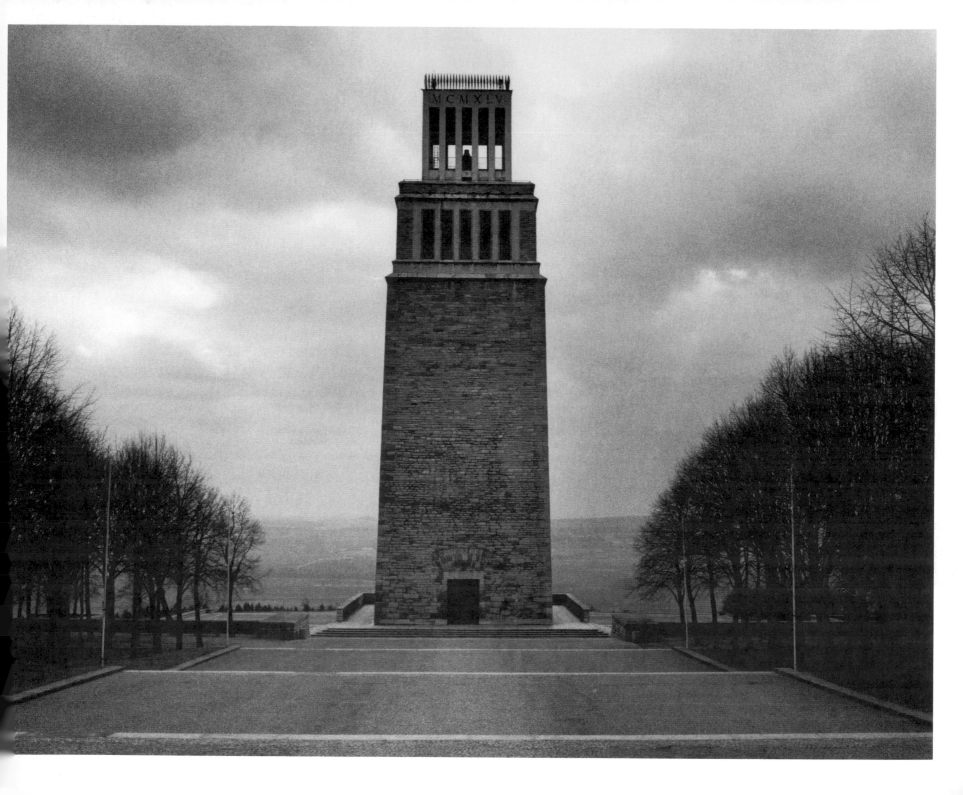

85. Buchenwald: The subject of Cremer's *Revolt of the Prisoners* is the Buchenwald prisoner revolt liberating the camp prior to the arrival of the Americans. This bronze sculpture consists of 11 figures in movement and is 4 meters high (ca. 13 ft.).

Fritz Cremer (b. 1906, Arnsburg/Ruhr) studied sculpture in Essen (1922–26) and at the Academy of Art in Berlin (1927–34). He joined the Communist party in 1929 and protested Käthe Kollwitz's expulsion from the Prussian Academy of Art in 1934. He was drafted, served in Greece and Crete, and was a prisoner of war in Yugoslavia. From 1946 to 1950 he was professor of sculpture at the Academy of Applied Arts in Vienna. After returning to Berlin in 1950, he accepted a commission to work on the memorial at Buchenwald. He also completed Lammert's unfinished Ravensbrück monument.

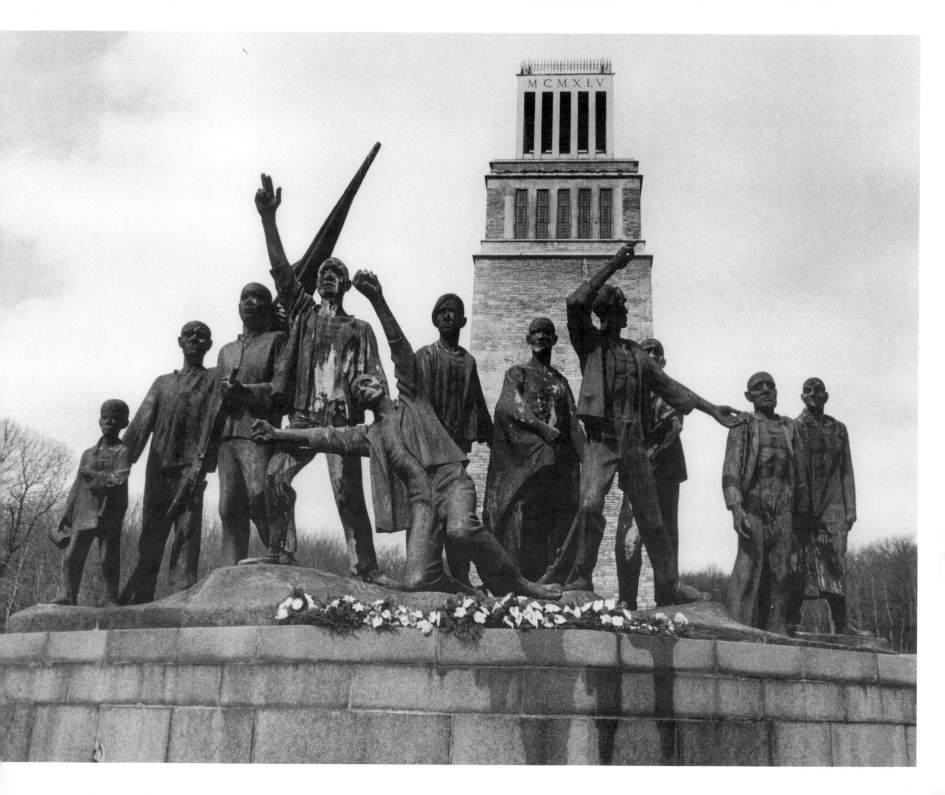

86. Buchenwald: One of seven stelae with bas-reliefs forming a narrative cycle of the seven years from the creation of Buchenwald in 1937 to its liberation in April 1945. Each bas-relief is inscribed with poetry by Johannes Becher, the communist poet laureate of the German Democratic Republic. The seven reliefs exit in the massive 316 meter long and 18 meter wide Avenue of the Nations. This photograph shows the third bas-relief, which deals with the exploitation and death of the prisoners; it was carved by Waldemar Grzimek, who is also known for his sculpture at the Sachsenhausen crematoria.

Waldemar Grzimek (b. 1918, Rastenburg, East Prussia) studied until 1941 at the Academy of Fine Arts in Berlin. He was drafted into the German army and served from 1941 to 1945; since 1946 he has taught sculpture at art academies in Halle and Berlin. In 1959 he was awarded the German Democratic Republic's national prize.

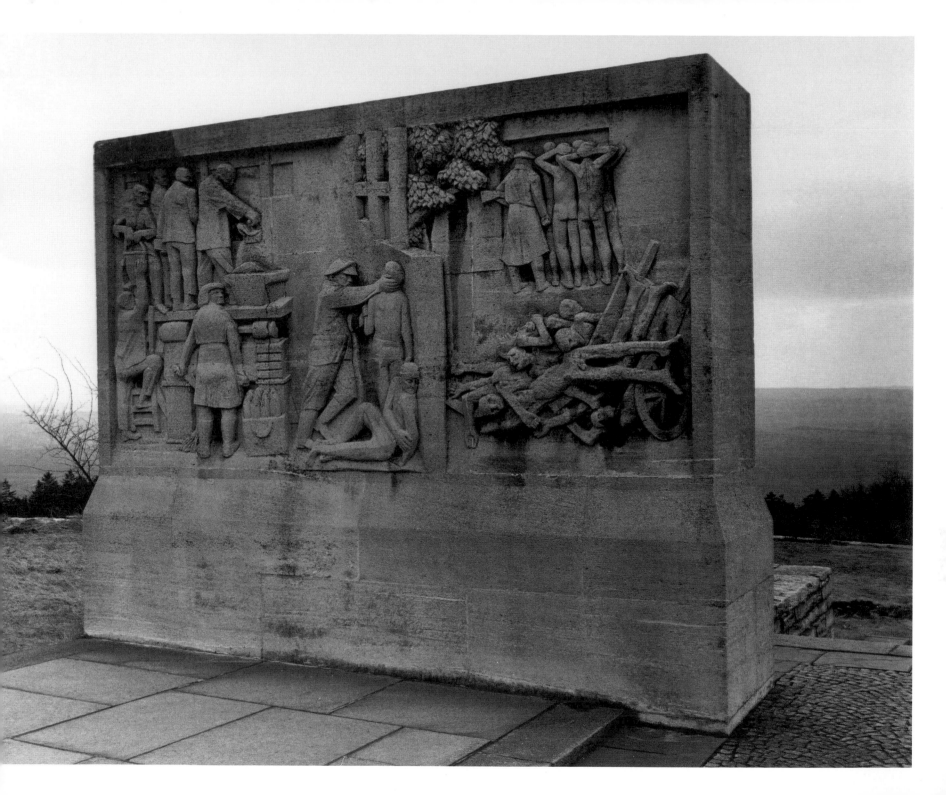

87. Amsterdam, Jonas Daniel Meijerplein: *The Dock Worker* statue, located in the Jewish quarter of Amsterdam, honors the participants of the 25–26 February 1941 strike in Amsterdam, which publicly protested the deportation of 400 Jews (to Buchenwald and Mauthausen) and the German decision to send Amsterdam shipyard workers to Germany. During the strike the streetcars stopped in Amsterdam, utilities went dead, and the shipyards were deserted.

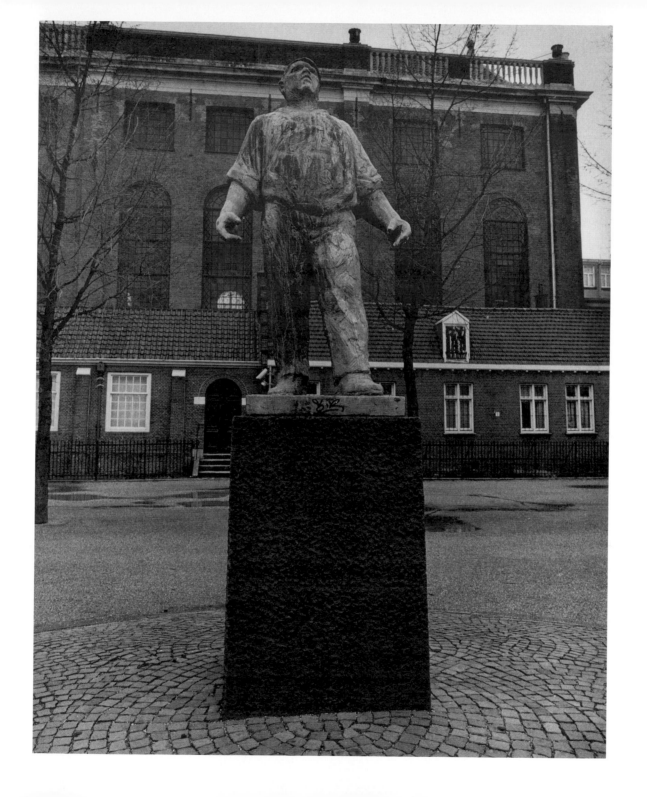

88. Amsterdam, Museumplein: Monument erected in November 1978 honoring 250,000 Gypsies killed by the Nazis. Also located at Museumplein is the memorial for the women of Ravensbrück. (Photograph courtesy of Ad van Denderen, Amsterdam)

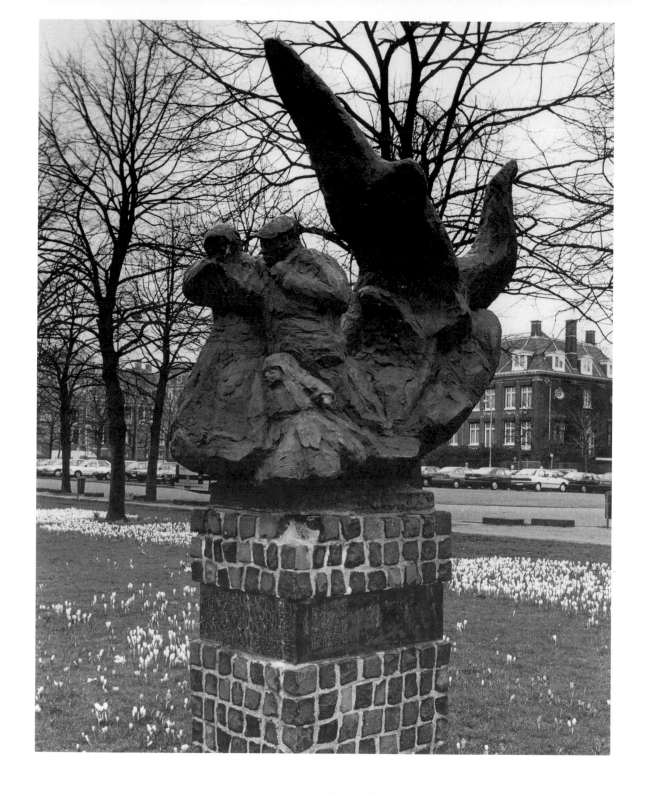

89. Amsterdam, Westermarkt: The *Homomonument,* unveiled in September 1987, is centrally located in downtown Amsterdam (very close to the Anne Frank House). The monument honors homosexuals persecuted by the Nazis. Designed by Karin Daan, it consists of three inverted pink granite (Rosa Porino stone) triangles, connected to form one large triangle covering 561 square meters (5,925 sq. ft.). The inverted triangle in various assigned colors was the insignia worn by all concentration camp prisoners. (Photograph courtesy of Ad van Denderen, Amsterdam)

Karin Daan (b. 1944, Gennep) studied at the Arnhem Academy of Fine Arts (1965–70). Since 1981 she has built numerous environmental sculptures and buildings in the Netherlands.

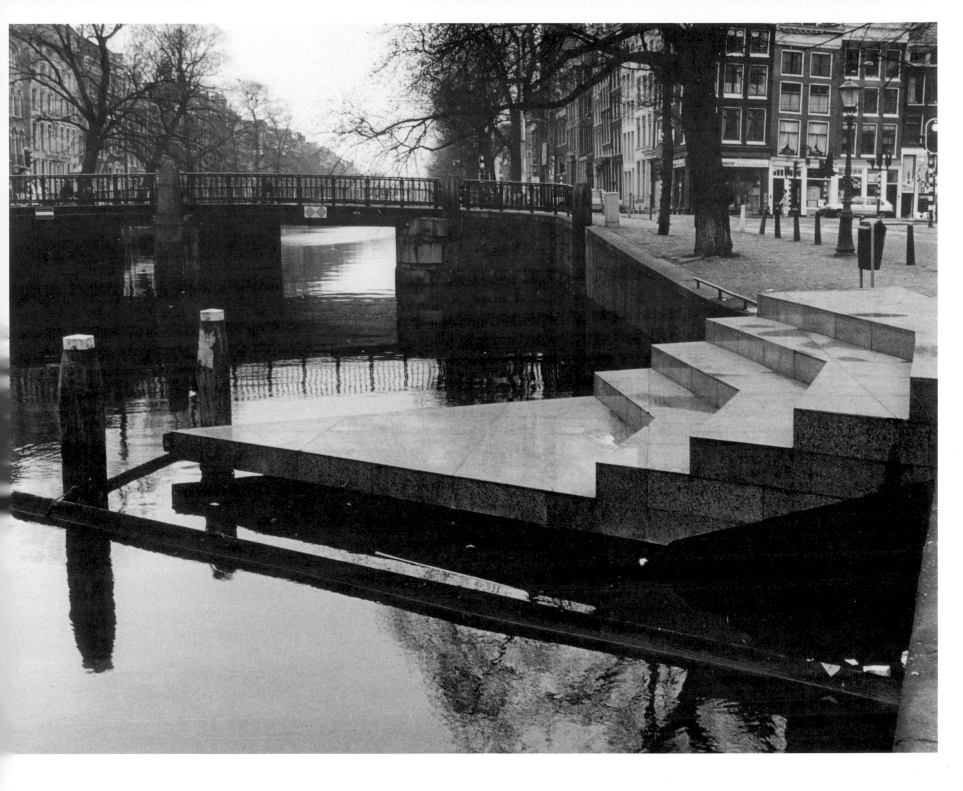

90. Paris, corner of rue Geoffrey-l'Asnier and rue Grenier-sur-l'Eau: The *Memorial of the Unknown Jewish Martyr*, completed in 1956, is located at the edge of the Jewish quarter in the heart of Paris, near the city hall and the Seine and adjacent to the *Centre de Documentation Juive Contemporaine*. Designed by the architects G. Goldberg and A. Persitz, it consists of a massive stone wall with a Jewish star and an inscription in Hebrew and French and a tomb inscribed with the names of concentration camps and ghettos, which contains the ashes of the martyrs.

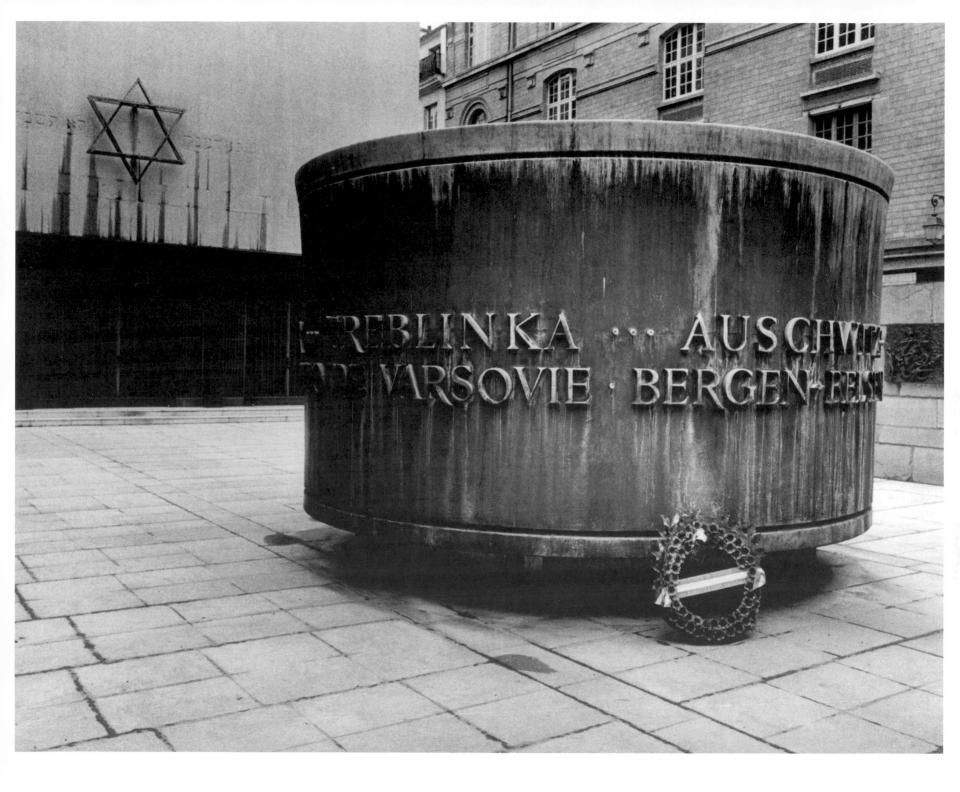

91. Paris, Ile de la Cité: At the eastern tip of the Ile de la Cité, behind Notre Dame cathedral and the small garden at the Square de l'Ile de France, is the *Mémorial de la Déportation*, an underground vault commemorating the French victims of the Nazi concentration camps. The dedication to "the 200,000 French martyrs killed in the camps and deportations, 1940–1945" is carved in thin, red block print symbolizing blood.

204

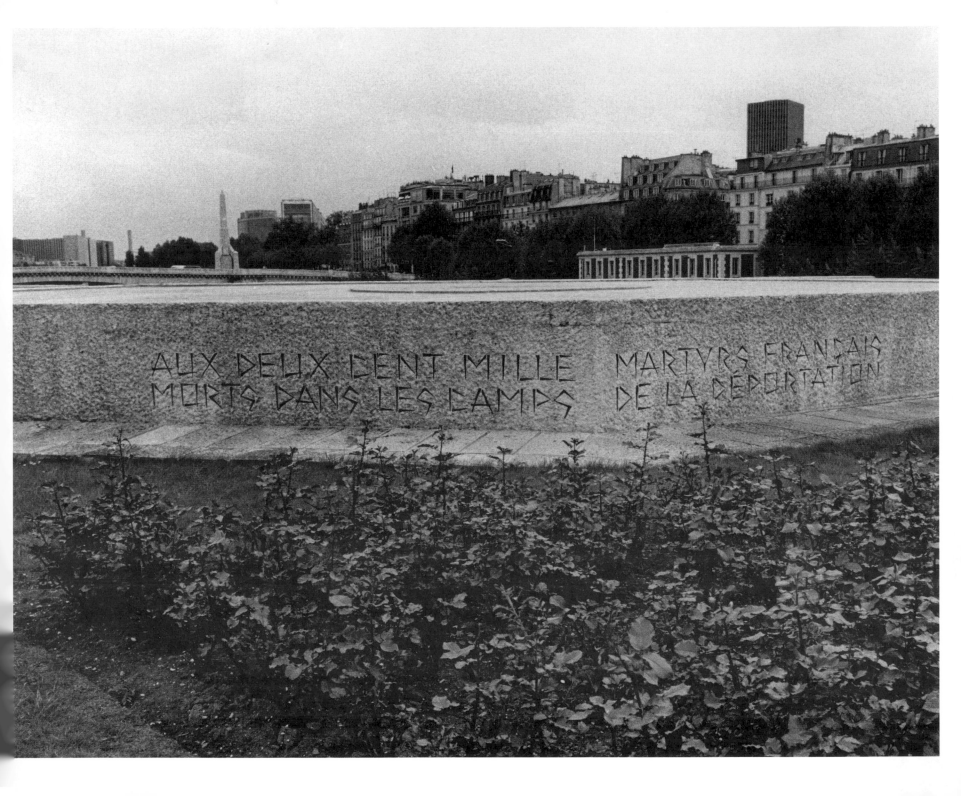

92. Paris, Ile de la Cité: The underground plaza is surrounded by high stone walls; at one end is a metal grate, evocative of prison bars or sewer grates, facing the Seine. The black metal stakes with small jutting metal triangles on top of the grate resemble barbed pikes and evoke feelings of imprisonment and menace.

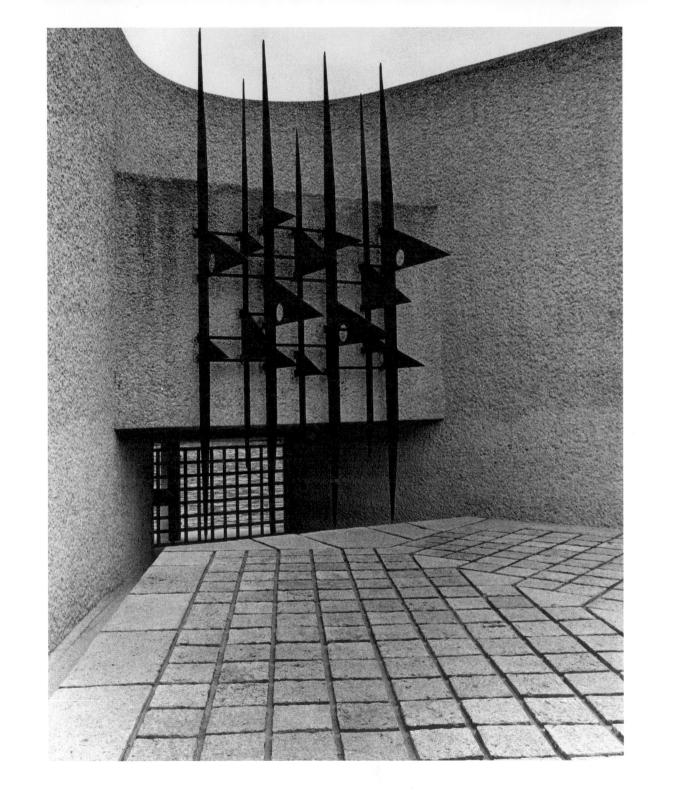

93. Paris, Ile de la Cité: On the opposite end of this subterranean plaza are two granite blocks with a narrow slit; this photograph shows the entrance and exit to the memorial.

94. Paris, Ile de la Cité: This stark and simple memorial designed by O. Pingusson contains a small circular alcove after the slitlike entrance. In this alcove are small tombs of earth from the camps underneath bloodred equilateral triangles (used to symbolize concentration camp prisoners) and inscriptions carved into the stone walls. The alcove leads to iron bars in front of a long narrow tunnel containing 200,000 dots of dull light made by backlighted quartz pebbles. The design adapts the Jewish tradition of paying homage to the dead by placing a stone on the grave. The low ceilings in this crypt, iron bars, and long corridors evoke a sense of confinement and menace. It is the most effective memorial in Paris and among the most powerful monuments in Europe.

95. West Berlin: On a pedestrian island outside the Wittenbergplatz subway station in downtown Berlin is a simple sign consisting of twelve linked shingles. It reads: "We must never forget these places of terror," followed by the names of ten concentration camps and killing centers. Few pedestrians ever stop to read it.

96. East Berlin: The memorial at the Weissensee cemetery to 28 Jewish communist members of the Herbert Baum resistance group, executed by the Nazis in June 1942.

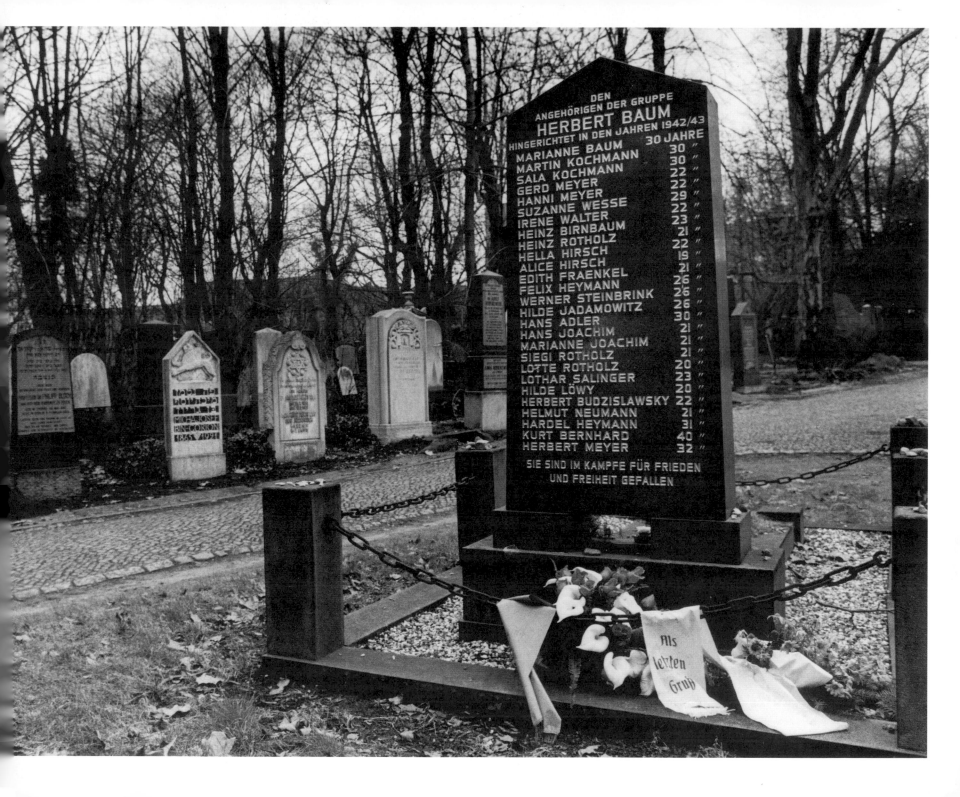

DEN
ANGEHÖRIGEN DER GRUPPE
HERBERT BAUM
HINGERICHTET IN DEN JAHREN 1942/43

MARIANNE BAUM	30	JAHRE
MARTIN KOCHMANN	30	"
SALA KOCHMANN	22	"
GERD MEYER	22	"
HANNI MEYER	29	"
SUZANNE WESSE	22	"
IRENE WALTER	23	"
HEINZ BIRNBAUM	21	"
HEINZ ROTHOLZ	22	"
HELLA HIRSCH	19	"
ALICE HIRSCH	21	"
EDITH FRAENKEL	26	"
FELIX HEYMANN	26	"
WERNER STEINBRINK	26	"
HILDE JADAMOWITZ	30	"
HANS ADLER	21	"
HANS JOACHIM	21	"
MARIANNE JOACHIM	21	"
SIEGI ROTHOLZ	20	"
LOTTE ROTHOLZ	20	"
LOTHAR SALINGER	23	"
HILDE LÖWY	20	"
HERBERT BUDZISLAWSKY	22	"
HELMUT NEUMANN	21	"
HARDEL HEYMANN	31	"
KURT BERNHARD	40	"
HERBERT MEYER	32	"

SIE SIND IM KAMPFE FÜR FRIEDEN
UND FREIHEIT GEFALLEN

97. East Berlin: The memorial of the Berlin Jewish community at Weissensee cemetery. It states: *"May the Eternal One always remember what happened to us. Dedicated to the memory of our murdered brothers and sisters, 1933–1945, and to the living, who must fulfill their legacy."*

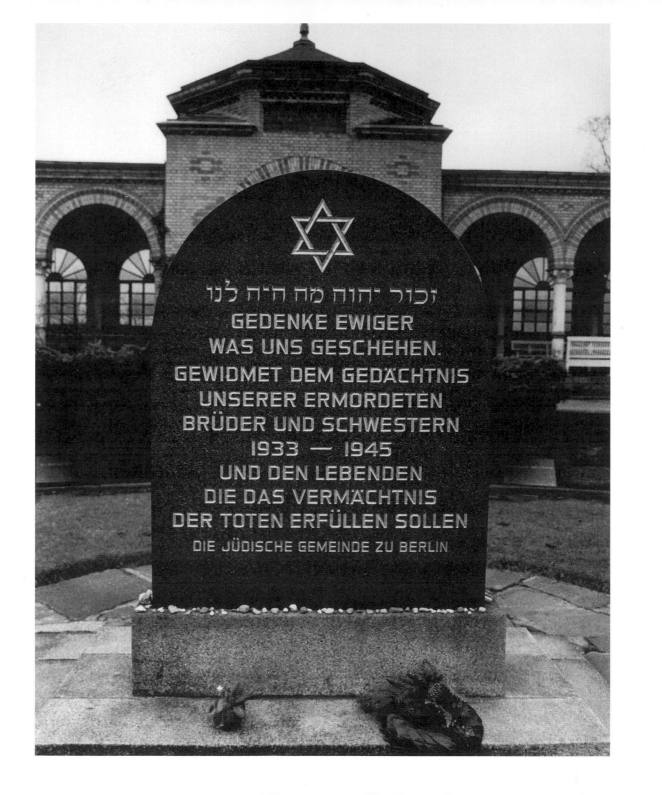

98. East Berlin: Jewish tombstones in Weissensee cemetery.

99. Carpi: Courtyard of the Museum of Deportation landscaped with 15 reinforced concrete freestanding pillars, each 6 meters high (19.5 ft.), inscribed with the names of concentration camps to which Italians had been deported. This museum also serves as the memorial for the transit camp at Fossoli, located 3.2 miles outside Carpi, from which Italian Jews and partisans had been deported to the East after the German occupation of Italy. (Photograph courtesy of ANED and Paolo Monti, Milan)

100. Carpi: The Museum of Deportation is housed in one wing of the Pio Palace on the main square. The interior walls of the memorial are inscribed with quotes from the last letters of the partisans sentenced to death, frescoes by Corado Cagli (an antifascist artist, born in 1910 in Ancona, who immigrated to Paris in 1938 and New York in 1940, served with the U.S. Army at the liberation of Buchenwald, and returned to Rome in 1947), and also with the names of 37,000 Italians deported and murdered in Nazi concentration camps. The architects and designers were Lodovico B. Belgiojoso, Enrico Peressutti, Ernesto Rogers, and Guiseppe Lanzani. The wall inscriptions are similar to the memorial in the Pinkas Synagogue in Prague, where the names of 77,000 deported and murdered Bohemian and Moravian Jews are inscribed on every available wall space. (Photograph courtesy ANED and Paolo Monti, Milan)

PAOLO LAGHI - ... GENNARO DELLA GIOVANPAOLA - BRUNO TOMMASI - FORTUNATO PAULETTO - PIETRO POSSEGA - RODOLFO TREVES - LEOPOLDO SIROK - MICHELE SCHIAVONE - FORTUNATO SCRANZIO - ARMANDO LE...RDON - GIUS...
...PIOMBI - SPAR...NE SECC - GIUSEPPE INGEGNIERI - SANTO INNOCENTI - VITTORIO ZANGO - RICCARDO INNOCENTI VERTERI - NATE PERUSCO - ATTILIO SENIGALLIA - AURELIO SCHENONE - MARCO SCHIUNNACH - ANTONIO PREGALI - GIOVANNI MAGLICA...
...CESCANG...COCHE - FILIPPO FAUSTINELLI - RENATO INGHIRAMI - ERALDO TURINETTO - ANDREA ALMONTE - ENRICO UKMAR - VINCENZO CAMILLI - FERDERICO CASTANO - AMEDEO CASTELLANI - LORENZO CINOTTI - FEDERICO CIPOLLA - FRANZ CLAVI - OTT...
...TOMMAS...NASARDO - ANTONIO UGOTTA - GIUSEPPE VIDMAR - GIUSEPPE ROGOLINI - BASILIO IUSSA - ALBINO KORADIN - EDRO COLOMBINI - ANACLETO COLOMBO - DEMETRIO CRUCITTI - ARTURO CUCCHETTI - NESTORE SPAGARINO - MASSIMILINO GABRIE...
...NI VISENTIN - GIUSEPPE ZANET - RODOLFO VIDMAR - SALVATORE ROMANO - MICHELE KAIC - CARLO OZOLA - BRUNO DAL MASO - MARIO ELMERINO - ELVEZIO ERCORINI - ALCIDE FANTONI - GIUSEPPE NOSATI - BRUNO VIOLIN - RENZO BOCCH...
UBALDO ZANUTTIG - ANGELO PIAZZOLA - LUCIANO REBECCHI - ISIDORO SACCANI - CARLO DE CANI - PIETRO FILLA - ROBERTO SPAGIARI - GIUSEPPE ELTO - ANGELO ERMACORA - FRANCESCO FERRARI CARLO VALENTA - ALFREDO VINCENZONI -
FRANCESCO ZANGNI - ANTONIO ZENETTICH - GIUSEPPE PIACENZA - GASTONE SALOMON - MICHELE CELLA - LUIGI SFREDDO - BRUNO ERBISTI - GIOVANNI FANTINI - ANTONIO FARAUDO - TARCISIO TESSARI - FRANCESCO ZELINSCEK -
GIUSEPPE ZANGARDI - GIACOMO RIZZARDINI - GIOVANNI ROCCA - GIUSEPPE FOTO - MARIO FOLLINI - FELICE SGRABLIC - UMBERTO FERRARI - ANTONIO VISENTIN - OTTAVIO SGARDELLO - ANTONIO BONCOMPAGNO -
LAZZARO EFRATI - FRANCESCO CHISTA - LUCIANO BUDICIN - GIOVANNI BUDINI - ALCEO FIORAVANTI - NATALE SKABAR - DE GRADO FERRARI - ANGELO VIETTI - LUIGI SGUIZZATO - STEFANO SAVAN - STEFANO PLUT -
FILIPPO FABIANI - EDOARDO DENTIS - MARCELLO BARONCINI - CORRADO BUDIN - CARLO ROBBA - NUNZIO SANTINI - FRANCESCO ZIC - LUIGI VIGNOLO - ANGELO VALEGGHI - FRANCESCO INNAMORATI -
SALOMONE IPPOLITI - SACCO ISRAEL - COSTANTINO BASILE - GIOVANBATTISTA TRESEMME - GIUSEPPE SARO - GIUSEPPE MILIANI - GIUSEPPE MINETTI - ANTONIO BERTI - PIETRO CARTURAN -
EMELIO RE GIANNINO ENRICO BARONCINI - GIUSEPPE KUKANIC - EGIDIO DETELLA - ERMINIO SARTO - STEFANO MILLETICH - GIOVANNI LIZZUL - NICODEMO TANI SERRANO -
LUIGI BASALDELLA ...DELCHI BARONCINO - GAETANO GUASCONI - GIOVANNI ROINI - BRUNO DE PONTI - SALVATORE MILIONE - ANTONIO LIZZUL - DALLA SCHIAVA ROVIGLIO -
GIOVANNI BUDINI ARMANDO CERRUTI - SILVIO FREZZATO - BRUNO KOMAC - GIACOMO FIOREGGI - GIACOMO FIORENETINO - ETTORE VISCONTI - BRUNO TECUZ -
ODOARDO FOCHE...NI - GUERRINO KIRSIC - GILDO IURETIC - SILVIO BUDICIN - FRANCESCO GAZZAROLI - FAUSTO CUMINI - ANDREA DELTON - MARINO ROSI -
GIUSEPPE FINO...LLI - GIUSEPPE KLEBCAR - GIOVANNI FORMENTO - LUCIANO GENNARI - DIDINO DELLE CASE - PIETRO BIGATTI - PIERO POLI -
GIOVANNI FESTU...O - GAETANO MAMBRINI - GIUSEPPE KONJEDIC - ALFONSO GERACI - REMIGIO COLLAVINO - GOFFREDO BINGIANNI -
MARIANO FACCHI... FRANCESCO MANAZZON - CARLO CONDI - CRISPINO APPOLONI - FRANCESCO GIOVANNINI - STANISLAO GIOVI -
LYDIA NICCOLLI - ANTONIO SURINA - LUIGI BARICELLI - RACHILDO BERTAIOLA - SERVILLIO ICRI - ATTILIO COLLARETTO -
VINCO PAPAGNI - MARIO BARCANO - SANTO BIANCHI - SEVERINO BERTOCCHI - MARIO IPPOLITO - ANTONIO ISKRA -
NARCISO VERDI - ALBINO SOBOLI - ANTONIO MOTTA - GIUSEPPE CUZZOLO - CESARE ISOARDI - PIETRO TARO -
ENZO ZANARGNA - AUGUSTO CAVERZASIO - LUIGI DELLAGNOLA - ARTURO CARLI - RIDOTTI ROSA -
EUGENIO VIDE... SOCRATE CONFALONIERI - ANTONIO LOCAR - ALBERTO BON - TOMMASO POLIC...
GUIDO SALVADORI - TITO COSCASSA - RODOLFO LJUBICK - BENIAMINO BIANCO -
ANTONIO TROMBA - ITALO BARO - ALDO LOMBARDINI - GIACOMO BARDOTTO -
PIETRO UGOTTI - OLIVO BASIRI - GIOVANNI LOMBASI - GIUSEPPE FURINI -
ALBINO ZANCA - MARIA KORREN - LUIGI BARBIERI - EUGENIO ILIANI -
ANTONIO ZANETA - DELFO MORI - PIETRO TERPIN - GIACOMO FURCO -
ITALO LAVANDA ...ELIA BASSO - ETTORE TANTIN - ALDO TARUGGI -
ANTONIO COSSINOSCOVI - TULLIO BASSE VI - UGO INDRI -
GIANFRANCO BIANCHI - GUGLIELMO IMBIMBO -
GIUSEPPE COSLIANI - GIOVANNI INGUGLIA -
GIACOMO SLOCIAL - RODOLFO FRANETICH -
OSVALDO OLIVIERI - DOMENICO FRANTINO -
CARMINE OLIVIERO - ANTONIO FRANZI -
LUIGI OLIVIERI - VITTORIO BERTARINI -
CORRADO OCCHIALI - VALENTINO BIANCHI -
TOMASO OTTONELLO - ANTONIO BUSCONI -
VITALE OTTONELLO - GIUSEPPE CIUSANI -
GIUSEPPE ORLINI - GIOVANNI MAROSINI -
PASQUALE ORSALA - GIUSEPPE GHEDINI -
ORESTE ORSETTI - GIOVANNI GONELLA -
SANTE NOFERINI - TEODOLINDO FELICI -
SALVATORE NOTRICA - VLADIMIR KOVACIC -
LORENZO NOTARIO - GIUSEPPE LERCO -
MARCO NOVELLATI - FRANCESCO LENOTTI -
DOMENICO NOVELLO - VITTORIO LEONI -
GIOVANNI OCCELLI - LUCIANO GERBELLA -
FERDINANDO LUCCO - CARMELO GERARDI -
LUIGI MUCCHITTA - QUIRINI CINGOLANI -
FABIO LUCOVICH - FAUSTO JANOTTI -
MARIO CARROSIO - IGNAZIO KJUDER -
CESARE CARRON - ROMUALDO MARTINI -
OLIVIERO LIMONTA - RICCARDO JERINA -
ACHILLE LINARI - LEOPOLDO LER...

101. San Sabba: Located in Trieste in a former rice factory in the commercial district known as San Sabba, the camp was initially used as a prison. After the German occupation of Italy in October 1943, it became, under SS control, a concentration camp and killing center with its own gas chamber and crematorium, where 5,000 prisoners (including Italian and Yugoslav Jews and partisans) were executed and their corpses burned. The *Risiera di San Sabba* was also a transit camp with deportations to Auschwitz, Buchenwald, Dachau, and Mauthausen. The memorial and historical museum opened in 1964. This photograph shows the concrete pillars at the entrance to the San Sabba Memorial, designed by the architect Romano Boico. The original entrance and courtyard were destroyed by the Germans in April 1945 and were redesigned as a narrow entrance passage between high walls by Boico to symbolize oppression, terror, and confinement. (Photo courtesy ANED and Paola Mattioli, Milan)

102. San Sabba: Although the crematorium was blown up when the Nazis fled, one wall of the original crematorium remained, revealing where the ovens had been located. The metal pavement in front of the crematorium shows the location of the original gas chamber, where prisoners were murdered by carbon monoxide produced by a diesel engine. (Photo courtesy ANED and Paola Mattioli, Milan)

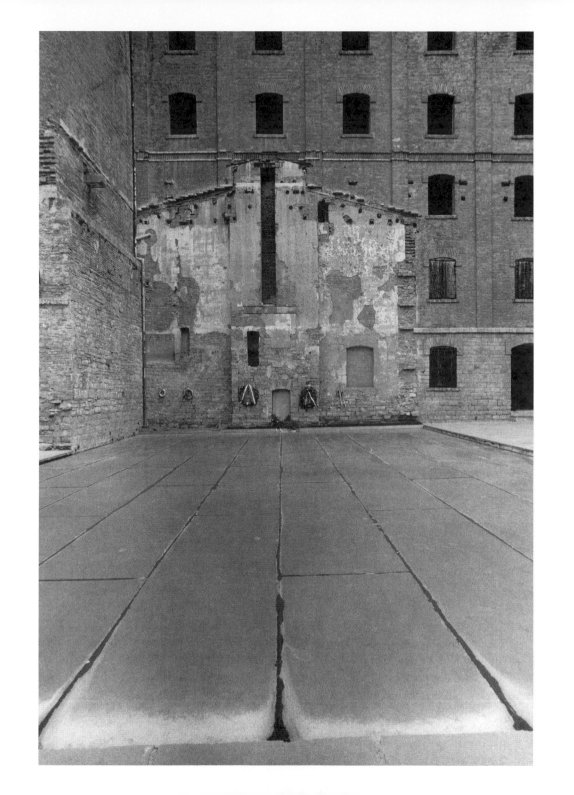

103. San Sabba: The 17 jail cells in the left wing of the building. The first cells were reduced in size, necessitating that prisoners stand for hours in unlighted cells. (Photo courtesy ANED and Paola Mattioli, Milan)

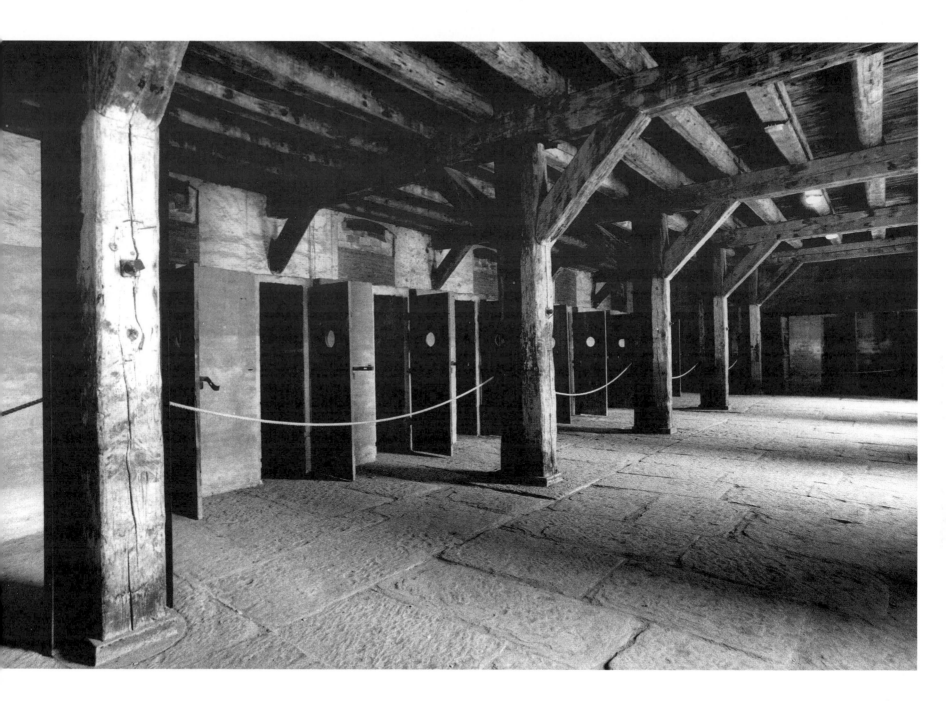

104. San Sabba: The camp courtyard; on the far right, the steel column, located at the site of the former crematorium chimney, was designed as a symbol of the killing center by Romano Boico and is dedicated to the memory of the victims. (Photo courtesy ANED and Paola Mattioli, Milan)

105. Warsaw: The *Warsaw Ghetto Monument*, designed by Nathan Rapoport, stands alone in a landscaped plaza at the intersection of Anielewicz and Zamenhof streets. The memorial was dedicated on the fifth anniversary of the ghetto revolt in April 1948 and is surrounded by postwar apartment buildings. The plaza provides little inkling of the size of the ghetto, which once covered nearly one-third of Warsaw.

232

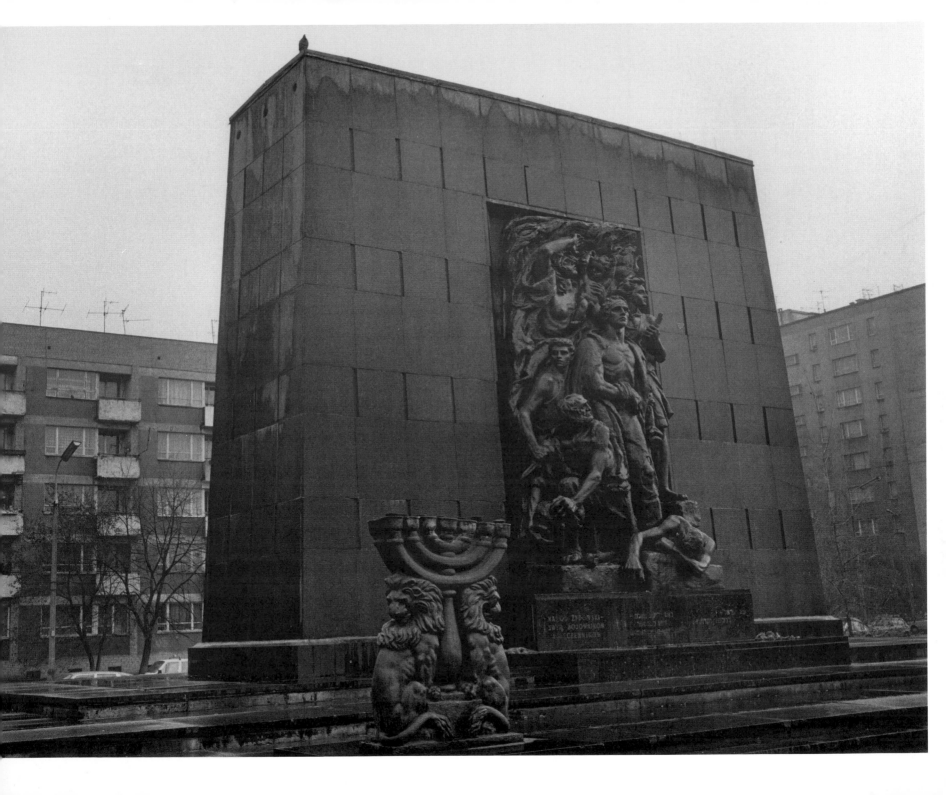

106. Warsaw: The two-sided monument by Rapoport consists of a 36 ft. high bronze statue of Mordecai Anielewicz, head of the Jewish Fighting Organization, standing amidst the burning ghetto surrounded by his ghetto fighters; the back side of the monument contains a stone bas-relief about Jewish martyrdom under the Nazis. The figures are encased in a freestanding labradorite granite wall. Ironically, this granite had originally been imported from Sweden in 1942 for a monument to celebrate the German victory over Polish Jews. The idealized physique of the ghetto fighters, as depicted by Rapoport, bears scant resemblance to the emaciated ghetto inhabitants of 1943. The base of the memorial carries inscriptions in Hebrew, Polish, and Yiddish, dedicated "to the Jewish people, its heroes and its martyrs."

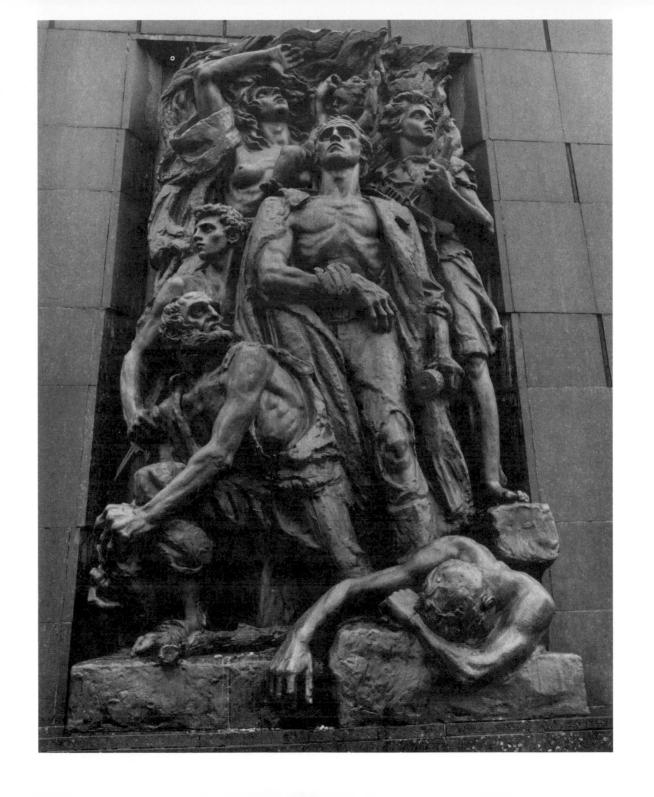

107. Warsaw: Standing in front of the Anielewicz monument is a menorah resting on two lions.

Nathan Rapoport (b. 1901, Warsaw – d. 1987, New York) fled to the Soviet Union after the German invasion of Poland. He designed the Warsaw ghetto monument in exile in Novosibirsk (western Siberia) in 1943, but it was rejected by officials in Moscow. Rapoport returned to Warsaw in late 1946 with a clay maquette; the Warsaw City Arts Committee accepted his design, if it could be completed in time for the fifth anniversary of the ghetto revolt. Since Warsaw was in ruins, the work was cast and poured in Paris. Rapoport emigrated to Israel in 1948, setting up sculpture studios in both New York and Jerusalem. After 1949 he completed many memorials and sculptures about the Holocaust in both Israel and the United States.

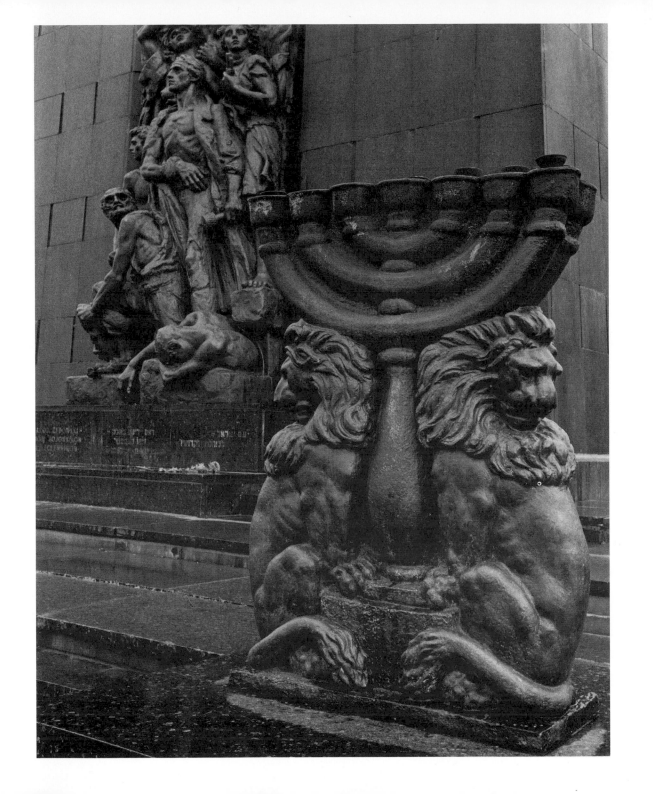

108. Warsaw: At 18 Mila Street a small memorial stone with inscriptions in Polish and Hebrew marks the ruins of Mordecai Anielewicz's ghetto bunker.

109. Warsaw: A new memorial completed on Stawki Street in 1988 marks the *Umschlagplatz,* a German word meaning "reloading place." This was where the Jews of Warsaw were herded onto train ramps for deportation to Treblinka. A memorial tablet with names of many deportees is located inside the monument.

110. Philadelphia, Benjamin Franklin Parkway and 16th Street: This 18 foot bronze sculpture designed by Nathan Rapoport was the first Holocaust memorial "to the six million Jewish martyrs" erected in the United States; it was dedicated in April 1964. The florid and heavy-handed work combines biblical motifs with the Holocaust: an unconsumed burning bush, a dying mother, Jewish resistance fighters, a child with a Torah, and a blazing menorah.

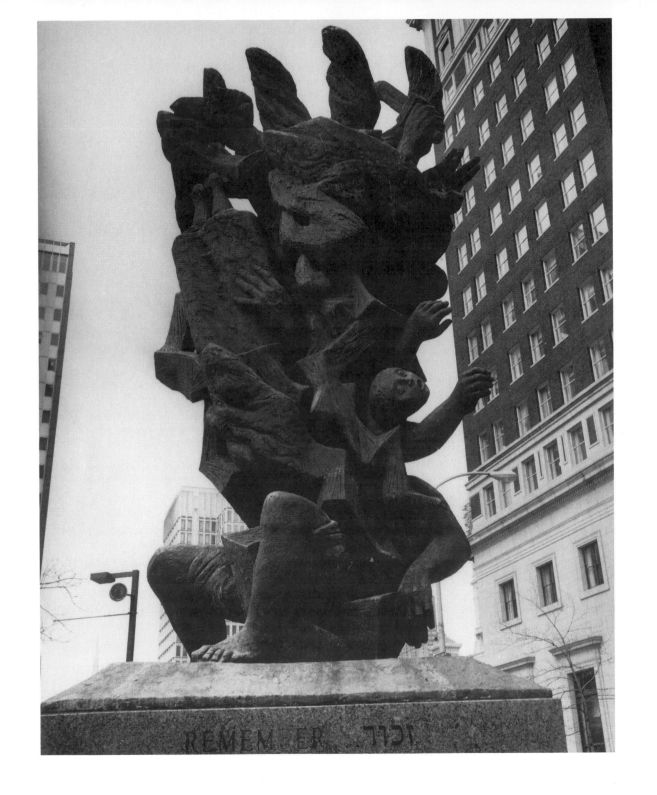

111. New York, Dag Hammarskjöld Plaza (47th Street near First Avenue) facing the United Nations: This memorial, entitled *Monument of the Holocaust*, consists of seven bronze bas-reliefs by Arbit Blatas. The fourth and fifth reliefs are located above the English and Hebrew inscription "Remember—*Zachor*" and depict *Punishment* and *Execution in the Ghetto*. The bas-reliefs were mounted on a specially constructed pink granite wall (13 x 21 ft.) by the Anti-Defamation League in 1982. Each bas-relief is 3 feet x 2 feet. At the dedication ceremony Blatas said: "In this unique plaza facing the nations of the world, these bronzes are dedicated to the six million Jews who perished in the Holocaust in World War II, in memory of the peoples of all races, colors and creeds who have suffered persecution throughout the ages—among them my mother and father." Blatas had previously completed a similar series of bas-reliefs at the Campo del Ghetto Nuovo in Venice (1980), dedicated to the memory of his mother, who had died in a concentration camp. He also gave two Holocaust bas-reliefs to the *Memorial of the Unknown Jewish Martyr* in Paris (1981).

Arbit Blatas (b. ca. 1914, Kaunas, Lithuania; resides in France and Venice) at the age of 15 had already exhibited in Lithuania. He immigrated to France in the 1920s, becoming the youngest member of the School of Paris group. He has completed 27 portraits in oil and bronze of members of the School of Paris, including Pierre Bonnard, Henri Matisse, Raoul Dufy, Jean Cocteau, and many others. In 1939 Blatas left for the United States, returning to France in the 1950s. His works are represented in the collections of the Orangerie museum in Paris; the Metropolitan Museum of Art, the Museum of Modern Art, and the Whitney Museum in New York; and collections in England, Italy, and Switzerland. He has designed nine operatic productions in collaboration with his wife, the opera singer and stage director Regina Resnik. In 1978 he was awarded the Chevalier of the Legion of Honor by the French government for his contributions to French art.

REMEMBER זכור

MEN, WOMEN, CHILDREN, MASSES FOR THE GAS CHAMBERS
ADVANCING TOWARD HORROR BENEATH THE WHIP OF THE EXECUTIONER
YOUR SAD HOLOCAUST IS ENGRAVED IN HISTORY
AND NOTHING SHALL PURGE YOUR DEATHS FROM OUR MEMORIES
FOR OUR MEMORIES ARE YOUR ONLY GRAVE.

Andre Tron

112. Berkeley, Judah L. Magnes Memorial Museum: Marika Somogyi's 7 foot high sculpture *In Memoriam* is installed on the landscaped grounds in front of the Magnes Museum. The sculpture—made from cast stone, stainless steel, and glass—consists of three linked figures, enveloped in a black shroud-like shape; at the bottom is a hollow area containing fragments of broken glass. The figures represent broken lives and the physical pain associated with stepping on broken glass, but this work also contains an element of hope since the figures rise above the glass shards. It is the only sculpture in the United States commemorating the November 1938 pogrom, popularly known as *Kristallnacht* (Crystal Night).

Somogyi (b. Budapest, immigrated to the United States in 1957; resides in Berkeley, California) is renowned for her medallic art, including medals commemorating Marc Chagall, Raoul Wallenberg, Kurt Weill, Emma Lazarus, Eleanor Roosevelt, the *Statue of Liberty*, and the designs submitted to the invitational competitions for medals commemorating the bicentennials of the U.S. Constitution and the U.S. Congress. Her works are represented in the collections of the Smithsonian Institution, the National Sculpture Gallery in New York, the Statue of Liberty National Monument Museum in New York, the Judah L. Magnes Museum, the Federation Internationale de la Medaille Museum in Stockholm, and the Swedish Royal Museum. She received the American Numismatic Association "Excellence in American Medallic Art" award in 1989. Somogyi has completed a second Holocaust sculpture entitled *Kaddish*, the prayer for the Jewish dead, which is in the artist's own collection. It commemorates the Jews killed in the small Hungarian town of Györ, including all of her relatives.

113. San Francisco, Lincoln Park: George Segal's sculpture
The Holocaust was installed and dedicated in a public
ceremony in November 1984 at a site near the Palace of the
Legion of Honor in Lincoln Park, overlooking the Golden
Gate Bridge. The realistic work consists of 11 life-size white
bronze figures and occupies a space of roughly 20 x 20 feet.
Ten bodies lie on the floor in a heap behind a single male
figure, who stands behind a white bronze barbed wire fence.
The sculpture is installed on the incline below the turnabout
in the Palace of the Legion of Honor parking lot. The
landscaping was done by Asa Hanamoto, who as a teenager
was interned in America's concentration camps for Japanese
Americans. Flowers, *jahrzeit* candles, and wreaths are
frequently placed at the Segal monument, signs of veneration
and respect for a secular shrine; similar behavior is seen at the
Vietnam Veterans' Memorial in Washington, D.C.

Segal's original plaster cast (10 x 10 x 20 ft.) was
purchased by the Jewish Museum, New York, and installed
there in 1986. His sculpture has thus acquired the character
of a national monument, available simultaneously outdoors in
San Francisco and indoors in New York.

George Segal (b. 1924, New York; resides in New
Jersey) is a major American sculptor and painter. His
commissions include *The Sacrifice of Isaac* in Tel Aviv (1973);
The Restaurant for the Federal Building in Buffalo (1976); a
rejected sculpture for Kent State University (1978); *The
Steelworkers* at the Federal Plaza Mall in Youngstown, Ohio
(1980); and *Gay Liberation* (1980). Segal has used the
technique of casting living persons in many of his works.

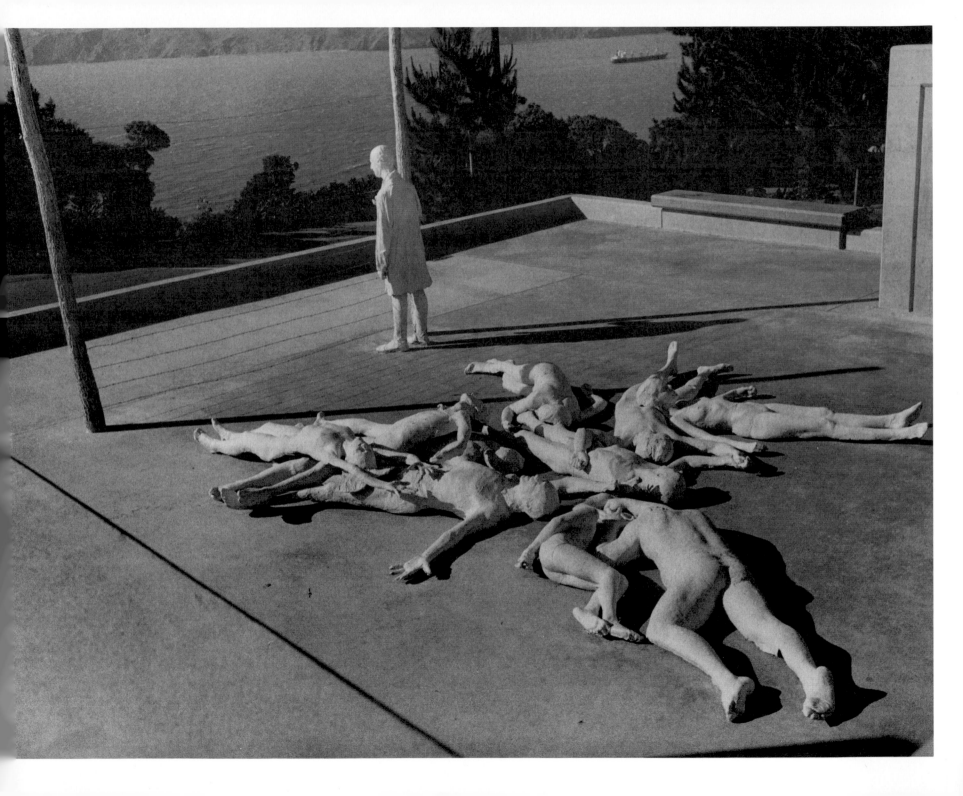

114. Segal's *The Holocaust* in his North Brunswick, New Jersey, studio; photographed in 1985.

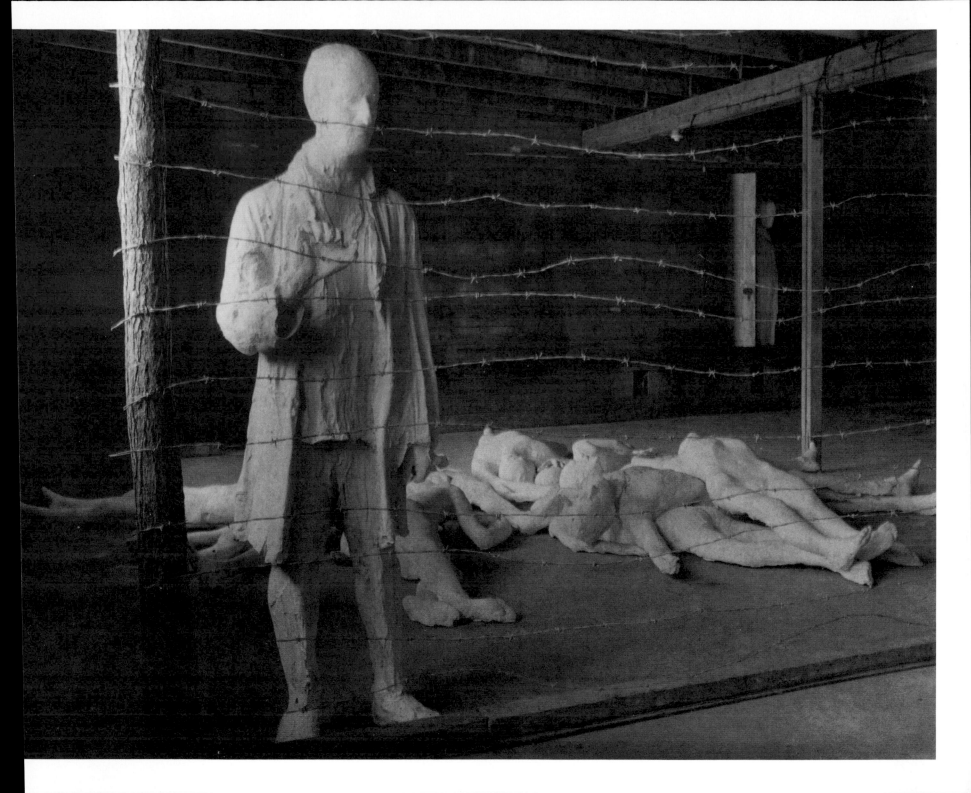

115. Long Beach, Long Island: The memorial, commemorating those who perished and those who rescued Jews during the Holocaust, is located at Kennedy Plaza opposite City Hall. Dedicated in June 1987, the monument and inscriptions are based on designs by Stanley R. Robbin, a physician imprisoned in Plaszow and Mauthausen concentration camps. The architect, Monte Leeper, was trained at Kent State University and at the Rosary School of Fine Arts in Florence, Italy. The monument consists of an inverted pyramid of highly polished black granite on a triangular base, 12 feet x 24 feet. Three etched panels contain an inscription to Janusz Korczak and the memory of the lost children; an unconsumed burning bush and barbed wire, symbolizing the camps; and an inscription to the righteous Gentiles Raoul Wallenberg, Oscar Schindler, and Maximillian Kolbe. A Holocaust library and resource center is located in the adjacent public library. (Photograph courtesy of Jim Strong, Hempstead, New York)

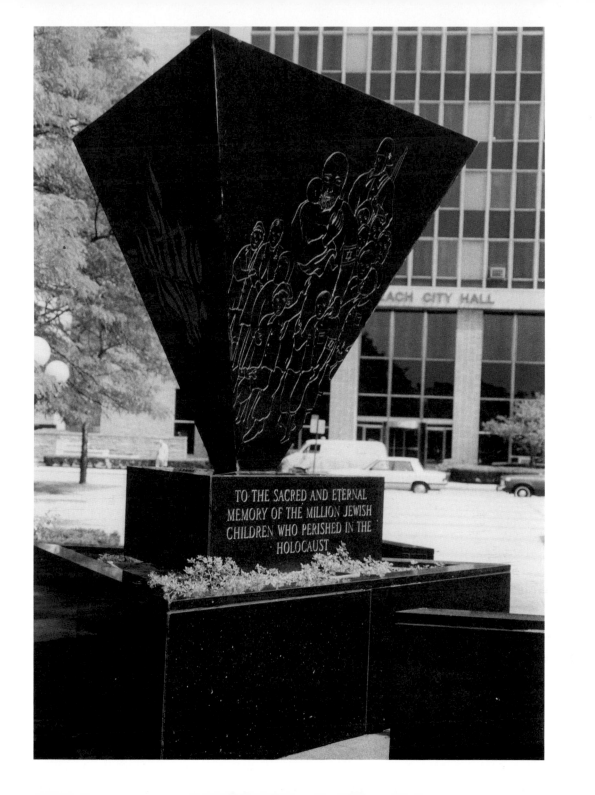

116. Jerusalem, Yad Vashem: This wrought-iron gate, designed by the Israeli artists David Palombo and Bezalel Schatz, serves as the entrance to the Hall of Remembrance (*Ohel Yizkor*). The interior walls of this central memorial building of the Yad Vashem complex are made of Galilean rocks set in unplastered and unpainted cast concrete. The mosaic floor is inscribed with the names of 22 concentration camps in Hebrew and Latin print, and ashes of those who perished in the Holocaust are buried under flagstones in front of the eternal flame. There is no artificial lighting in the Hall of Remembrance, only the eternal flame supplemented by a small amount of natural light from an opening in the ceiling.

117. Jerusalem, Yad Vashem: *The Monument to Jewish Soldiers, Partisans, and Ghetto Fighters*, designed by the Israeli artist Bernie Fink of Kibbutz Yisre'el, consists of six hexagonal granite blocks, each weighing 20 tons. The interior lattices form a window shaped like a Star of David, symbolizing the six million Jewish victims. The structure is supported by a skeletal steel frame. The sword blade, symbolizing armed Jewish resistance, rises in the middle of the star and is 6 meters high (ca. 19.5 ft.). It is dedicated to the one and a half million Jews and partisans who fought in the Allied armies. The inscriptions on the blade are in English, French, Hebrew, Russian, and Yiddish and include the names of the major battles of World War II as well as the emblems of the Allied armies. The monument, erected in 1985, is located behind the Yad Vashem art museum and overlooks the *Valley of the Destroyed Communities.*

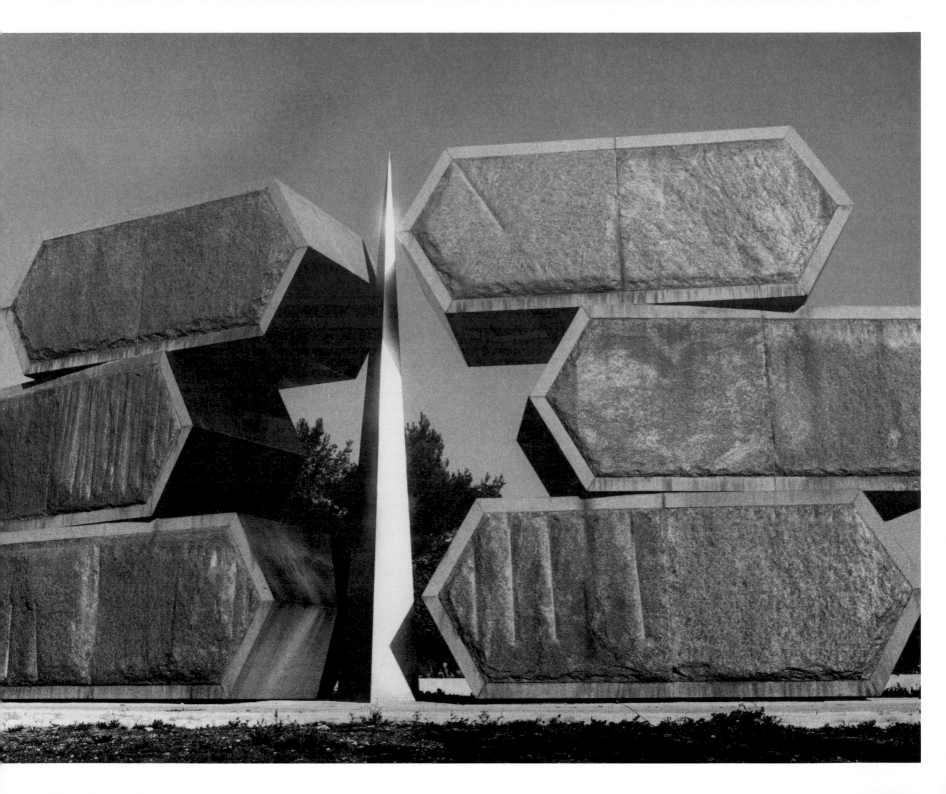

118. Jerusalem, Yad Vashem: Leah Michaelson, *The Silent Cry*, basalt, 195 x 90 meters (633.75 ft. x 292.5 ft.), installed in the landscaped sculpture garden surrounding the growing Yad Vashem building complex.

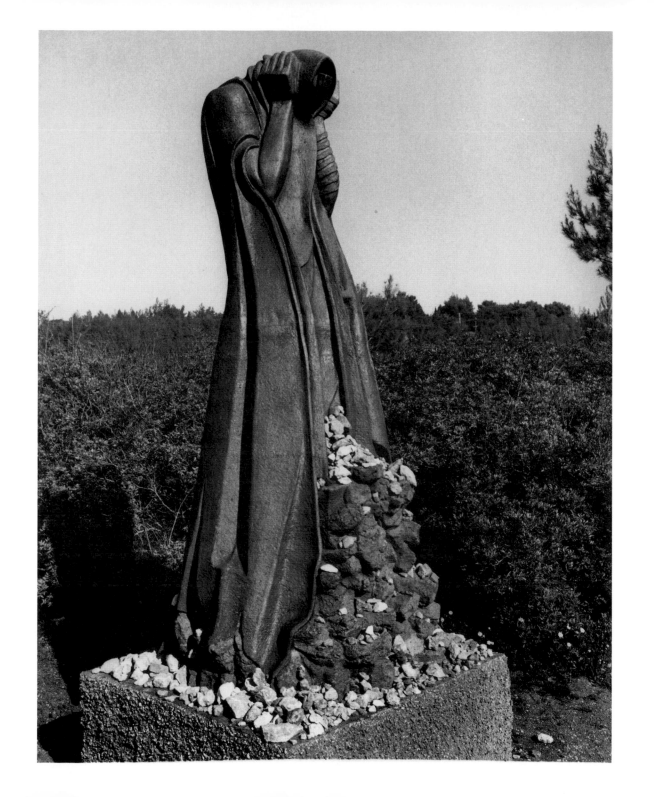

119. Jerusalem, Yad Vashem: Boris Sakstier, *Janusz Korczak and the Children of the Ghetto*, bronze, 1.6 x 2.2 meters (5.2 ft. x 7.15 ft.), installed in the landscaped sculpture garden surrounding the growing Yad Vashem building complex.

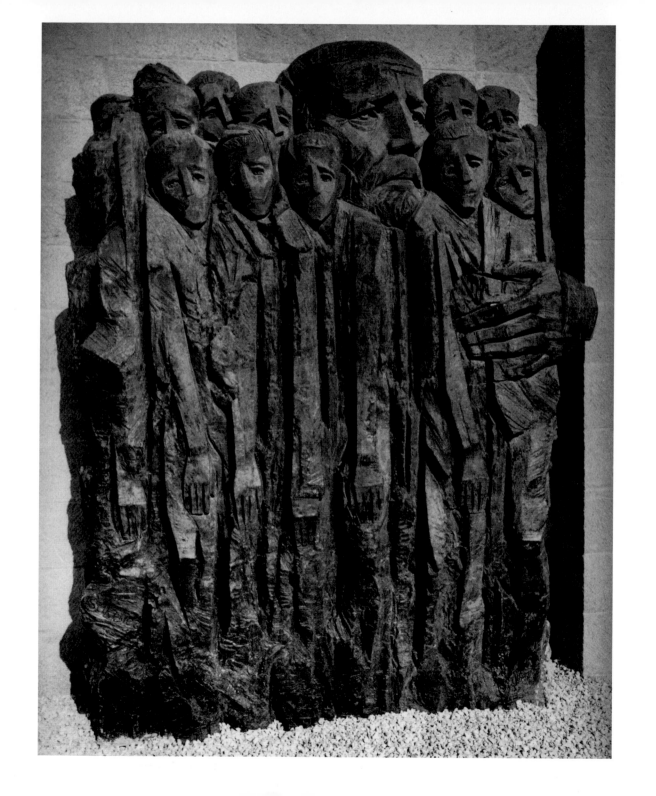

120. Jerusalem, Har Zion: Located on Mount Zion in the old city, the memorial crypt, often called "the Chamber of Martyrs," is located next to the ostensible tomb of King David.

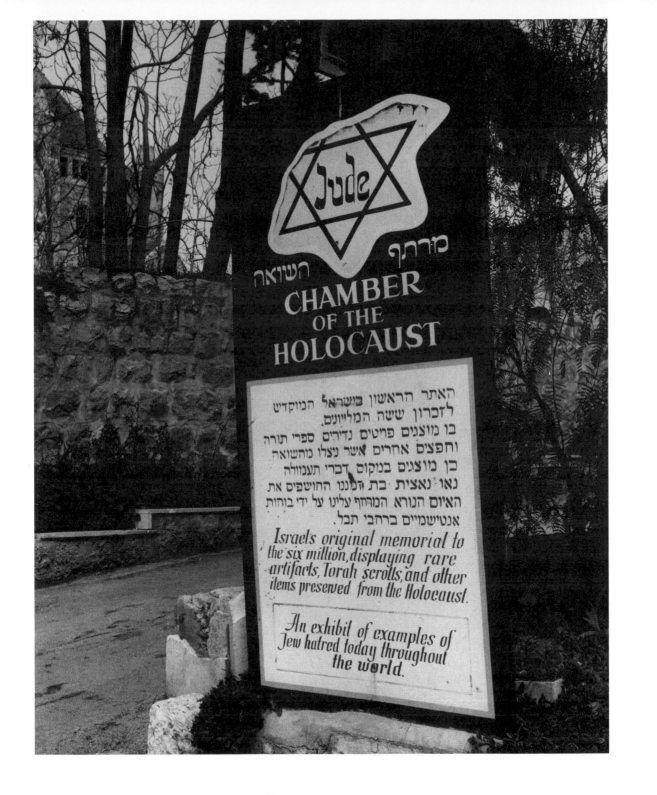

121. Jerusalem, Har Zion: A simple tomb commemorating the Jews murdered at Bergen-Belsen and other Nazi camps is inscribed in English, French, and Hebrew. The courtyards and walls of the memorial contain numerous additional inscribed gravestones and plaques to individuals, families, and communities.

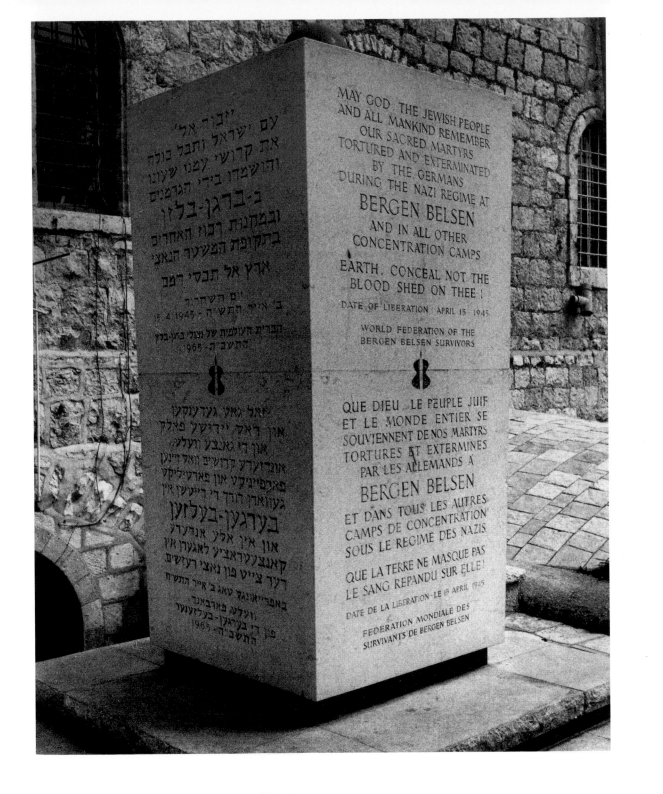

122. Jerusalem, Har Zion: The walls carry inscriptions to individuals and families.

123. Lohamei Hageta'ot (the Ghetto Fighters' Kibbutz Holocaust Museum), near Nahariya: Founded by partisans and survivors of the camps and ghettos, this museum combines Holocaust art and history. One of the twelve large galleries is devoted to Elsa Pollak's clay figures depicting her Auschwitz memories. Pollak described her sculpture as autobiographical: "I feel obligated to leave something of all the suffering. . . . Man created these horrors, but did not invent a language in which to describe them. The memories stayed alive and urged me on without respite. And thus I arrived at sculpture."

Rows of emaciated clay figures awaiting "Selection" show Pollak's use of sculpture as autobiographical narrative. Pollak's elongated clay figures accentuate agony and communicate the vulnerability of the emaciated walking dead, the "Musulmen." The sole and obsessive subject of her art is Auschwitz: prisoner tattoo and identity numbers, daily soup rations, roll calls, overcrowded bunk beds, forced labor, and death marches. Stark and simple, her art parallels Léon Delarbre's studies of hanging men in Dora or Zoran Music's Dachau cycle *We are not the last*.

Elsa Pollak, née Ehrlich (b. Kosice, Czechoslovakia; resides in Israel) was deported to Auschwitz in 1944 and later to Lenzing, a subcamp of Mauthausen, where she was assigned to forced labor at a pulp factory. In 1949 she studied art and ceramics in Vienna with the painter and sculptor Kurt Goebel. She immigrated to Israel in 1962. Her works are often exhibited in Israel and Italy. (See Zvi Szner, ed., *Elsa Pollak: Auschwitz 5170* [Israel: Ghetto Fighters' House and Hameuchad Publishing House, 1979].)

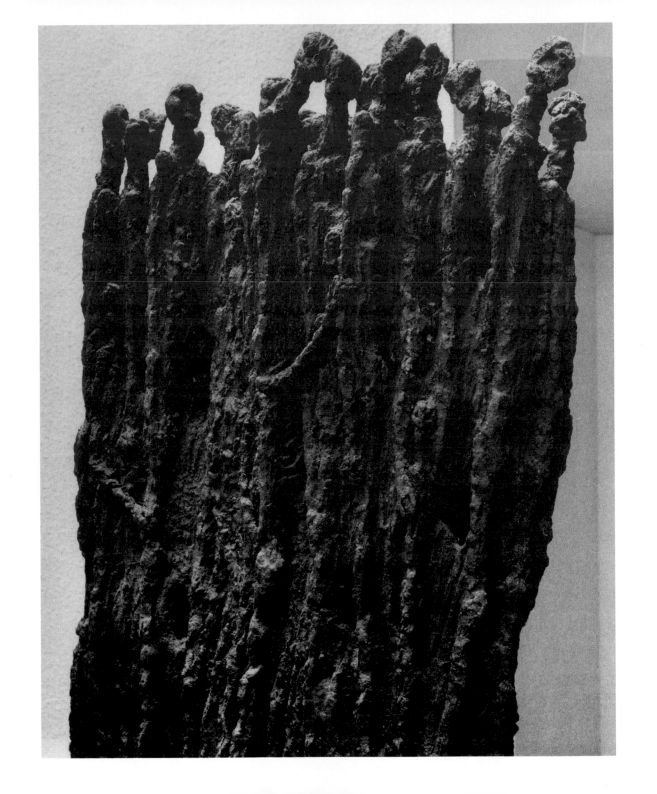

FOUR

THE AESTHETICS OF MEMORIAL PHOTOGRAPHY

Ira Nowinski's photographs of Holocaust memorials were taken between December 1987 and September 1989. They record sites, landscapes, and sculptures in seven countries: Austria, France, the Federal Republic of Germany, the German Democratic Republic, Israel, Poland, and the United States.

Photographs are a form of communication, serving simultaneously as objective and subjective documents. But even in the straight documentation of landscape and architectural photography, it is possible to introduce new and unconventional vantage points (photo 127). The changing of angles by photographing downward or the use of closeups to enlarge patterns, textures, and structures that might ordinarily pass unnoticed are part of a wide range of choices available to the professional photographer (see photo 52). The photographs were taken in early spring and late autumn in oblique natural lighting, thereby accentuating the mood of the various sites and monuments.

Nowinski's photographs direct the viewer's attention to the object relationships between monument and landscape, thereby encouraging a fresh view of even such well-known sites as Dachau (photos 124–28). His documentary style discloses the unexpected and the haunting natural beauty that exists even at sites of humanity's evil (photo 125). These photographs enable the reader to access the visual heritage of the Holocaust.

The images themselves reveal the paradoxical answer to the question posed in this book's title, *In Fitting Memory*—that various nations and artists have used different strategies to memorialize the victims of the Holocaust. These secular shrines rooted in contemporary needs provide an institutional anchor for public memory, irrespective of the skill of their artistic solutions.

124. Dachau: Landscape outside the main crematorium. The poplar trees were planted by the prisoners.

125. Dachau: Drainage canal, grass, fences, and barbed wire; photographed facing south from the bridge at the drainage canal.

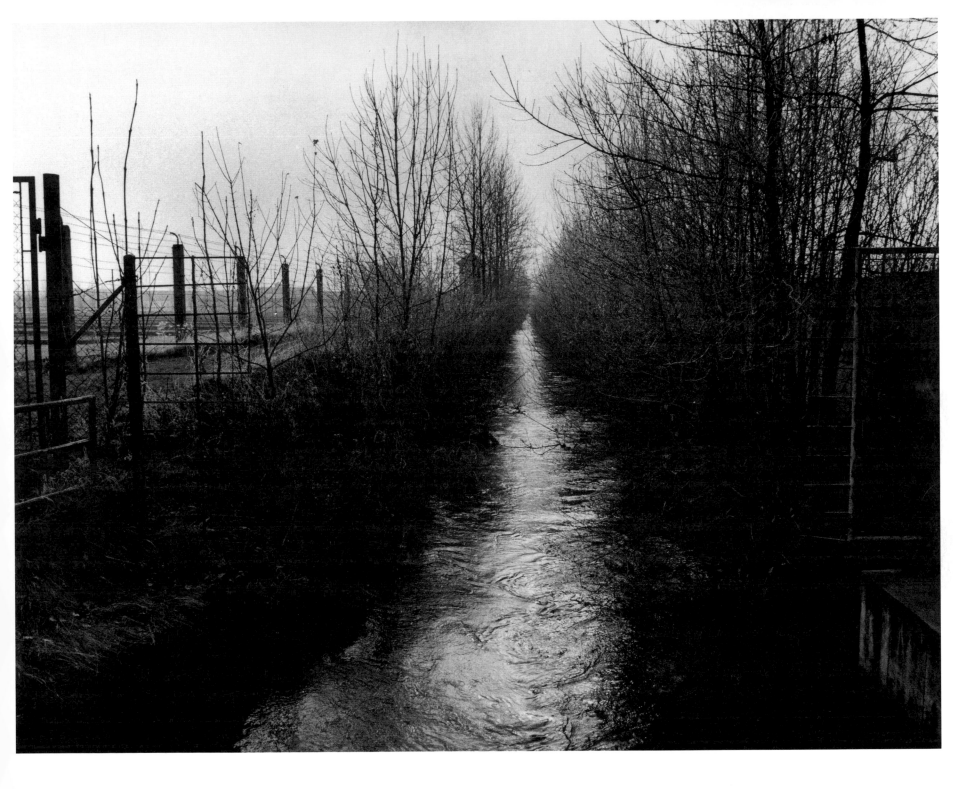

126. Dachau: The entrance of the Jewish Memorial Temple built in 1965.

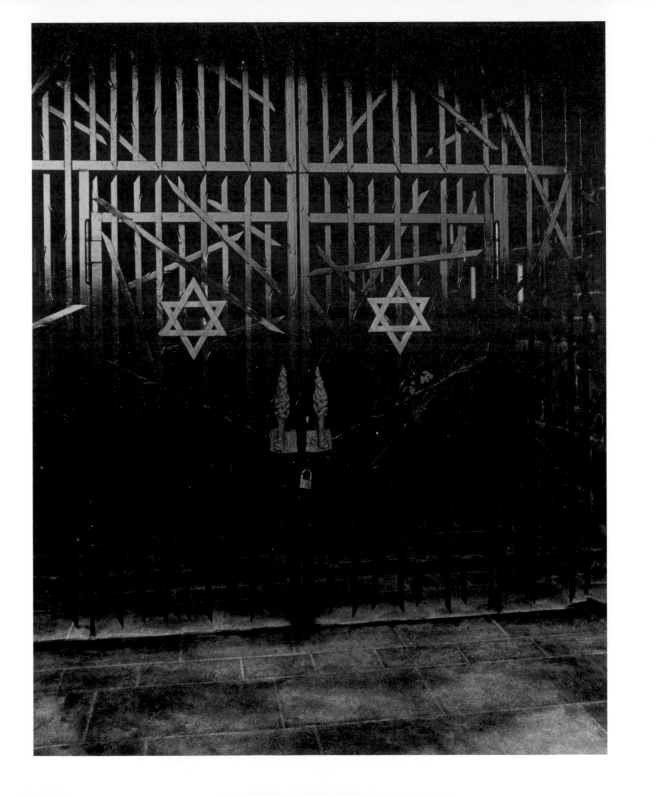

127. Dachau: View to the west from the Catholic *Todesangst Christi Kapelle* built in 1960.

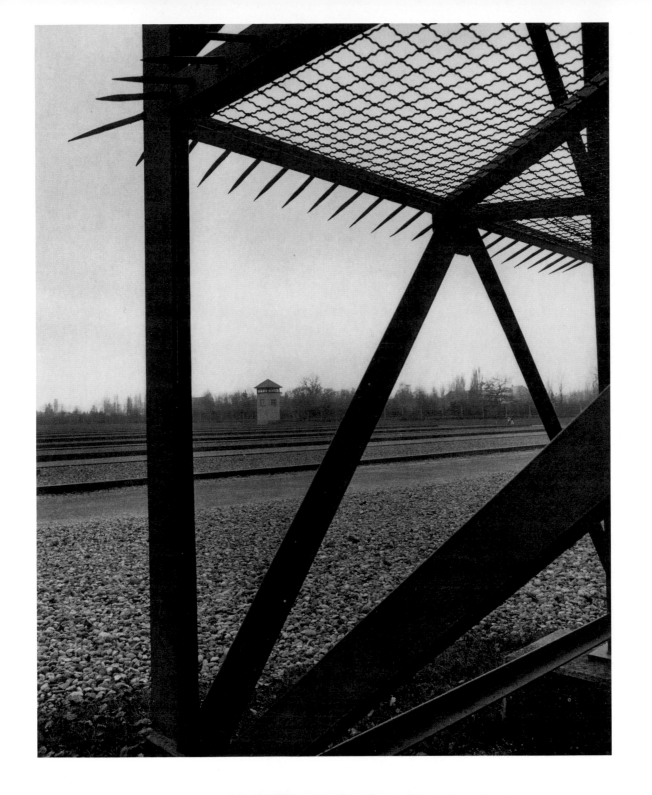

128. Dachau: View to the north in the direction of the barracks from Nandor Glid's International Memorial built in 1968.

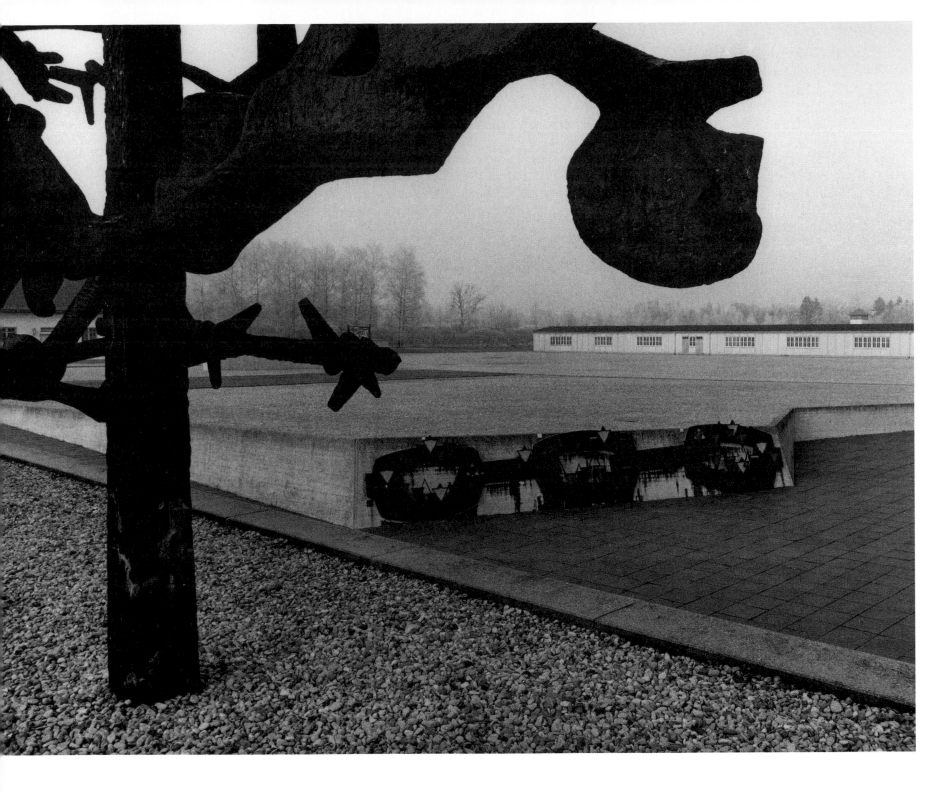

129. Yad Vashem, Jerusalem: In 1979 a smaller replica of Nandor Glid's Dachau memorial (30 ft. long x 12 ft. high) was installed at the northwestern edge of the plaza behind the Yad Vashem Museum and the Hall of Remembrance. Retitled *In Memory of the Victims of Concentration Camps*, Glid's bronze sculpture overlooks the hills of Jerusalem. The monument interacts differently with the landscape and dazzling sunlight of Jerusalem than with the outdoor setting at Dachau; the metal often acquires a molten glow in the reddish haze of a Jerusalem sunset (see photo 72, pages 166–67). Glid's austere and symmetrical sculpture of emaciated and tortured corpses pierced by barbed wire contains explicit reference to the European graphic tradition of Crucifixions and Pietàs as well as to the iconographical language of anti-fascist, Christian, and Jewish art about the Holocaust since the 1930s.

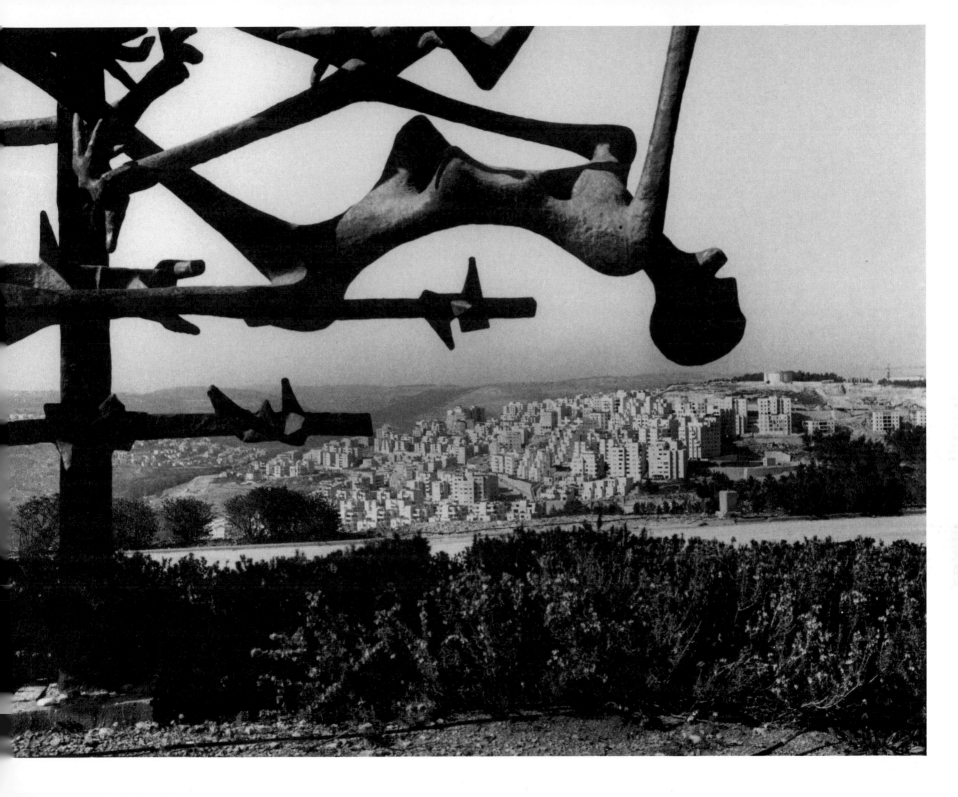

130. Buchenwald: Train tracks at Buchenwald concentration camp. Arriving prisoners were forced to march approximately four miles to the camp entrance.

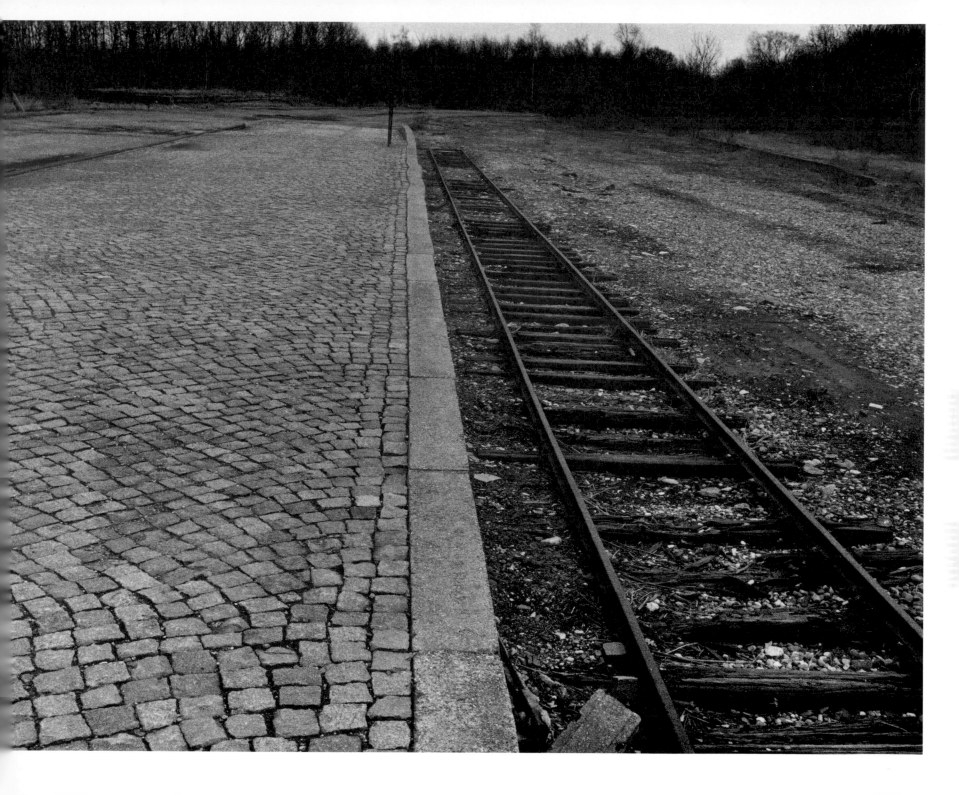

131. Sachsenhausen: Reflected photographic image from the first-floor exhibition in the pathology barrack.

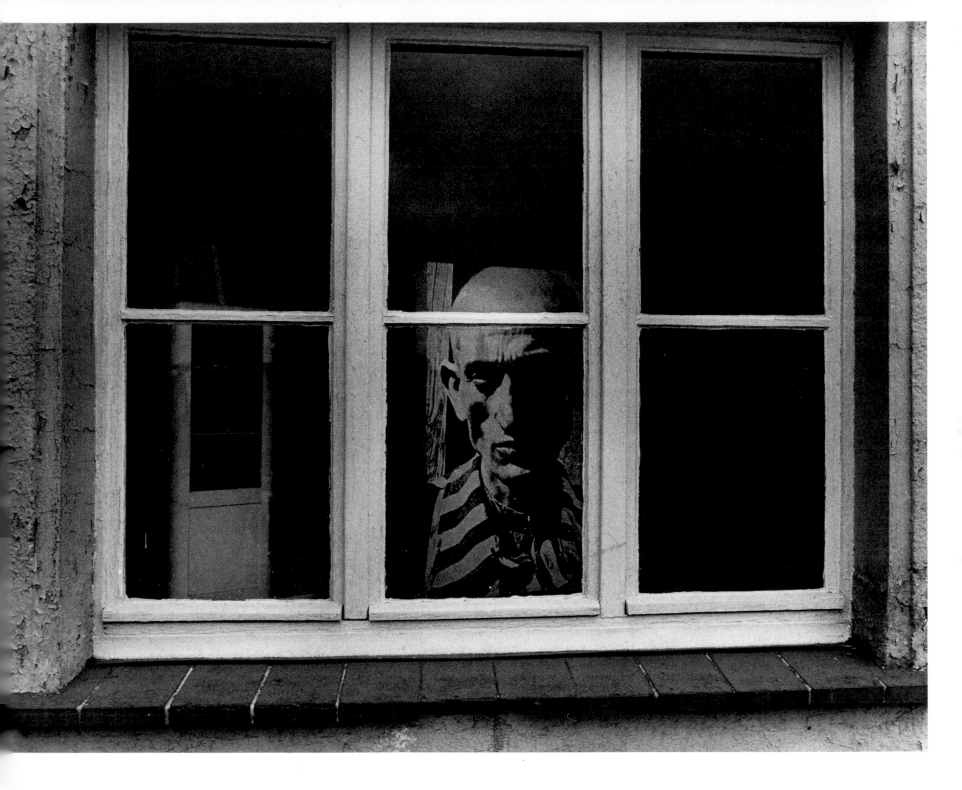

132. Birkenau: Inside a women's barracks.

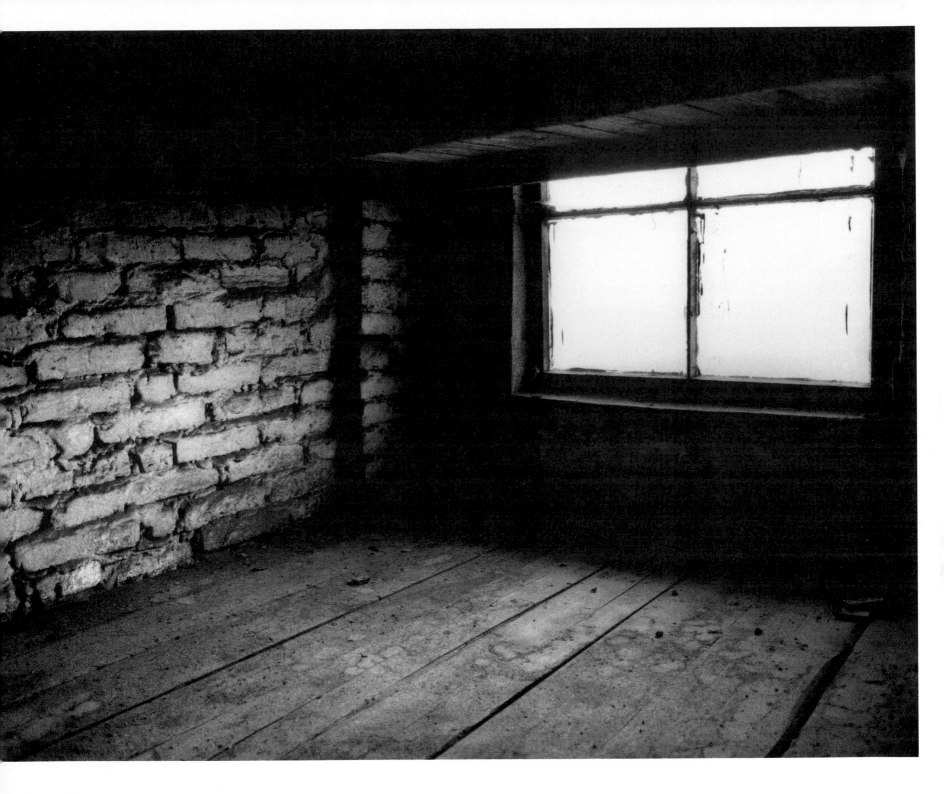

133. Lublin: Jewish tombstone with mortar shell hole.

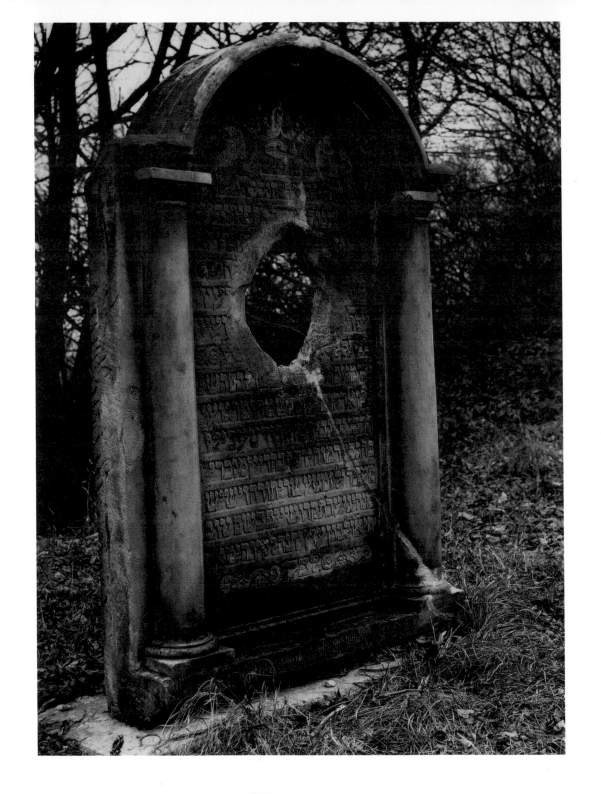

134. Warsaw: The top of a gravestone in the Warsaw Jewish cemetery. Many of these stones are now being restored by the Jewish community in Warsaw.

135. Cracow: The wall around the Remah Synagogue incorporates remnants of hundreds of broken tombstones unearthed during the restoration of the cemetery after World War II.

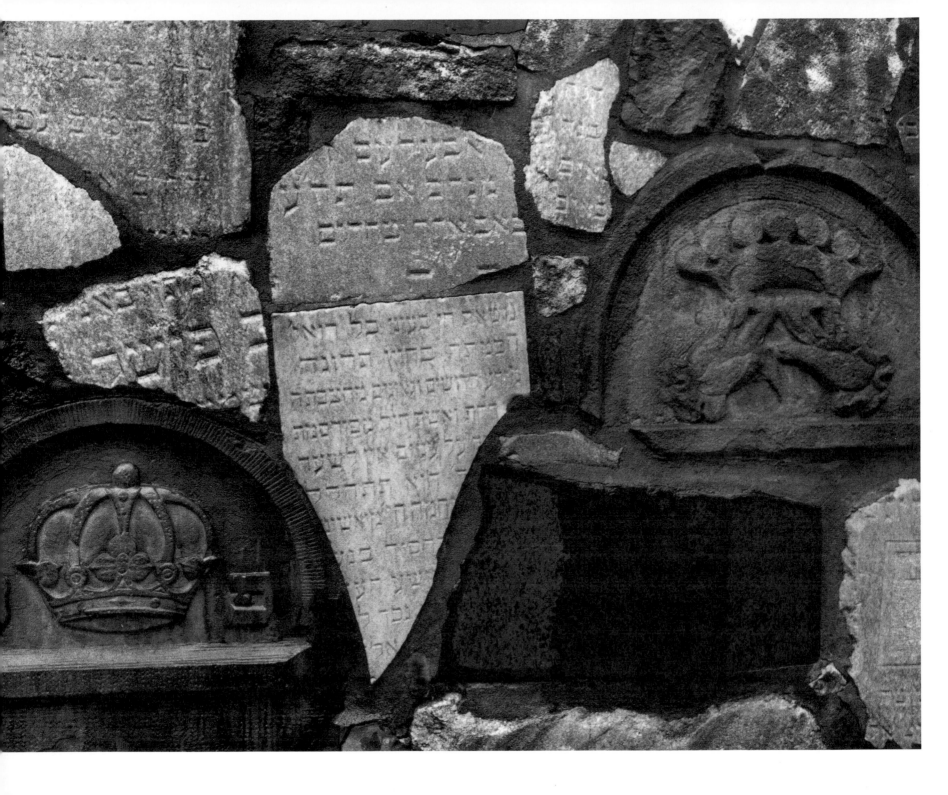

FIVE

ANNOTATED BIBLIOGRAPHY

The following annotated bibliography makes no claim to completeness. The entries are divided into topical and geographical subsections. The literature selected is heterogeneous in language and scope and includes entries from disciplines as diverse as art and architectural history, material culture studies, historical site archeology, visual anthropology, documentary photography, conservation and museum management, communications, and cultural and political history as well as the history of the Holocaust and the concentration camps. The literature selected for inclusion also contains references from guidebooks, newsletters, and exhibition catalogs published by concentration camp memorials and selected articles from European and American newspapers and periodicals to fill bibliographical lacunae.

Although there is at present neither a comprehensive directory nor a multinational bibliography to all Holocaust memorial sites, there are both critical and filopietistic guides for several countries, cities, and a few memorial sites.

Inevitably, any bibliography becomes dated, especially for the topic of memorialization, which is a new and rapidly changing interdisciplinary subject. It is hoped that the following entries will assist the general reader and the specialist in obtaining access to the eclectic literature of this new field.

I. GENERAL

Foote, Kenneth E. "To Remember and Forget: Archives, Memory and Culture." *American Archivist* 53, no. 1 (Summer 1990): 378–92.

 An article about the use of symbols at traumatic sites to convey warnings as well as history; se-

lected case studies include nuclear and toxic waste dumps, the Salem witch trials sites, and Holocaust sites.

Friedlander, Henry. "Holocaust als Problem der politischen Bildung in den USA." In *Lerntag des Zentrums für Antisemitismusforschung*, vol. 5, ed. Wolfgang Scheffler and Werner Bergmann, 109–28. Berlin: Technische Universität Berlin, 1988.

> Analysis of the aims, contents, and politics of Holocaust museums, memorials, and educational institutions in the United States with comparisons to those in Israel and Germany.

Leon, Warren, and Roy Rosenzweig, eds. *History Museums in the United States: A Critical Assessment*. Urbana and Chicago: University of Illinois Press, 1989.

> A survey and evaluation of American historical museums, historic sites, and interpretive programs. The essays with particular application to Holocaust memorial sites and museums include Gary Kalik, "Designing the Past"; John S. Patterson, "From Battle Ground to Pleasure Ground: Gettysburg as a Historic Site"; and Thomas J. Schlereth, "History Museums and Material Culture."

Lowenthal, David. *The Past is a Foreign Country*. Cambridge, London, and New York: Cambridge University Press, 1985.

> A thought-provoking survey about memory, history, and relics; how and why we preserve, restore, and reshape objects and sites from the past for present needs, using case studies from the Renaissance to Auschwitz.

Steinberg, Rolf. Photographs by Manfred Hamm and intro. by Robert Jungk. *Dead Tech: A Guide to the Archeology of Tomorrow*. San Francisco: Sierra Club Books, 1982.

> A photographic and textual survey of the archeological remains of the industrial era (e.g., steel, coal, and auto graveyards as well as the collapsed remnants of the Westside Highway, New York) and twentieth century military detritus (e.g., the Maginot Line, the Atlantic Wall, World War II aircraft carriers, Cape Canaveral, and the debris of nuclear test sites).

II. PUBLIC SCULPTURE

Beardsley, John. *Art in Public Places*. Washington, D.C.: Partners for Livable Places, 1981.

> A survey of how sculptures for public sites were chosen and funded.

Capasso, Nicholas. "Constructing the Past: Contemporary Commemorative Sculpture."*Sculpture* 9, no. 6 (November–December 1990): 56–63.

> A thoughtful article about the resurgence of contemporary memorials in the United States.

Dozema, Marianne, and June Gargrove. *The Public Monument and Its Audience*. Cleveland: Cleveland Museum of Art, 1977.

> An exhibition catalog about the relationship between public art and its audience.

Elsen, Albert E. *Rodin's Thinker and the Dilemmas of Modern Public Sculpture*. New Haven and London: Yale University Press, 1986.

An important history about the creation, reception, installation, removals, and controversies surrounding Rodin's *The Thinker*; provides methodological analogies for the analysis of Holocaust public sculpture.

Mittig, Hans-Ernst. *Das Denkmal*. Tübingen: Studienbegleitbrief 8 des Funkkollegs Kunst, 1987.

Introductory materials for an adult education course about memorials in the context of contemporary political culture, with case studies about retaining or removing monuments of previous regimes.

Stalker, Douglas, and Clark Glymour. "The Malignant Objects: Thoughts on Public Sculpture." *The Public Interest* 66 (Winter 1982): 3–21.

A polemic attacking contemporary public sculpture and the propriety of government support and public patronage.

III. SURVEYS OF EUROPEAN AND OTHER MEMORIALS

American Jewish Congress. *In Everlasting Remembrance: Guide to Memorials and Monuments*. New York: American Jewish Congress, 1969. Brochure.

A dated but useful pamphlet about memorials in Austria (Mauthausen), Czechoslovakia (Prague and Theresienstadt), France (Paris), Germany (Bergen-Belsen, Berlin, Buchenwald, and Dachau), Holland (Amsterdam), Israel (the Ghetto Fighters Kibbutz and Yad Vashem), Italy (Rome), Poland (Auschwitz, Treblinka, and Warsaw), Denmark and Sweden, Yugoslavia (Belgrade), and planned but unbuilt memorials in Brussels, London, and New York. Each entry is illustrated.

Brebeck, Wulf E., Angela Genger, Dietfrid Krause-Vilmar, Thomas Lutz, and Gunnar Richter. *Zur Arbeit in Gedenkstätten für die Opfer des Nationalsozialismus*. Berlin: Aktion Sühnezeichen Friedensdienste, 1988.

An anthology based on an international seminar held under the auspices of Aktion Sühnezeichen about the work of Holocaust memorials at: Yad Vashem in Israel; Carpi and San Sabba in Italy; the Anne Frank Foundation and Westerbork in the Netherlands; Mauthausen in Austria; Auschwitz, Maidanek, and Stutthof in Poland; Terezin in Czechoslovakia; Buchenwald and Ravensbrück in the German Democratic Republic; Breitenau, Dachau, Papenburg, the Old Synagogue Essen, Neuengamme, and Wewelsburg in the Federal Republic of Germany; and the United States Holocaust Memorial Museum.

Dachauer Hefte: Studien und Dokumente zur Geschichte der nationalsozialistischen Konzentrationslager, 6 (1990).

Special thematic issue entitled *Erinnern oder Verweigern: Das schwierige Thema Nationalsozialismus* about the role of memorials and museums in the institutionalization of historical

memory. The anthology includes, among others, articles in German by Wolfgang Benz, "Postwar Society and National Socialism: Remembrance, Amnesia, Rejection"; Ralph Giordano, "Fear of History? Memorial Work in Dachau and Elsewhere"; Jochen August, "Auschwitz Changes People: The International Youth Center in Oswiecim"; and Ulrike Haas, "Memorial Texts 1945 to 1999."

Dimensions: A Journal of Holocaust Studies 3, no. 2 (1987).

Special issue (*Are Memorials Reflecting History?*) of a popular journal published by the International Center for Holocaust Studies of the Anti-Defamation League, New York, including articles by David Altshuler, "New York's Living Memorial to the Holocaust," 9; Harold Marcuse, "West German Strategies for Commemoration," 13–14; Annette Wieviorka, "The French Jewish Struggle for Memory," 10–12; and James Young, "The Texture of Memory: Holocaust Memorials and Their Meaning," 4–8.

Hüppi, Adolf. *Kunst und Kult der Grabstätte*. Olten: Walter Verlag, 1968.

A survey of cemetery iconography; pages 405–37 deal with grave sites from World War I and twentieth century developments in cemetery architecture and landscaping.

Marcuse, Harold, Frank Schimmelfennig, and Jochen Spielmann. *Steine des Anstosses: Nationalsozialismus und Zweiter Weltkrieg in Denkmalen, 1945–1985*. Hamburg: Museum für Hamburgische Geschichte, 1985. Brochure.

A critical exhibition catalog about the failures of World War II and Holocaust memorials erected in Europe since 1945; also includes several memorials in South Africa and the United States.

Miller, Judith. *One, by One, by One: Facing the Holocaust*. New York: Simon and Schuster, 1990.

A popular and highly opinionated survey of the transmission of historical memory in six nations (Austria, West Germany, France, the Netherlands, the United States, and the Soviet Union) affected by the Holocaust. Includes sections on the Klaus Barbie trial, the Kurt Waldheim controversy, and the disparity beween the self-serving Dutch mythology of decency symbolized by Anne Frank and the realities of Dutch collaboration. Despite several interesting interviews, the study generally covers well-known information.

Mosse, George L. *Fallen Soldiers: Reshaping the Memory of the World Wars*. New York and Oxford: Oxford University Press, 1990.

A provocative study of war memorials, monuments, and military cemeteries in Germany, England, France, and Italy, analyzing the symbols depicting the myth of the war experience in World War I and World War II. The concluding chapter, "The Second World War, the Myth, and the Postwar Generation" (201–25), is of particular importance.

Rieth, Adolf. *Monuments to the Victims of Tyranny.* New York, Washington, and London: Praeger, 1968.

The first and still classic multinational survey of European Holocaust memorials; copious photographic illustrations.

Van Eck, Ludo. *Het Boek der Kampen.* Leuven (Belgium): Kritak, 1979. In Flemish.

An uncritical but useful compendium of concentration camp historic sites with their postwar memorials in Austria, Belgium, Czechoslovakia, the Federal Republic of Germany, France, the German Democratic Republic, the Netherlands, Poland, and the Soviet Union. The volume contains numerous historic and contemporary photographs of the memorial sites today as well as an appendix with a glossary of camp jargon.

Young, James E. "Memory and Monument." In *Bitburg in Moral and Political Perspective*, ed. Geoffrey Hartman, 103–13. Bloomington: Indiana University Press, 1986.

An interesting but not always convincing study of memorials as symbolic texts; apologetic about Israeli memorials.

———. *Writing and Rewriting the Holocaust: Narrative and the Consequences of Interpretation.* Bloomington and Indianapolis: Indiana University Press, 1988.

The last chapter, "The Texture of Memory: Holocaust Memorials and Meaning" (172–89), explores video testimonies and memorial sites as narrative literature.

———. "Holocaust Memorials, Memory and Myth: Mixing History with National Ideals." *Moment* (June 1989): 21–29, 59.

A survey of memorial styles in Europe, the United States, and Israel, derived from Young's earlier essays; occasionally glaring historical errors, such as the definition of "Night and Fog" described as Jewish rather than resistance prisoners "endangering German security."

IV. MEMORIALS BY COUNTRIES

A. Austria

Beckermann, Ruth. *Unzugehörig: Oesterreicher und Juden nach 1945.* Vienna: Löcker Verlag, 1989.

Provocative linked essays about the problematical interaction of Austrians and Jews since 1945, including a critical analysis of Alfred Hrdlicka's "Memorial against Fascism and War" at Albertina Square in Vienna, the mystique of Austrian antifascism, postwar Austrian antisemitism, and the politics of restitution for Jews and other victims.

Exenberger, Herbert. *Wien: Antifaschistischer Stadtführer.* Vienna: Wiener Bildungsausschuss der SPÖ, 1985. Pamphlet.

A critical guide to sites of persecution and resistance in Vienna; also published in English and French.

Fein, Erich. *Die Steine reden, Gedenkstätten des*

österreichischen Freiheitskampfes: Mahnmale für die Opfer des Faschismus, Eine Dokumentation. Vienna: Europa Verlag, 1975.

> A diffuse survey of memorials for Austrian victims of the Nazis inside Austria and in other countries as well as Austrian monuments for non-Austrian victims. Copious photographs, including the texts of memorial inscriptions and plaques.

Horowitz, Gordon J. In the Shadow of Death: Living Outside the Gates of Mauthausen. New York and Toronto: Free Press, 1990.

> An interesting analysis of the relationship between the inhabitants of the physically adjacent town of Mauthausen and the concentration camp. The last chapter, "The Vanishing Traces" (164–88), concerns postwar attitudes toward the preservation of the site and the problematical nature of public memory.

Lachnit, Peter, ed. Wien wirklich: Ein Stadtführer durch den Alltag und seine Geschichte, 2d ed. Vienna: Verlag für Gesellschaftskritik, 1983.

> An informative left-wing guide to Vienna, including chapters on the East European Jewish quarter in Leopoldstadt (61–85) and the refugees from Austria, 1934–38 (109–13).

Pelinka, Anton, and Erika Weinzierl, eds. Das Grosse Tabu: Österreichs Umgang mit seiner Vergangenheit. Vienna: Österreichische Staatsdruckerei, 1987.

> A provocative and challenging anthology about the Austrian confrontation with its Nazi heritage, including essays by Hermann Langbein, Felix de Mendelssohn, Wolfgang Neugebauer, Oliver Rathkolb, and Erika Weinzierl.

Thurner, Erika. Kurzgeschichte des nationalsozialistischen Zigeunerlagers in Lackenbach, 1940 bis 1945. Eisenstadt: Burgenlandische Landesregierung in Zusammenarbeit mit dem Landesfonds für die Opfer des Krieges und Faschismus, 1984. Brochure.

> History of this labor and assembly center for Austrian Romani and Sinti, most of whom were deported to Lodz and Chelmno, and the 1984 memorial.

Wenzl, Hans. Ein kurzer Wegweiser zu den Stätten des Gedenkens an die Zeit des Faschismus im Zentrum Wien. Vienna: Presse und Informationsdienst der Stadt, 1988. Brochure.

> A pamphlet on memorials for the period 1938–45 in the inner city of Vienna; also in English.

B. Czechoslovakia

Ahrends, Martin. Photographs by Dirk Reinartz. "Ein langer Tag in Terezin." Die Zeit Magazin, no. 47 (13 November 1987): 13–21, 24, 28.

> A photographic essay with excellent descriptions of Terezin (Theresienstadt) today.

Dedeckova, Jirina, et al. Pamatna mista boje proti fasismu a valce v Terezine a v Litomericich. Prague: Nase Vojsko, 1984. Brochure.

A multilingual (Czech, English, French, German, and Russian) guide to the memorials at Terezin and Litomerice.

Novak, Vaclav, et al. *Terezin.* Pamatnik Terezin and Soveroceske nakladatelstvi, 1988.
A richly illustrated volume about the history and contemporary memorial at Terezin; in Czech, captions and summaries also in English, French, German, and Russian.

C. France

Darmon, Richard. "Le camp des Milles: antichambre d'Auschwitz au coeur de la Provence." *Tribune Juive* (13–19 January 1984): 19–30.
An illustated article about the internment and transit camp at Les Milles near Aix-en-Provence, including illustrations of the collectively painted wall murals by the interned artists.

Goldberg, G., and A. Persitz. "Monument commemoratif à Paris, tombeau du martyr juif inconnu." *L'Architecture d'aujourd'hui*, no. 55 (July–August 1954): 20–24.
The architects explain the design of the monument to the Unknown Jewish Martyr in Paris.

Prost, Antoine. "Les monuments aux morts." In *Les lieux de memoire*, ed. Nora Pierre, 195–225. Paris: Gallimard, 1984.
An analysis of French monuments to the deceased soldiers of World War I.

Roitsch, Jutta. "Die Tage des roten Staubes: Spurensuche im französischen Konzentrationslager Les Milles." *Frankfurter Rundschau*, 4 October 1986.
Article about the failure to build a memorial at Les Milles.

Wieviorka, Annette. "Un lieu de memoire: Le memorial du martyr juif inconnu." *Pardes* 2 (1985): 80–98.
For the English translation, see above: *Dimensions* 3, no. 2 (1987).

Ziegler, Jürgen. *Mitten unter uns Natzweiler-Struthof: Spuren eines Konzentrationslagers.* Hamburg: VSA, 1986.
A survey of the history and contemporary sites of Natzweiler-Struthof concentration camp and its subsidiaries; also includes facsimile documents as well as historical and contemporary photographs.

D. Federal Republic of Germany

(1) Surveys

Eichmann, Bernd. *Versteinert, verharmlost, vergessen: KZ-Gedenkstätten in der Bundesrepublik Deutschland.* Frankfurt: Fischer, 1985.
Critical essays about 20 sites, including the euthanasia institutions of Hadamar and Grafeneck; the concentration camps at Bergen-Belsen, Stukenbrock, Wewelsburg-Niederhagen, Hinzert, Flossenbürg, Dachau, Neuengamme, Kemna, and Neue Bremm; the labor reeducation camp at Nordmark; the Old Synagogue Essen; and the

memorials to the teenage *Edelweiss* pirates in Cologne, the Scholl family in Munich, and the resisters executed at Plötzensee prison in Berlin. An appendix gives supplementary literature and clear directions on reaching these sites by car and public transportation.

Garbe, Detlef, ed. *Die vergessenen KZs? Gedenkstätten für die Opfer des NS-Terrors in der Bundesrepublik.* Bornheim-Merten: Lamuv, 1983.

Valuable and original essays about German political amnesia at Holocaust sites such as Moringen, the Moor camps, and the auxiliary labor camps of Sachsenhausen in West Berlin as well as essays about the problems of maintaining memorials at Dachau, Neuengamme, Wewelsburg, and Obere Kuhberg.

Hartman, Geoffrey, ed. *Bitburg in Moral and Political Perspective.* Bloomington: Indiana University Press, 1986.

An anthology occasioned by the Reagan-Kohl visit to Bitburg in May 1985, including essays by Theodor W. Adorno, "What Does Coming to Terms with the Past Mean?" (114–29); Saul Friedländer, "Some German Struggles with Memory" (27–42); Raul Hilberg, "Bitburg as Symbol" (15–26); and Primo Levi, "The Memory of Offense" (130–37). The second half of the book reproduces selected newspaper accounts, editorials, and speeches by President Reagan and Chancellor Kohl and Richard von Weizsäcker's Bundestag speech about the Bitburg affair.

Lehrke, Giesela. *Gedenkstätte für die Opfer des Nationalsozialismus: Historisch-politische Bildung an Orten des Widerstandes und der Verfolgung.* Frankfurt and New York: Campus, 1988.

Analysis of the educational effectiveness of Holocaust memorials, archeological work camps, and alternative city tours.

Mosse, George. *The Nationalization of the Masses: Political Symbolism and Mass Movements in Germany from the Napoleonic Wars through the Third Reich.* New York and Scarborough, Ontario: NAL and Times-Mirror, 1977.

An excellent illustrated chapter (42–72) deals with national monuments.

Niemandsland: Zeitschrift zwischen den Kulturen 1, no. 1 (1987).

A special issue, perceptive but disjointed, about German identity and historical memory, including articles by Klaus Schlosser about the monument to the unknown deserter in Bremen-Vegesack erected in 1986 (100–101); Stephen Schmidt-Wulffen about the Hamburg-Harburg monument against fascism by Esther and Jochen Gerz (85–87); Jochen Spielmann about the relationship between memorials and historical identity (70–83); and Wolfgang Wippermann about the history of the Tannenberg memorial from 1927 to 1945 under German and Polish rule (58–69).

Pingel, Falk. "Erinnern oder Vergessen? Überlegungen

zum Gedenken an den Widerstand und an die Opfer des Nationalsozialismus." *Aus Politik und Zeitgeschichte: Beilage zur Wochenzeitung das Parlament* (28 February 1981): 14–29.

> A sensitive and interesting analysis of West German memorials as a reflection of current knowledge about the victims; also includes a critical discussion of the educational effectiveness and local impact of these memorials.

Puvogel, Ulrike. *Gedenkstätte für die Opfer des Nationalsozialismus: Eine Dokumentation.* Bonn: Bundeszentrale für politische Bildung, 1987.

> A comprehensive survey of memorials in the Federal Republic of Germany, including extensive bibliography, photographs, and maps. The appendix by Peter Sonnet covers the major memorials in the German Democratic Republic, but is not free from anticommunist prejudices.

Rabinbach, Anson, and Jack Zipes, eds. *Germans and Jews Since the Holocaust: The Changing Situation in West Germany.* New York and London: Holmes and Meier, 1986.

> An interesting anthology about the relationship between Germans and Jews after 1945, including essays by Jean Améry and Manès Sperber.

(2) Specific Sites

The following alphabetically arranged entries represent only a small sample of the extensive literature available about individual West German memorial sites and their problems. Two journals—*Gedenkstätten-Rundbrief* and

Zeichen—published by Aktion Sühnezeichen (Berlin) provide regular coverage about West German memorials. Additional information about memorials and related projects is also covered by the monthly newsletter *AVS: Arbeitsgemeinschaft verfolgter Sozialdemokraten (1933–1945),* ed. Heinz Putzrath, published by the Social Democratic Party Executive in Bonn. After the opening of the Berlin Wall in 1989, these journals have also covered the changes in memorial policy brought by the political events that followed, and after October 1990 have expanded coverage to all of unified Germany.

(I) BERLIN

Eckhardt, Ulrich. Photographs by Elke Nord. *Der Moses Mendelssohn Pfad: Eine Berliner Zeitreise oder Wanderwege in eine versunkene Stadt.* Berlin: 750 Jahre Stadt Berlin, 1987.

> Richly illustrated walking tour through the archeological ruins of Jewish Berlin.

Endlich, Stephanie, and Florian von Buttlar. "Über die Schwierigkeit, sich der NS-Geschichte durch Kunst zu nähern." In *Imitationen, Nachahmung und Modell: Von der Lust am Falschen,* 230–51. Basel and Frankfurt: Stroemfeld and Roter Stern, 1989.

> Essay published in an exhibition catalog of the Museum für Gestaltung in Zurich and the Museum der Alltagskultur des 20. Jahrhunderts (Werkbund Archiv) in Berlin. Reviews the failure to find appropriate architectural and design concepts for the former site of the Gestapo headquarters in Berlin. Includes an excellent summary of the Gestapo site design competitions in the

1980s with incisive comparative comments about the relationship to related projects in West Germany, Israel, and the United States. Differentiates design needs between perpetrator and victim sites and their national historical contexts.

Geisert, Helmut, Peter Ostendorff, and Jochen Spielmann. *Gedenken und Denkmal: Entwürfe zur Erinnerung an die Deportation und Vernichtung der jüdischen Bevölkerung Berlins.* Berlin: Berlinische Galerie, 1988.

An exhibition catalog of the designs submitted for the memorials at the sites of the former Levetzowstrasse Synagogue (the assembly center for Berlin Jewish transports, 1941–43) and the Berlin Gruenewald train station; also contains useful survey about the politics of postwar West Berlin memorial choices.

Hämer, Hardt-Waltherr, ed. *Zum Umgang mit dem Gestapo-Gelände: Gutachten im Auftrag der Akademie der Künste Berlin.* Berlin: Akademie der Künste, 1988.

Mimeographed documentation about the Berlin debates concerning the utilization of the former Gestapo headquarters site for a memorial. Includes essays by Leonie Baumann discussing the project of the Active Museum, Stefanie Endlich about the status of the various project proposals and submissions, and Robert Frank about the archeological remnants at the site. Extensive appendix (70 pp.) includes photographs at the site, architectural renderings of the kitchen and jail cells located there, and drawings and plans of the Prinz Albrecht Palais before 1933.

Volkmann, Barbara, ed. *Diskussion zum Umgang mit dem Gestapo Gelände: Dokumentation.* Berlin: Akademie der Künste, 1986.

Transcript of the February 1986 hearings about creating a memorial at the site of the former Gestapo headquarters.

Weissler, Sabine, ed. *Der umschwiegene Ort.* Berlin: Neue Gesellschaft für bildende Kunst, 1987. Brochure.

Photographic exhibition catalog of lay archeologists uncovering the foundations and cellar jail at the site of the Gestapo headquarters.

Wippermann, Wolfgang. *Steinerne Zeugen: Stätten der Judenverfolgung in Berlin.* Berlin: Pädagogisches Zentrum und Verlag Albert Hentrich, 1982.

Despite factual errors, this is a useful photographic compilation of former Nazi buildings, historic sites, and memorials in Berlin.

(II) BONN

Bildungswerk für Friedensarbeit, ed. *Antifaschistischer Stadtführer: Bonn zur Zeit des Nationalsozialismus.* 3d ed. Bonn: Bildungswerk für Friedensarbeit, 1988.

Map and explanations of the sites of persecution and resistance for an alternative tour of Bonn.

Duve, Freimut, ed. *Mahnmal für die Opfer des Krieges und der Gewaltherrschaft in Bonn.* Bonn: SPD Bundestagsfraktion, 1985. Brochure.

Protocol of the July 1985 SPD debate about the proposed national memorial in Bonn.

(III) BREMEN

Müller, Brigitte. *Kunst gegen Krieg und Faschismus in Bremen/Bremerhaven*. 2d ed. Bremen: Der Senator für Bildung, Wissenschaft und Kunst, 1987. Brochure.

Photographic guide to Holocaust monuments, plaques, murals, and public sculpture in Bremen and Bremerhaven.

(IV) DORTMUND

Duhme, Thomas, et al., eds. *"Unseren tapferen Helden . . .": Kriegs– und Kriegerdenkmäler und politische Ehrenmale; Dortmunder Beispiele*. Dortmund: Klartext, 1987.

An exhibit catalog produced by the Design Seminar of the Fachhochschule Dortmund showing local war memorials 1866–1945, including more than 30 pages of photographs. The illustrations include the Soviet military memorial and the cenotaph for Polish forced labor located in the central cemetery, the memorial for the Jewish community of Dortmund, and the memorial at Dortmund-Bittermark; several photos show graffiti defacing former Nazi monuments.

(V) FRANKFURT

Best, Michael, ed. *Der Frankfurter Börneplatz: Zur Archeologie eines politischen Konflikts*. Frankfurt: Fischer, 1988.

Anthology of sometimes polemical articles about the controversial destruction of the remains of the former Frankfurt Jewish ghetto and cemetery, which occurred concurrently with the opening of the Frankfurt Jewish Museum.

Stadt Frankfurt, Amt für kommunale Gesamtentwicklung und Stadtplanung, ed. *Jüdische Gedenkstätte Börneplatz: Ausstellung der ausgezeichneten Wettbewerbsarbeiten 1988*. Frankfurt: Stadt Frankfurt, 1988.

Illustrated exhibition catalog of the winners' entries from the municipal competition for a memorial to the Frankfurt Jewish community at Börneplatz.

Stadt Frankfurt and Jüdische Gemeinde Frankfurt, eds. *Die Synagoge an der Friedberger Anlage: Gedenkstätte für die ehemalige Synagoge der Israelitischen Religionsgesellschaft*. Frankfurt: Stadt Frankfurt, n.d. Brochure.

Historical essays by the Jewish architect Salomon Korn about the Schützenstrasse synagogue and its successor, the Friedbergeranlage synagogue (1–20); the second article, by Bettina Clausmeyer-Ewers (21–28), analyzes plans to erect a Jewish memorial in the former air raid shelter bunker at Friedbergeranlage.

(VI) HAMBURG

Bringmann, Fritz, and Hartmut Roder. *Neuengamme —Verdrängt, vergessen, bewältigt?: Die zweite Geschichte des Konzentrationslagers Neuengamme, 1945–1985*. Hamburg: VSA, 1987.

An incisive historical analysis of the postwar problems of the Neuengamme memorial and the failure to maintain the integrity of the site because of the construction of two prisons on the terrain of the former concentration camp.

Hedinger, Bärbel, et al. *Ein Kriegsdenkmal in Hamburg*. Hamburg: Tutor Verlag, 1979.

The history of Richard Kuöhl's memorial to the Hamburg 76th Infantry Regiment installed at Stephansplatz (1934–36) and the post-1945 reception to this residue of Nazi militarism and memorial sculpture.

Hempel-Küter, Christa, and Eckart Krause. *Hamburg und das Erbe des Dritten Reiches: Versuch einer Bestandsaufnahme.* Hamburg: Behörde für Wissenschaft und Forschung and Staatliche Pressestelle, 1989.

Semi-official summary of Hamburg institutions and sites dealing with the persecution of Jews and the resistance.

Werner, Gabriele. "Welche Realität meint das Reale?: Zu Alfred Hrdlickas Gegendenkmal in Hamburg." *Kritische Berichte* 16, no. 3, (1988): 57–67.

Critical discussion of Hrdlicka's countermonument dedicated to the victims of the Hamburg fire storm (1943), installed opposite Kuöhl's "Kriegsklotz" at Stephansplatz.

(VII) HESSE

Die Grünen im Landtag Hessen, Lothar Bembenek, and Frank Schwalba-Hoth, eds. *Hessen hinter Stacheldraht; Verdrängt und vergessen: KZs, Lager, Aussenkommandos.* Frankfurt: Eichborn, 1984.

A superbly organized and well-written survey of concentration camps, forced labor camps, labor education camps (*Arbeitserziehungslager*), prisoner of war (POW) camps, penal camps, Gypsy camps, and euthanasia centers in Hessen. Each entry contains brief informative essays about the history of each camp, facsimiles of relevant historical documents and photographs for each camp, information about the postwar use of these sites, and references to archival and published sources.

Heimatgeschichtlicher Wegweiser zu Stätten des Widerstandes und der Verfolgung 1933–1945, Vol. 1: *Hessen*, comp. Ursula Krause-Schmidt, Marianne Ngo, Hans Einbrodt, et al. Cologne: Pahl-Rugenstein, 1984.

A useful survey of all localities of persecution and resistance in Hesse, including brief historical summaries, maps, photographs, and postwar histories of the sites. This region includes the former concentration camps at Breitenau near Kassel and Osthofen near Worms.

(VIII) LOWER SAXONY

Heimatgeschichtlicher Wegweiser zu Stätten des Widerstandes und der Verfolgung 1933–1945, Vol. 2, pt. 1: *Niedersachsen I: Regierungsbezirke Braunschweig und Lüneburg*, comp. Ursula Krause-Schmidt, Marianne Ngo, Gottfried Schmidt, et al. Cologne: Pahl-Rugenstein, 1985.

A useful survey of all localities of persecution and resistance for the districts of Braunschweig and Lüneburg in Lower Saxony, including brief historical summaries, maps, photographs, and postwar histories of the sites. This region includes the former concentration camps at Moringen and Bergen-Belsen.

Heimatgeschichtlicher Wegweiser zu Stätten des Widerstandes und der Verfolgung 1933–1945, Vol. 2, pt. 2: *Niedersachsen II: Regierungsbezirke Hannover und*

Weser-Ems, comp. Ursula Krause-Schmidt, Marianne Ngo, Gottfried Schmidt, et al. Cologne: Pahl-Rugenstein, 1986.

> A useful survey of all localities of persecution and resistance in the districts of Hanover and Weser-Ems in Lower Saxony, including brief historical summaries, maps, photographs, and postwar histories of the sites. This region includes the former Moor (*Emslandlager*) camps.

(IX) THE MOOR CAMPS

Hannelore Weissmann. *Auf der Suche nach den Moorsoldaten,* 2d ed. Papenburg: Aktionskomitee Emslandlager and Officina, 1986.

> A systematic brochure providing information about the 15 camps collectively known as the *Emslandlager,* or Moor camps; including a brief history of each camp, description of the site today, relevant photographic illustrations, and maps.

(X) NUREMBERG

Wunder, Thomas. *Das Reichsparteitagsgelände in Nürnberg, Entstehung, Kennzeichen und Wirkung: Eine Einführung zur Begehung des ehemaligen NS-Parteitagsgeländes.* Nuremberg: Kunstpädagogisches Zentrum im Germanischen Nationalmuseum, 1984. Brochure.

> Interesting analysis of the former site of Nazi party rallies and how it is currently used for antifascist education.

(XI) SAARLAND

Heimatgeschichtlicher Wegweiser zu Stätten des Widerstandes und der Verfolgung 1933–1945, Vol. 4: *Saarland,* comp. Hermann Volk. Cologne: Pahl-Rugenstein, 1990.

> A useful survey of all localities of persecution and resistance in the Saarland, including brief historical summaries, maps, photographs, and postwar histories of these sites. Special features of this volume include entries about emigration from the Saarland to France after 1933 and related resistance organizations, the participation of Saarland inhabitants on the republican side in the Spanish Civil War, the euthanasia institutions at Merzig and Homburg, the deportation of Saarland Jews to Gurs, the satellites of Hinzert concentration camp, and the former Neue Bremm concentration camp.

(XII) WEWELSBURG

Hüser, Karl. *Wewelsburg 1933 bis 1945, Kult- und Terrorstätte der SS: Eine Dokumentation.* 2d ed. Paderborn: Bonifatius, 1987.

> A history of the SS Ordensburg, the concentration camp, and the memorial museum; includes photographs, facsimile documents, and extensive chronology.

E. German Democratic Republic

Burghoff, Ingrid, and Lothar Burghoff. *Nationale Mahn- und Gedenkstätte Buchenwald.* Berlin and Leipzig: VEB Tourist Verlag, 1970. Brochure.

> Illustrated guidebook to the history of the camp and the postwar memorial.

Frank, Volker. *Antifaschistische Mahnmale in der*

Deutschen Demokratischen Republik: Ihre künstlerische und architektonische Gestaltung. Leipzig: Seemann Verlag, 1970.

> A survey of memorials and monuments in the German Democratic Republic, includes photographs.

Koch, Heinz. *Nationale Mahn- und Gedenkstätte Buchenwald: Geschichte ihrer Entstehung.* Weimar: Buchenwald, 1988. Brochure.

> History of the Buchenwald memorial museum from 1945 to the present.

Lagergemeinschaft Sachsenhausen, ed. *Sachsenhausen: Dokumente, Aussagen, Forschungsergebnisse und Erlebnisberichte über das ehemalige Konzentrationslager Sachsenhausen.* Berlin: VEB Deutscher Verlag der Wissenschaften, 1981.

> History of the concentration camp and memorial at Sachsenhausen.

Litschke, Egon. *Nationale Mahn- und Gedenkstätte Ravensbrück: Museum.* Rostock: Ostsee-Druck, 1988. Brochure.

> Guide to the memorial museum of the first women's concentration camp.

Miehte, Anna Dora, and Hugo Namslauer. *Denkmalpflege in der Deutschen Demokratische Republik: Zur Gestaltung und Pflege politischer Gedenkstätten.* Berlin: Institut für Denkmalpflege, 1981. Brochure.

> Discussion of the appropriate uses of landscaping and architecture at Soviet memorial cemeteries, the mass grave of Sachsenhausen forced laborers in Lieberose-Jamlitz, and the Below Forest, where the Sachsenhausen death march occurred.

F. Israel

Dafni, Reuven, ed. *Yad Vashem: The Holocaust Martyrs' and Heroes' Remembrance Authority.* Jerusalem: Yad Vashem, 1989.

> Guidebook to all aspects of Yad Vashem, including color photographs of its many sculptures and monuments.

Elon, Amos. *The Israelis: Founders and Sons.* New York: Penguin, 1984.

> Informative discussion of Yad Mordechai and Yad Vashem in the context of Israeli social and political developments (197–209).

Jersualem Post Supplement, 1 June 1985.

> Special issue about Yad Vashem.

Kampf, Avram. *Jewish Experience in the Art of the Twentieth Century.* South Hadley, Mass.: Bergin and Garvey, 1984.

> Includes a useful survey of postwar Israeli art and sculpture about the Holocaust.

Lishinsky, Yosef. "Yad Vashem as Art." *Ariel: A Review of Arts and Letters in Israel,* no. 55 (1983): 14–25.

> An uncritical description with photographs of public sculpture and the art museum at Yad Vashem.

Lopate, Phillip. "Resistance to the Holocaust." *Tikkun* 4, no. 1 (May–June 1989): 55–65.

An original critique of Yad Vashem and other established Holocaust commemorative practices.

G. Italy

Apih, Elio. *Mostra Storica della Risiera di S. Sabba*. Trieste: City of Trieste and Municipal Museums of History and Art, 1983. Brochure.

Exhibition catalog containing historical introduction about the concentration camp at the Risiera di San Sabba and facsimile reproductions of the historical exhibition, with explanatory captions in English, Italian, and Serbo-Croatian.

Carpi, Castello dei Pio. *Museo Monumento al Deportato Politici e Razziale nei Campi di Sterminio Nazisti*. Carpi: Nuovagrafica, n.d. Brochure.

Illustrated brochure in English containing translated texts of the wall inscriptions from prisoners' last letters and description of the permanent exhibition at the Pio Palace in Carpi, commemorating the transit camp at Fossoli (located 3.2 miles from Carpi) and the political and racial victims of the Nazi concentration camps.

Ducci, Teo, ed. *Revisitando i Lager*. Florence: Idea, n.d.

Exhibition catalog containing photographs of San Sabba in Trieste by Paola Mattioli (32–43, 46).

Gualdi, Romano (photographer). Text by Carlo Federico Teodoro. *... Dove anche il fango è pulito: Il Campo di Concentramento di Fossoli*. Modena: Analisi, 1990. Brochure.

Contains 29 photographs taken in 1973 of the residual original site of the Fossoli transit camp, including barracks, wall inscriptions by the prisoners, and postwar commemorative plaques as well as an introductory text about the transit camp at Fossoli.

Klerr, Edward D. "A Monument to the Martyrs: Italian Jewry Erects Unique Memorial to the 8,000 Italian Jews Slaughtered by Nazism and Fascism during the War." *National Jewish Monthly* (December 1947): 130, 158.

Leoni, Giovanni, ed. *Trentacinque progetti per Fossoli*. Milan: Electa, 1990.

Bilingual Italian and English catalog containing historical introduction and illustrated descriptions of 35 entries from an international design competition by the town of Carpi for a new historical memorial at the Fossoli transit and concentration camp, located 3.2 miles from the town of Carpi. Includes a general historical introduction by Enzo Colloti (11–34); a history of the camp at Fossoli and the postwar project Nomadelfia (a city for orphans and abandoned children briefly located at Fossoli) by Enea Biondi et al. (35–79); an essay on the architectural design of deportee monuments by Massimo Bulgarelli (80–87); the present conditions and project purposes of a new memorial at the former Fossoli transit camp by Paoli Fresni et. al. (88–92), and reproductions of the

submissions for a new memorial at Fossoli (93–249).

Trieste, City of. *Risiera di San Sabba: Monumento Nazionale*. Trieste: Cultural Institutions of the City of Trieste, n.d. Flyer (contained in all tourist information packets).

> A brief history of La Risiera, a rice factory converted by the Nazis into a concentration camp in October 1943, including sketches of the original camp, including gas chamber and crematorium, and the memorial.

H. The Netherlands

Het Nederlands Monument in Mauthausen, n.p., 1986.

> An illustrated brochure about the construction of the Dutch monument at Mauthausen.

Koenders, Pieter. *Het Homomonument*, trans. Eric Wulfert. Amsterdam: Stichting Homomonument, 1987. Brochure.

> The history of the design and installation of the homosexual memorial at Westermarkt Square in Amsterdam. The text is simultaneously printed in Dutch and English.

Guidebooks are available for three other Dutch memorial sites: the Anne Frank House and the new Museum of the Dutch Resistance (*Verzetsmuzeum*) in Amsterdam and the internment and transit camp at Westerbork.

I. Poland

Only a limited selection of the extensive literature on Holocaust sites in Poland has been selected for inclusion, with emphasis on publications in Western languages. The memorials at Auschwitz-Birkenau, Maidanek, and Stutthof have guidebooks and monograph and periodical publications as well as special exhibition catalogs available in Polish, often with English and German summaries.

Council for the Preservation of Monuments to Resistance and Martyrdom, ed. *Scenes of Fighting and Martyrdom, Guide: War Years in Poland, 1939–1945*. Warsaw: Sport i Turystica, 1966.

> The first comprehensive English guide to all memorial plaques, monuments, and museums about the Holocaust and resistance in Poland; includes 291 photographs.

Lewin, Nathan. "Zichronot, Jewish Poland: A Land of Only Memories." *Washington Jewish Week* (24 September 1987): 1, 12–19.

> A survey of Jewish memorial sites in Auschwitz-Birkenau, Cracow, Lodz, Rzeszow, Warsaw, and Wieliczka.

Niezabitowski, Malgorzata. Photographs by Tomaz Tomaszewski. "Remnants: The Last Jews of Poland." *National Geographic* 170 (3 September 1986): 362–89.

> A richly illustrated article about the current conditions and prospects of Jews living in Poland, condensed from an identically titled larger book.

Rady Ochrony Pomnikow Walki i Meczenstwa, ed. *Pamiec wiecznie Zywa, 1947–1987*. Warsaw, 1988.
A guide to the activities of the Council for the Preservation of Monuments to Resistance and Martyrdom, including brief descriptions and photographs of the memorials at Auschwitz-Birkenau, Chelmno, Lambinowice, Maidanek, Palmiry, Paviak prison (Warsaw), Plaszow (Cracow), Radogoszcz (Lodz), Sobibor, Stutthof, and Treblinka. Good bibliography of publications and exhibitions of these memorials.

———. *Scenes of Martyrdom and Fighting of Jews on the Polish Lands, 1939–1945*. Warsaw: Sport i Turystyka, 1978. Brochure.
Photographs and descriptive texts of the major Jewish monuments in Poland; texts in English, French, German, Polish, Russian, and Yiddish.

J. Soviet Union

Gittelman, Zvi. "History, Memory, and Politics: The Holocaust in the Soviet Union." *Holocaust and Genocide Studies* 5, no. 1 (1990): 23–37.

K. The United States

Baigall, Matthew. "Segal's Holocaust Memorial." *Art in America* (Summer 1983): 134–36.
The installation of George Segal's memorial at Lincoln Park overlooking the Golden Gate Bridge in San Francisco.

Berenbaum, Michael. "The Americanization of the Holocaust." In *Bitburg and Beyond: Encounters in American, German, and Jewish History*, ed. Ilya Levkov, 700–710. New York: Shapolsky Books, 1986.
Explains the growth of American Jewish identification with the Holocaust and the increasing number of secular commemorative ceremonies and institutions concerning the Holocaust in the United States.

Carter, Malcolm. "The FDR Memorial: A Monument to Politics, Bureaucracy, and the Art of Accommodation." *Art News* (October 1978): 51–57.
The story of a memorial that was never built.

Griswold, Charles L. "The Vietnam Veterans Memorial and the Washington Mall: Philosophical Thoughts on Political Iconography." *Critical Inquiry* 12 (Summer 1986): 688–719.
An interesting analysis of the relationship between the *Vietnam Veterans Memorial* and other memorials built on the Mall in Washington.

Lewis, Stephen. *Art out of Agony: The Holocaust Theme in Literature, Sculpture, and Film*. Toronto: CBC Enterprises, 1984.
Pages 109–18 contain an interview with George Segal about the San Francisco Holocaust sculpture.

Milton, Sybil. "Ständige Erinnerung und Mahnung: Der Holocaust und die nachkriegspolitische Kultur." *Das Parlament* (21–28 July 1989): 16.
Analysis of American Holocaust museums and

institutions with critical comments about American approaches.

Rosenblatt, Gary. "Holocaust Memorials in the United States: How Many Are Enough?" *Baltimore Jewish Times*, 6 February 1987, 56–59.
> Survey and analysis of the proliferation of local Jewish monuments to the Holocaust in the United States.

Scruggs, Jan C., and Joel L. Swerdlow. *The Vietnam Veterans Memorial: To Heal a Nation.* New York: Harper and Row, 1985.
> A good comparative study of memorial design for controversial historical events.

Szonyi, David M., ed. *The Holocaust: An Annotated Bibliography and Resource Guide.* New York: KTAV for the National Jewish Resource Center, 1985.
> Chapter 5 lists educational and commemorative centers as well as archives and libraries (259–75), and chapter 6 contains a list of Holocaust memorials and landmarks in the United States and Canada (278–306).

Thompson, Vivian Alport. *A Mission in Art: Recent Holocaust Works in America.* Macon, Ga.: Mercer University Press, 1988.
> A survey of recent American Holocaust art by survivors and others, including descriptions of the memorials at Seattle (Wash.), Toledo (Ohio), West Hartford (Conn.), and Wilmington (Del.).

U.S. Holocaust Memorial Council. *Directory of Holocaust Institutions.* Washington, D.C.: Government Printing Office, 1988.
> Compendium of addresses and programs of relevant American institutions dealing with the Holocaust.

L. Other Countries

Brest, Jorge Romero. "Councours international de sculpture de Londres." *Art d'aujourd'hui* 4, no. 5 (July 1953): 6–11.
> Contains photographs from the Tate Gallery 1953 competition for a monument to the Unknown Political Prisoner.

City of Kurose, Japan, ed. *Gateway to Peace: Auschwitz Memorial Pavilion.* Kurose: City of Kurose, n.d.
> Glossy brochure in English and Japanese of a proposed memorial about Japan and the Holocaust.

Marmer, Nancy. "Boltanski: The Uses of Contradiction." *Art in America* (October 1989): 169–81, 233–35.
> A study of Christian Boltanski's recent installations and their interpretation of World War II and the Holocaust.

Reston, James, Jr. "Japan Teaches Its Own History." *New York Times Magazine* (27 October 1985): 52ff.
> A survey of Japan's confrontation with its own history and current amnesia about Japanese atrocities during World War II.

Tate Gallery. *The Unknown Political Prisoner: International Sculpture Competition.* London: Tate, 1953.
> Catalog with photos of the prize maquettes for a monument that was never built.

———. *Suffering Through Tyranny.* London: Tate, 1984. Flyer.
> Retrospective of the 1953 competition with some of the original maquettes supplemented by art against fascism and World War II atrocities.

SIX

Selected List of Holocaust Memorial Sites

I. EUROPE

Austria

Lackenbach
LACKENBACH INTERNMENT AND TRANSIT CAMP
Marktgemeinde Lackenbach, Burgenland

Gypsy memorial consisting of basalt stones from the Pauli-berg quarry, where Gypsies had once done forced labor. No remaining historic buildings.

Mauthausen
MAUTHAUSEN CONCENTRATION CAMP
Ca. 2 miles from the town of Mauthausen and 14 miles from the city of Linz, Upper Austria

CAMP SITE
Intact structure, including gate, wall, guard towers, prisoner barracks, crematorium, the infamous 186 steps (*Todes-stiege*), the quarry, and historical exhibitions.

POSTWAR MEMORIALS
A sculpture park located on the terrain between the former concentration camp and the quarry steps, includes 22 sculptures designated *Memorials of the Nations* and more than 30 inscribed plaques and stones.

The *Memorials of the Nations* were erected by the following countries and associations (some erected more than one memorial): Albania, Austria, Belgium, Bulgaria, Czechoslovakia, France, German Democratic Republic, German Federal Republic, Great Britain, Greece, Hungary, Italy, Luxembourg, the Netherlands, Poland, Soviet Union, Yugoslavia, and Committee for Jewish Victims of Mauthausen, Jewish Youth of Austria, and Spanish Republican Deportees.

Memorial plaques and stones include those from Norway, Romania, and Switzerland; the cities of Parma and Padua; and numerous private individuals.

Vienna
DOCUMENTATION ARCHIVE OF THE AUSTRIAN RESISTANCE (DÖW)
Wipplingerstrasse 8

Documentation center on Nazi terror in Austria, and exhibition about the persecution and resistance of Austrians, including Jews, throughout Europe, 1933–45.

Vienna
MONUMENT AGAINST WAR AND FASCISM
Albertina Square at the intersection of Augustiner Strasse and Operngasse

Controversial *Monument against War and Fascism* designed by Alfred Hrdlicka and installed in November 1989 on the triangular plot adjacent to the State Opera House and the Albertina Museum, where 300 victims of an air raid perished in March 1945. The monument consists of four parts: three sections are made from Carrara marble and granite quarried at Mauthausen; the Jewish figure is cast in bronze. The four sections include: "The Gate of Violence" (*Das Tor der Gewalt*) commemorating Austrian victims of the Nazis and the war; the bronze center figure of "The Prostrate Jew," an elderly bearded Jew with yarmulke, kneeling with toothbrush (commemorating the humiliation of Viennese Jews in 1938 forced to scrub streets) with barbed wire added on his back (when the monument was redesigned to prevent tourists from using the sculpture as a bench); "Orpheus Descending to Hades"; and "The Stone of the Republic." Explanatory panels in six languages have been added because of the complex and not always successful iconography.

Belgium

FORT BREENDONK CONCENTRATION CAMP
Between Brussels and Antwerp, 8 miles north of Mechelen

Concentration camp, including memorial to the Belgian resistance; historical exhibitions.

Brussels
MEMORIAL TO THE JEWISH MARTYRS
Memorial to be erected on rue Georges Charpentier in the Anderlecht section of the city.

Czechoslovakia

Lidice
14 miles north of Prague, near Kladno on route 7

Memorial and exhibition in the town obliterated by the Germans, June 1942, in reprisal for the assassination of Reinhard Heydrich.

Prague
PINKUS SYNAGOGUE
Located in the historic Jewish quarter of Prague

Memorial walls inscribed with the names of more than 77,000 Bohemian and Moravian Jewish victims.

Prague
Trida Politkckych Veznu 20

Former Gestapo headquarters and prison in the old Petschek Palace.

Terezin (Theresienstadt)
14 miles north of Prague on route 8

Original site of the Small Fortress and ghetto, preserved in-

tact; historical exhibitions about Terezin and Litomerice concentration camps; and national cemeteries (for Jews and Soviet Army).

Denmark

Copenhagen
MEMORIAL PARK
Ryvangen, Turborgvej

Cemetery with monument to those executed by the Germans.

Copenhagen
MUSEUM OF THE DANISH RESISTANCE MOVEMENT, 1940–45
Churchillparken

Historical exhibitions about Jewish rescue and Danish resistance.

Copenhagen
WESTERN CEMETERY
Theresienstadt memorial stone.

Padborg, South Jutland
FROSLEV PRISON CAMP
Museum in two buildings that formerly housed members of the Danish resistance arrested by the Germans.

France

Paris
CENTER OF CONTEMPORARY JEWISH DOCUMENTATION
17 rue Geoffrey l'Asnier
Paris 75004

Documentation center founded in 1942; the courtyard contains the memorial consisting of a stone wall with the Star of David and a tomb with the names of concentration camps and ghettos. Designed by G. Goldberg and A. Persitz. A short walk from the Ile de la Cité.

Paris
MÉMORIAL DE LA DÉPORTATION
Square behind Notre Dame Cathedral on Ile de la Cité. Square de l'Ile de France

Commemorates the 200,000 French Jews (30,000 from Paris) who died during the Holocaust. The memorial is a subterranean vault constructed around a tunnel of 200,000 lighted quartz pebbles, following the Jewish tradition of paying homage to the dead by placing a stone on the grave. The stark and simple design by O. Pingusson also includes low ceilings, and iron bars, conveying menace and imprisonment.

Pau
GURS TRANSIT CAMP
Located near the town of Pau

Residual camp structures with weatherbeaten handwritten memorial sign and cemetery; documentation center is being planned.

NATZWEILER-STRUTHOF CONCENTRATION CAMP
Located in the Vosges mountains, near Strasbourg, Alsace

Historic camp structures, national cemetery, and modern memorial by Bertrand Monnet and L. Fennaux.

German Democratic Republic

Berlin (East)
JEWISH CEMETERY
Grosse Hamburger Strasse 26

Historic Jewish cemetery from the nineteenth century, including grave site of Moses Mendelssohn, destroyed by the Gestapo in 1942. Adjacent to the cemetery is the first old-age home of the Jewish community of Berlin, which was used as an assembly center for the deportation of Berlin Jews, 1942–45.

Berlin (East)
LUSTGARTEN
Centrally located square where the Nazis erected the anti-Soviet propaganda exhibition burned by the Baum resistance group in May 1942. Memorial plaque to the Baum group by Jürgen Raue installed in 1981.

Berlin (East)
SCHÖNHAUSER ALLEE JEWISH CEMETERY
Nineteenth century Jewish cemetery where members of the German resistance were caught and hung.

Berlin (East)
VOLKSPARK FRIEDRICHSHAIN
Monument for German members of the International Brigade by Fritz Cremer.

Berlin (East)
WEISSENSEE JEWISH CEMETERY
Largest Jewish cemetery in Europe. Memorial stone for the Herbert Baum Jewish resistance group.

BERNBURG (ON THE SAALE)
Located ca. 18.6 miles north of Halle

Psychiatric hospital with memorial to those 8,601 patients murdered in the so-called euthanasia program between September 1940 and August 1941.

BRANDENBURG (ON THE HAVEL)
Former prison used as euthanasia institution in 1940; today it is the town hall. Commemorative relief for 8,000 victims on outside wall.

DORA-NORDHAUSEN CONCENTRATION CAMP
Located in the Harz mountains in Thuringia

CAMP SITE
Historic camp of Dora-Mittelbau razed in 1945, now being reconstructed as memorial; only crematorium stands.

POSTWAR MEMORIALS
Sculpture of prisoners by Jurgen Woyski next to crematorium, eternal flames, and landscaped park.

Fürstenberg
RAVENSBRÜCK CONCENTRATION CAMP
Near the town of Fürstenberg, 57 miles north of Berlin

CAMP SITE
Historic women's concentration camp includes walls, old punishment cells, and crematorium; no original barracks remain.

POSTWAR MEMORIALS
Modern reliefs and sculptures about female inmates by Will Lammert and Fritz Cremer.

Oranienburg
SACHSENHAUSEN CONCENTRATION CAMP
In the town of Oranienburg in the suburbs of Berlin, on the S train

CAMP SITE
Historic site of the largest camp in the German Reich includes walls, sentry boxes, Jourhaus, barracks arranged in a semicircle, and morgue; the crematorium ruins contain a modern sculpture by Waldemar Grzimek.

POSTWAR MEMORIALS

Marked trail of death marches; special museum of the European antifascist resistance; separate Jewish barracks; and obelisk memorial with inverted red triangles in roll call area.

Weimar
BUCHENWALD CONCENTRATION CAMP
5 miles northwest of the city of Weimar

CAMP SITE
Camp surrounded by barbed wire fence. A few buildings, including Jourhaus, crematorium, and laundry, remain; the destroyed barracks are outlined on the ground with stones. Memorial plaques and stones randomly placed inside camp include those for Ernst Thälmann, Rudolf Breitscheid, Soviet POWs, murdered British and Canadian paratroopers, and Polish prisoners. Historic museum in former SS buildings.

POSTWAR MEMORIALS
Modern monument park includes freestanding reliefs, sculpture, bell tower, and enclosed tombs on the Avenue of Nations.

German Federal Republic

BERGEN-BELSEN CONCENTRATION CAMP
Near the town of Bergen, not far from the city of Celle

Historic camp site; all structures were burned in 1945 to combat epidemics. Only mass graves remain. Includes a Jewish memorial (1945); international memorial (1950s); inscription for murdered Gypsies (1982); document house initially opened in 1966, expanded in 1990.

Berlin (West)
FASANEN STRASSE SYNAGOGUE
Fragments of historic structure incorporated as memorial in the current Jewish community center and names of concentration camps and killing centers inscribed on courtyard wall.

Berlin (West)
LEVETZOW STRASSE MEMORIAL
Memorial plaque on wall outside a children's playground (1960s); marble sculpture incorporating remnants of deportation car; and metal sign listing Berlin deportations. Former site of synagogue that served as the first deportation center for Berlin Jews during 1941–42.

Berlin (West)
MARIA REGINA MATYRUM
Heckerdamm 230, Charlottenburg

Church of the Atonement built in 1962 to commemorate Catholic and Lutheran resistance, including Bernhard Lichtenberg (whose burial crypt is in Saint Hedwig Cathedral in East Berlin) and Erich Klausener; crypt with Pièta sculpture by Fritz Koenig.

Berlin (West)
PLÖTZENSEE MEMORIAL
Historic prison where members of the 20 July 1944 plot to assassinate Hitler were executed; modern memorial and exhibition.

Berlin (West)
STAUFFENBERG STRASSE MEMORIAL
Bus #29 at the intersection of Reichspietschufer and Stauffenberg Strasse

Memorial and museum of the German resistance on the second floor of reconstructed former Wehrmacht supreme headquarters building (formerly Bendlerstrasse). Commemorates 20 July 1944 plot to assassinate Hitler. Sculpture and memorial plaque in courtyard.

Berlin (West)
Tiergarten Strasse 4

Memorial plaque to the "forgotten victims" of the Nazi euthanasia killings, installed into the pavement in front of Philharmonic Hall, which replaced the building that housed the headquarters of the euthanasia program during World War II.

Berlin (West)
WANNSEE VILLA
Am Grossen Wannsee 56

Memorial plaque on outside gate of villa, where on 20 January 1942 Heydrich chaired the interdepartmental meeting that discussed the "final solution of the Jewish question." Formerly a children's convalescent home; now being renovated as memorial with historic exhibition.

Berlin (West)
Wittenberg Platz

Freestanding memorial plaque with shingles listing the concentration camps. Located on paved plaza adjacent to Wittenberg Platz subway station, opposite KaDeWe department store.

Dachau
DACHAU CONCENTRATION CAMP
10 miles northwest of Munich

Historic camp site with entrance, barbed wire fence, guard towers, and crematorium remaining. Reconstructed model

of prisoners' barracks and large historic exhibition. Lutheran, Catholic, and Jewish memorial chapels and one postwar sculpture by Nandor Glid.

Düsseldorf
DÜSSELDORF MEMORIAL
Mühlenstrasse 29

Permanent exhibition about the victims of the Nazi regime in Düsseldorf, located in the former police building (including detention cells) of 1933.

Essen
OLD SYNAGOGUE
Steeler Strasse 29, located near the downtown pedestrian mall

Memorial in surviving shell of old synagogue, built 1911–13, the interior destroyed during the November 1938 pogrom. Opened in 1980 as municipal memorial and documentation center with permanent exhibit on the history of the Jews in twentieth century Essen and on persecution and resistance in Essen, 1933–45.

Floss
FLOSSENBÜRG CONCENTRATION CAMP
Northern Bavaria near Czech border; nearest train station Weiden [Oberpfalz] and local bus connections via Neustadt a.d. Waldnaab and Floss

Historic camp site with former SS building, quarry, and crematorium remaining. Park with exhibition, but also houses local light industry. Administered by the Dachau Memorial.

Freudenthal (Württemberg)
SYNAGOGUE
Strombergstrasse 19

Educational and cultural center in the reconstructed premises of the former synagogue, including historical exhibitions.

Guxhagen
BREITENAU MEMORIAL
Located in the former Benedictine convent in Guxhagen, about 9.3 miles south of Kassel

Historical exhibition for the concentration and labor camp at Breitenau, June 1933–March 1934 and 1940–45.

HADAMAR
Mönchsberg 6

Psychiatric hospital and former euthanasia institution, including cemetery for about 15,000 murdered patients and historical exhibition.

Hamburg
NEUENGAMME CONCENTRATION CAMP
Located in the Hamburg suburb of Vierlande

Historic camp site now partly occupied by maximum security prison and juvenile detention center. Only *Klinkerwerke* (brick factory where prisoners worked) and canal built by prisoners remain. Includes documentation house with exhibition and marked trail of former camp sites; postwar memorial flagstones and sculpture.

Saarbrücken
NEUE BREMM
Southwest Saarbrücken, Metzer Strasse

Memorial obelisk and plaques erected in 1947 plus documentation center built in the 1980s.

Ulm
OBERE KUHBERG
Located in Ulm/Neu-Ulm

Documentation center with historical exhibition in the former fortress walls of the Obere Kuhberg concentration camp.

Greece

Athens
JEWISH MUSEUM OF GREECE
36 Amalias Avenue

Permanent research collection and exhibition on the Holocaust in Greece.

Salonika
CENTER FOR HISTORICAL STUDIES OF SALONIKA JEWS
Opened in 1985. Permanent photographic exhibit on the history and fate of Salonika Jews after 1880.

Hungary

Budapest
JEWISH MUSEUM
Dohány Street 12

Permanent exhibition on the history and fate of Hungarian Jews.

Budapest
MAGYAR MUNKASMOZGALMI MUSEUM
Szentharomsag Street 2

Museum of the Hungarian labor movement, including permanent exhibit about resistance to German and Hungarian Nazis and fascists.

Budapest
MEMORIAL FOR JEWISH MARTYRS
Behind the Dohány Street Synagogue

Ca. 33-foot-high stone monument erected in 1948 with inscriptions in Hungarian and Hebrew, located in the cemetery in the synagogue courtyard.

At the intersection of Rumbach and Wesselényi Streets, between the synagogue cemetery and the community center, a memorial to the Hungarian victims of the Holocaust was erected in 1989 at the site of the former ghetto gate. Designed by Imre Varga, it consists of a silvery metallic tree with eight branches in the shape of an inverted menorah. The lower third of each branch bears leaves with the names of victims inscribed on each side of each leaf.

Italy

Carpi
FOSSOLI TRANSIT CAMP
Located in the Pio palace on main square in Carpi, 3.2 miles from the original transit camp

Memorial and museum about the camp of Fossoli. The transit camp was created in 1943 on the site of a previous POW camp in a suburb of Carpi. Museum exhibition shows the fate of Jewish and political deportees. One room has the names of 37,000 Italians who died in various German concentration camps engraved on walls. Documentation center under the auspices of ANED and Federation of Italian Jewish Communities.

Milan
MEMORIAL FOR ITALIAN POLITICAL PRISONERS
12.5-foot-high abstract steel structure erected in 1946 and designed by Belgiojoso, Peresutti, and Rogers.

Milan
MUNICIPAL CEMETERY
Mausoleum to Jewish martyrdom erected in 1947. Twelve individual tombs designed to be representative of the fate of the entire Jewish community under fascism and German occupation, by architect Manfredo Urbino.

Rome
ARDEATINE CAVE
Memorial to the hostages shot by the Germans in the Fosse Ardeatine near Rome in 1944. Limestone statue by Francesco Cozzia (1950). Jewish graves are identified by a Star of David on headstones. Barbed wire and abstract sculptures at gates.

Trieste
RISIERA DI SAN SABBA
Staff and guards previously stationed at Belzec, Sobibor, and Treblinka in Poland established a concentration camp in San Sabba in October 1943. Served as transit camp for Jews on way to Auschwitz and other German camps. Also ca. 5,000 persons, mostly partisans, killed there and corpses burned in crematorium. Camp site totally intact; old buildings, courtyard, crematorium, and modern museum with memorial. Camp became national monument in 1965 and operates under the administrative jurisdiction of the city of Trieste.

Venice
GHETTO NUOVO
Arbit Blatas bronze bas-reliefs installed on a faded brick wall topped with residual strands of barbed wire; see entry for New York, Anti-Defamation League.

Luxembourg

Esch-sur-Alzette
NATIONAL MUSEUM OF THE RESISTANCE
Three buildings with double colonnade, permanent exhibition.

Wiltz

WILTZ MEMORIAL

Ca. 78-foot-high tower memorial in the town of Wiltz for the victims of the 1942 general strike. Erected in 1956; designed by architect Roger Vercollier.

The Netherlands

AMERSFOORT TRANSIT CAMP

Ca. 7.5-foot-high limestone monument to the unknown prisoner, designed by Fred Sieger in 1952. Nothing remains of the camp.

Amsterdam
ANNE FRANK HOUSE

Prinsengracht 263

Exhibition in the house where the Otto Frank family was hidden during the German occupation.

Amsterdam
GYPSY MONUMENT

Museumsplein

Sculpture erected in 1978.

Amsterdam
HOMOMONUMENT

Westermarkt

Monument consisting of a pink triangle in Rosa Porino granite in honor of the homosexual and lesbian victims of the Holocaust; designed by Karin Daan.

Amsterdam
RAVENSBRÜCK MEMORIAL

Museumsplein

Memorial to the women of Ravensbrück erected in 1975, designed by Guido Eckhardt, Frank Nix, and Joost van Santen.

Amsterdam
STATUE OF A DOCK WORKER

This realistic statue, located on the square in the former Jewish quarter where the Portuguese and Ashkenazi synagogues are located, commemorates the 1942 strike that protested the deportation of Amsterdam Jews.

Rotterdam
ROTTERDAM MEMORIAL

Ca. 20-foot-high statue for the *Destroyed City*, to commemorate the destruction of the inner city by German bombers in 1940; designed by Ossip Zadkine in 1953.

WESTERBORK TRANSIT CAMP

Located near Assen in northeastern Holland

Nothing remains of the historic camp that served as a transit center for the deportation of Dutch Jews and Gypsies. Monument erected in 1970 about a mile from the original site; utilizes an old railroad spur to symbolize the deportations. Documentation center erected near monument in 1983 with permanent exhibition surveying Dutch Jewish history and persecution of Dutch Jews under German occupation.

Norway

Oslo
AKERHUS FORTRESS

Site of former prison where members of the Norwegian resistance were executed by the Germans. Modern museum about resistance and deportations in Norway.

Poland

BELZEC EXTERMINATION CAMP
Southeast Poland, Lublin district

Camp totally destroyed by the Germans. Modern monument designed by Mieczyslaw Welter. Ca. 500,000 Jews and Gypsies were killed there.

CHELMNO [KULMHOF] EXTERMINATION CAMP
Western Poland, ca. 10 miles from town of Kolo and 30 miles from Lodz

Site demolished by the Germans. Modern monument erected in 1960s. Ca. 300,000 Jews and Gypsies, mostly from the Lodz ghetto, were killed there.

Cracow
PLASZOW CONCENTRATION CAMP
Located in suburbs of Cracow

Nothing remains of the historic camp. Monument designed by Ryszard Szczypzynski and Witold Ceckiewicz erected in the early 1960s.

Lublin
MAIDANEK CONCENTRATION CAMP
Located in suburb of Lublin

Historic site still containing 11 barracks, crematorium, warehouses, and barbed wire fence. Modern museum opened in October 1944, specializes in concentration camp art. Memorial sculpture designed by Wiktor Tolkin and Janusz Dembek, erected in 1970.

OSWIECIM [AUSCHWITZ] CONCENTRATION CAMP
In Upper Silesia, ca. 40 miles west of Cracow

The camp site covers 40 miles and contains Auschwitz I (*Stammlager*, or main camp), Auschwitz II (the Birkenau complex and killing center), and Auschwitz III (the BUNA-Monowitz I.G. Farben labor camp). Site of all three camps substantially intact with fences, towers, and barracks. Crematoria with gas chambers remain only as ruins. Modern historical museum located in Auschwitz I, containing documentation center and various exhibitions. The exhibit on the "Martyrdom of the Jews" is located in Block 27. Also modern architectural memorial plaza and sculptures.

ROGOZNICA [GROSS-ROSEN] CONCENTRATION CAMP
Located in Silesia

Historic camp site remains almost intact with iron gate, barbed wire fence, search lights, guard towers, SS barracks, prisoner reception and bath building, and punishment cells. Modern museum with permanent exhibition and mausoleum made of granite quarried by the prisoners and containing ashes from the crematorium.

SOBIBOR EXTERMINATION CAMP
Eastern Poland, ca. 45 miles southeast of Warsaw

Camp was totally destroyed by the Germans. Modern monument and mass grave mound located there today. Ca. 500,000 Jews and Gypsies were killed there.

SZTUTOWO [STUTTHOF] CONCENTRATION CAMP
Ca. 20 miles northeast of Gdansk

The surviving historic site includes several prisoner barracks, camp commandant's office and villa, crematorium, gas chamber, and barbed wire fence. Modern memorial and historical museum; sculpture designed by Wiktor Tolkin uses prisoner identification numbers as motif of granite monument.

TREBLINKA EXTERMINATION CAMP
Northeastern Poland, near town of Malkinia

Camp was totally destroyed by the Germans. Modern monument, erected in 1964 and designed by the sculptors Adam Haupt and Franciszek Duszenko, consists of symbolic cemetery with 17,000 stones of various shapes and sizes, most inscribed with the name of a community obliterated during the Holocaust. Central stone memorial, 22 feet high, is dedicated to the Jews of Warsaw. More than one million Jews were killed there. Treblinka served as final destination for the deported Jews of the Warsaw ghetto.

Warsaw
JEWISH HISTORICAL INSTITUTE AND MUSEUM
Swierszeskiego 79

Research center with martyrs museum about the history of the ghetto in Warsaw and other Polish towns.

Warsaw
PAVIAK PRISON MUSEUM
Dzielna 24–26; Intersection of Dzielna and Paviak

Memorial and museum located in the former prison located in the Warsaw ghetto, where Jews and Poles were incarcerated by the Germans.

Warsaw
WARSAW GHETTO MEMORIAL
Intersection of Anielewicz and Zamenhof

Located on empty plaza in the former ghetto. Erected on the fifth anniversary of the ghetto uprising (April 1948) and consists of realistic sculpture designed by Nathan Rapoport. This is the only explicit public memorial for a Jewish ghetto in Poland.

More than 2,000 inscribed plaques, memorial stones, and monuments are found at various localities in Poland.

Soviet Union

Kaunus
FORT IX
In Lithuania, ca. 62 miles from Vilnius

Museum of the concentration camp at Fort IX.

Kiev
BABI YAR

Memorial for those Jews murdered by Einsatzgruppe C in September 1941. The actual mass graves lie under a four-lane highway, although an artificial trench symbolizes the original site of the massacres.

Kiev
UKRAINIAN STATE MEMORIAL MUSEUM OF THE HISTORY OF THE GREAT PATRIOTIC WAR
Museum about Kiev under Nazi occupation.

Minsk
MUSEUM OF THE HISTORY OF THE GREAT PATRIOTIC WAR

Moscow
SOVIET ARMED FORCES MUSEUM
This museum includes material on World War II and resistance.

Paneriai
PANERIAI EXTERMINATION CAMP
In Lithuania, a short distance from Vilnius

Memorial and exhibition at the former killing center of Paneriai (Ponary).

Princiupiai
In Lithuania, ca. 27.3 miles from Vilnius

Like Oradour sur Glans in France or Lidice in Czechoslovakia, Princiupiai was razed by the Nazis in 1944. Historical site and memorial.

SALISPILS CONCENTRATION CAMP
In Latvia, 10.5 miles from Riga

Memorial complex, including sculpture, landscaped cemetery, and historical exhibition at the site of the former concentration camp.

Sweden

Halsingborg
TOWN HALL
Memorial plaque commemorating Swedish assistance in the rescue of Danish Jews.

Yugoslavia

Belgrade
BELGRADE JEWISH CEMETERY
A large memorial to the Jewish victims was erected in 1952 and designed by Bogdan Bogdanovic. It consists of two parallel stone walls containing inscriptions for 197 Jewish victims. The entrance to the memorial resembles two airplane wings containing Jewish symbols in cast iron. The path between the walls leads to a pedestal with a menorah.

Belgrade
JEWISH HISTORICAL MUSEUM
7 jul 71a/I; P.O.B. 841

Museum for the history of the Jewish community in Serbia, including memorial to the Jewish victims of the Germans.

Jasenovac
CONCENTRATION CAMP
On the left bank of the Sava River, alongside the Zagreb-to-Belgrade railroad line

Memorial and historical museum at the site of the former concentration camp. Modern sculpture, designed by Bogdan Bogdanovic, consisting of a 75-foot-high open flower crypt is located in the middle of the mass graves.

ZAGREB MEMORIAL
Memorial to the victims of mass executions in 1942, erected in 1962 in the Croatian capital, consisting of 12-foot-high abstract design by Dusan Dzamonja.

II. ISRAEL

Jerusalem
HA-IDRAH YESHIVA
Atop Ha-Idrah Yeshiva, adjacent to Wailing Wall

Yaacov Agam memorial (1987) consisting of six 6-foot transparent glass pillars serving as memorial candles, lighted by gas-fed flames and set in small fountains of water. On top are polished stainless steel Stars of David and large steel letters for the Hebrew word *yizkor*, or remembrance.

Jerusalem
YAD VASHEM
P.O.B. 3477
Jerusalem

The Central State Martyrs and Heroes Authority, built on the western slope of Mount Herzl, contains a research and documentation center as well as museums for historical and art exhibitions. The memorial includes: the Hall of Memory with eternal flame, the Hall of Names, a Garden of the Righteous, a sculpture terrace with contemporary replicas of Nandor Glid's Dachau monument and Nathan Rapoport's *Wall of Remembrance* as well as original sculpture

about the Holocaust, a children's memorial, the memorial cave, and a landscaped valley of the Destroyed Communities. Commemorative works include Bernie Fink's monument to Jewish soldiers and partisans, Elsa Pollak's Auschwitz monument, Buki Schwarz's *Pillar of Heroism*, and the Yad Vashem candelabra.

Lohamei Hageta'ot
Located between Acre and Nahariya

The Ghetto Fighters' Kibbutz contains a documentation center and museum of the Holocaust, which includes modern works of art and sculpture about the Holocaust. Very good models of ghettos and killing centers.

Moreshet
Kibbutz Ha'artzi Seinar, Givat Haviva

Documentation and pedagogical center in memory of Mordecai Anielewicz, the commander of the Warsaw ghetto uprising.

Kibbutz Mishmar Haemek
Memorial sculpture to the Children of the Holocaust, designed by Zeev Ben-Zwi in 1947.

Scroll of Fire
In the Judean hills at Kesalon

A modern memorial by Nathan Rapoport, the *Scroll of Fire* is a 26-foot-high bronze pillar with reliefs from Roman times to the Six Day War. It was commissioned by B'nai B'rith.

Other Israeli sites with memorial inscriptions and sculpture include: Kibbutz Beit Theresienstadt, Kibbutz Yad Mordechai, Mishar Hagenegev, and Yigael Tumarkin's sculpture *Holocaust and Survival* in Tel Aviv. There is no complete or central list available for Holocaust memorials in Israel.

III. UNITED STATES

Alabama

Mobile
Congregation Ahavas Chesed
1717 Dayphin Street

Hand-carved mahogany bas-relief sculpture to the six million martyrs; designed by John Shaw and carved by Abner Smiles.

Arizona

Tucson
Jewish Community Center
Near Campbell Avenue, across the Rillito River

Memorial sculpture plaza, fountain, and wall designed by Ami H. Shamir in 1989, including stylized ten commandments listing the names of the concentration camps.

California

Berkeley
Judah L. Magnes Museum
2911 Russell Street

Seven-foot-high sculpture by Marika Somogyi, *In Memoriam*. Also display of Holocaust memorabilia as well as regular exhibits of Holocaust art.

Beverly Hills
TEMPLE EMANUEL
300 North Clark Drive

A 4.5-foot outdoor shrine designed and made by Eric May. It uses *gematria* [the numerical equivalent of Hebrew letters] to spell the Hebrew phrase "Remember and Never Forget." The letters, made of oxidized steel, are in bas-relief; their numerical value by *gemetria* is 18, which stands for *chai*, or life.

Los Angeles
MARTYRS MEMORIAL
6505 Wilshire Boulevard, 12th floor

Official Yad Vashem memorial in Los Angeles, designed with entrance passage consisting of four model train cattle cars to simulate transports to the camps. Also crypt, chapel, and permanent exhibit.

Los Angeles
SIMON WIESENTHAL CENTER
9760 West Pico Boulevard

Museum and library on the Holocaust, including a commemoration hall and multi-media complex. Ten-foot-high brass broken Star of David, soaring into infinity, thus symbolizing spiritual and physical rebirth. The sculpture is very similar to Alexander Calder's submission to the 1953 London competition for a *Monument to an Unknown Political Prisoner*. New building to house the Museum of Tolerance (Beit Hashoah) now under construction.

San Francisco
LINCOLN PARK, PALACE OF LEGION OF HONOR
Parking lot turnout

George Segal's *The Holocaust* is a white, bronze 20 x 20 foot walk-in sculpture, installed on the hill below the Palace of the Legion of Honor, overlooking the Golden Gate Bridge. The landscape designer, Asa Hanamoto, was interned as a Nisei teenager in the camps created under Executive Order 9066.

Colorado

Denver
BABI YAR PARK
East Parker Road at Havana

Twenty-seven-acre park created in the memory of 33,000 Jews killed by the Germans at Babi Yar outside Kiev in 1941. Landscaped paths, groves of trees, and bridge. Financed by the city and county of Denver and the Babi Yar Foundation.

Connecticut

New Haven
EDGEWOOD PARK

Memorial to the Six Million, designed by architect Gustav Franziani and built by contractor George Skolnick. This section of the park, known as Holocaust Square, has six steel columns surrounded by simulated barbed wire at its center, forming a Star of David. Fifty planted trees are each inscribed with the name of a concentration camp.

West Hartford
JEWISH COMMUNITY CENTER
Sculpture of a giant Hebrew *chai*.

Delaware

Wilmington
FREEDOM PLAZA
Between city, county, and state office buildings on French Street

Holocaust memorial designed by sculptor Elbert Weinberg, located on city land but privately financed. Sculpture consists of life-size bronze figures and three 15-foot-high concrete columns engraved with names of concentration camps.

District of Columbia

Washington
UNITED STATES HOLOCAUST MEMORIAL MUSEUM

Memorial and museum under construction next to the Bureau of Printing and Engraving between 14th and 15th streets at Independence Avenue SW; renamed Raoul Wallenberg Place. Scheduled to open in 1993.

Florida

Miami Beach
HOLOCAUST MEMORIAL PLAZA
19th Street and Dade Boulevard, adjacent to Miami Beach Garden Center

Memorial plaza designed by architect Kenneth Treister containing 72-foot-tall bronze sculpture of outstretched arm in a 200-foot-diameter reflecting pool, surrounded by 14 bronze 3-foot-tall menorahs and a 200-foot colonnade

made of Jerusalem stone for exhibitions and the names of Jewish victims.

Georgia

Atlanta
Jewish section of Greenwood Cemetery
1173 Cascade Avenue, SW

Stone memorial monument with six huge candlesticks symbolizing the six million. Casket with ashes from Auschwitz buried at the base of the monument. Inscriptions in English, Hebrew, and Yiddish.

Maryland

Baltimore
Intersection of Gay, Lombard, and Water streets

Holocaust memorial erected by the Baltimore Jewish Council and located downtown on former site of the Inner Harbor Campus of Baltimore Community College. Designed by Donald Kann and Arthur Valk; dedicated in 1980. Two huge concrete monoliths, each 75 feet long x 18 feet high, hovering over plaza; they serve as entrance to an open park dedicated to the six million.

Massachusetts

Waltham
Brandeis University

Holocaust memorial adjacent to Berlin Chapel. Replica of six-foot-high bronze statue of Job by Nathan Rapoport.

Michigan

West Bloomfield
HOLOCAUST MEMORIAL CENTER
6600 West Maple Street

Museum, memorial, and resource center.

New Jersey

Deans
WASHINGTON CEMETERY

Holocaust memorial dedicated to the Jewish martyrs of Ungvar, Hungary, erected in 1976 by the Association of Jews from Ushorod. Lists victims from Ushorod killed in Auschwitz and other camps.

Jersey City
LIBERTY STATE PARK

Nathan Rapoport's sculpture *Liberation*, dedicated in May 1985, overlooking the *Statue of Liberty*, shows a young GI carrying an emaciated survivor.

New York

Albany
JEWISH COMMUNITY CENTER
340 Whitehall Road

Nathan Rapoport sculpture of burning bush.

Long Beach, Long Island
KENNEDY PLAZA

Holocaust monument with inscriptions based on original designs by Stanley R. Robbin, M.D. and the architect Monte Leeper, located in front of Long Beach City Hall and dedicated in June 1987. Consists of an inverted pyramid of highly polished black granite on a triangular base, containing three inscribed panels with reliefs to: (1) Janusz Korczak and the memory of the lost Jewish children; (2) an unconsumed burning bush and barbed wire, symbolizing the camps; and (3) the righteous Gentiles Raoul Wallenberg, Oscar Schindler, and Maximilian Kolbe.

New York City
ANTI-DEFAMATION LEAGUE
823 United Nations Plaza

Seven bronze bas-reliefs, each 3 x 2 feet, by Arbit Blatas, mounted on 13 x 21-foot pink granite wall. The subjects include deportation, *Kristallnacht*, quarry, punishment, execution in the ghetto, Warsaw ghetto revolt, and the final solution. Two additional bas-reliefs from this series were donated to the city of Venice for installation in the old Jewish ghetto (1980) and to the *Tomb of the Unknown Jewish Martyr* in Paris (1981).

New York City
CHURCH OF ST. JOHN THE DIVINE
1037 Amsterdam Avenue

Elliot Offner's bronze sculpture of a skeletal figure, entitled *Auschwitz Memorial Figure.*

New York City
JEWISH MUSEUM
1109 Fifth Avenue

George Segal's maquette of *The Holocaust*; cast of plaster, wood, and wire 10 x 10 x 20 feet.

New York City
LIVING MEMORIAL TO THE HOLOCAUST/ MUSEUM OF JEWISH HERITAGE
First and Battery Place, Battery Park City

Museum and memorial to be constructed in Battery Park City on the lower tip of Manhattan, opposite the *Statue of Liberty* and Ellis Island. Scheduled to open in 1992.

New York City
PARK AVENUE SYNAGOGUE
Madison Avenue and 87th Street

Two large sculptures by Nathan Rapoport affixed to facade. The statues are *Janusz Korczak and the One Million Children Who Perished*, and *Return to Israel*.

New York City
WORKMAN'S CIRCLE
45 East 3rd Street

Nathan Rapoport's 7.5-foot-high statue about Warsaw ghetto uprising.

Pennsylvania

Philadelphia
Benjamin Franklin Parkway at 16th Street

Martyrs monument erected in 1964. An 18-foot-high bronze statue by Nathan Rapoport, showing dying mother in flames, child with Torah scroll, patriarchal figure, arms wielding daggers. Figures are framed by blazing menorah and burning bush.

Tennessee

Memphis
JEWISH COMMUNITY CENTER
6560 Poplar

Seventeen-foot-high marble Holocaust memorial inscribed with the names of concentration camps and six eternal lights at the top.

Texas

Dallas
JEWISH COMMUNITY CENTER
7900 North Haven Road

Hexagonal monument, 24 feet high, with Nathan Rapoport's relief *The Last March*. Nearby are plaques inscribed to the Allied nations that liberated the camps and to the Danes for rescuing Jews; also lists number of Jews killed in each European country.

Washington

Seattle
JEWISH COMMUNITY CENTER
3801 Mercer Way
Mercer Island

Sculpture in bronze by Gizel Berman, 12 feet high, with words "You Shall Not Forget" in Hebrew.

IV. OTHER COUNTRIES

Australia

Sydney
Holocaust memorial in downtown plaza; constructed in 1985.

Canada

Montreal
JEWISH PUBLIC LIBRARY
Cumming House, 5151 Cote Saint Catherine Road

Sanctuary, attached to Holocaust museum, contains the names of concentration camps on its walls and a sealed urn with ashes from one of the camps mounted on the remnant of a column from a destroyed Warsaw synagogue. Column

and urn are installed on pedestal shaped like a Star of David below an eternal flame.

Ottawa
JEWISH CEMETERY
Highway 31

Granite monument, 11 feet high, shaped like Star of David with flame at top. Base carries Hebrew inscription "Remembrance," the number six million, and the dates "1933–1945." Erected in 1978.

Japan

Kurose, Hiroshima Province
AUSCHWITZ MEMORIAL PAVILION FOR PEACE

Memorial under construction on the linked themes of Auschwitz and Hiroshima. Also to include Japanese role in rescuing Jews in Kobe and Shanghai as well as exhibit on other twentieth century genocides. Work suspended in 1989 for financial reasons.

Osaka
ANNE'S ROSE CHURCH

Protestant church with Anne Frank statue in bronze. Also Holocaust garden, memorabilia, and Jewish library. All church members belong to the Japan Christian Friends of Israel.

South Africa

Johannesburg
WEST PARK CEMETERY

Sculpture by Herman Wald consisting of black granite base with six columns of 20-foot-high shofars mounted on 5-foot-high fists. In the center arch, formed by two rows of three shofars, is a spiral design of a 15-foot-high eternal light in bronze. Dedicated in 1959.

TECHNICAL NOTES ABOUT THE PHOTOGRAPHS

Ira Nowinski

EQUIPMENT

I used four cameras on the photographic field trips: two Leica cameras (an M4 and an M6) with an Elmarit lens (f2.8 28mm) and two Sumicron lenses (35mm and 90mm); a Nikon N2000 camera with a 105mm f2.5 Nikkor and, for close-ups, a 55mm Macro Nikkor lens; and in Poland, I also used a Hasselblad 500 cm camera with an 80mm lens. A Leitz tripod was used; occasionally I used a monopod, but usually hand-held the Leica. Prints were made with a Leitz Fotomat 1-C with a 50mm Nikkor, and also with an Omega D5500 with a 75mm Nikkor.

EXPOSURE AND LIGHTING

I used T-Max 400 Kodak film, which has a sharper resolution and less grain than other black and white films. I always overexposed by at least a 1/2 stop. The exposures were determined by careful examination of developed negatives, and after the first test films, I was able to calculate the various exposures without the use of a meter. The film was developed in a T-Max developer, diluted 1:5 at 72 degrees Fahrenheit in a four-reel stainless steel tank. Development time was 6.5 minutes, followed by a 30 second water bath, and then a rapid fix for 10 minutes. This film has an extra thick emulsion which requires a longer fixing time. I used Photo-Flow before hanging the negatives to dry.

PRINTS

To produce publication prints, I used Agfa Ensignia Paper, grades 2 and 3. This paper has a long tonal range and a hard emulsion coated with plenty of silver. This allows for long development times and contrast control. The paper also responds well to selenium toner, which gives the prints added shadow and detail and makes them suitable for archival preservation.

A split development technique was used with Kodak Selectol-Soft and Dektol developers. The prints were first put into a 68 degree Fahrenheit solution of Selectol-Soft, diluted 1:1 for one minute and then transferred to Dektol, diluted 1:2. This split development allowed control of highlights and enhancement of detail. Dektol strengthens the blacks and gives the shadow area a good contrast.

After the prints developed a full tonal range (sometimes 4 minutes in the developer), they were

transferred to a stop-bath solution and then to a fixing bath for 10 minutes. After thorough washing, the prints were transferred to a second fixing bath prepared without hardener, then to a selenium toning bath containing Hypo-Clear for 2 minutes under a strong light. After washing the prints, they were put on drying racks for 24 hours, followed by a one minute pressing at 270 degrees Fahrenheit. The prints were then retouched with a fine type 0 brush using spot tone retouching agent.

INDEX

Sybil Milton is the Senior Resident Historian of the United States Holocaust Memorial Council in Washington, D.C. She is coauthor of *Art of the Holocaust*, which won the National Jewish Book Award in Visual Arts in 1981 and is the definitive work on the subject. She is also the editor of *The Art of Jewish Children, Germany: 1936–1941; Innocence and Persecution* (1989) and has contributed numerous articles to books and journals about photography of the Holocaust as historical evidence, women and the Holocaust, Gypsies, and the fate of the Polish Jews expelled from Nazi Germany in October 1938. She also served as general editor of the Garland documentary series *Archives of the Holocaust* (1990) and as coeditor of volumes 1–7 of *The Simon Wiesenthal Center Annual*.

Ira Nowinski is an independent photographer residing in San Francisco. A graduate of the San Francisco Art Institute (1973) and a recipient of three grants from the National Endowment of the Arts, he has served as the official photographer of the San Francisco Opera since 1978 and has specialized in photographing opera companies and performances as well as the American Jewish experience. His work is represented in the permanent collections of the Museum of Modern Art, the Library of Congress, the National Museum of American Art of the Smithsonian Institution, the New York Public Library, the Victoria and Albert Museum in London, the Lund Museum in Sweden, Yad Vashem, and the Judah L. Magnes Museum, among others, and has also been exhibited at the M. H. de Young Memorial Museum, the San Francisco Museum of Modern Art, the National Museum of Photography in Bradford (England), the Museum of Performing Arts at Lincoln Center, and the New York Jewish Museum. His photographs have appeared in numerous newspapers and magazines, and his books include *Cafe Society: Photographs and Poetry from San Francisco's North Beach* (1978), *No Vacancy: Urban Renewal and the Elderly* (1979), *Grandissimo Pavarotti* (1986), *Backstage at the Opera* (1982), and *A Season at Glyndebourne* (1988).

The book was designed by Joanne Kinney. The typeface for the text is Optima, and the display type is Helvetica. The text is printed on 80 lb. S. D. Warren's Patina Matte paper and is bound as a three-piece case in Holliston's Roxite and ICG's Arrestox Amerspun Buckram cloth over 120 pt. genuine binder's boards.
Manufactured in the United States of America.